DETROIT
THEN & NOW

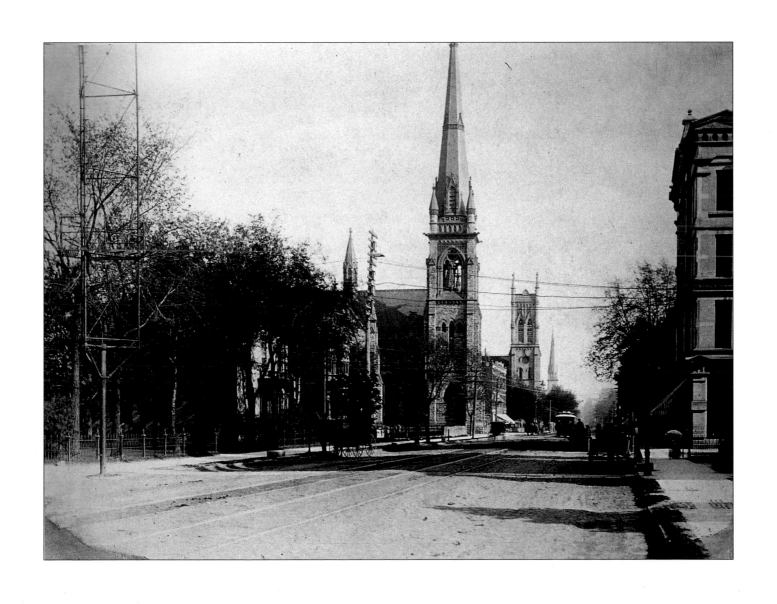

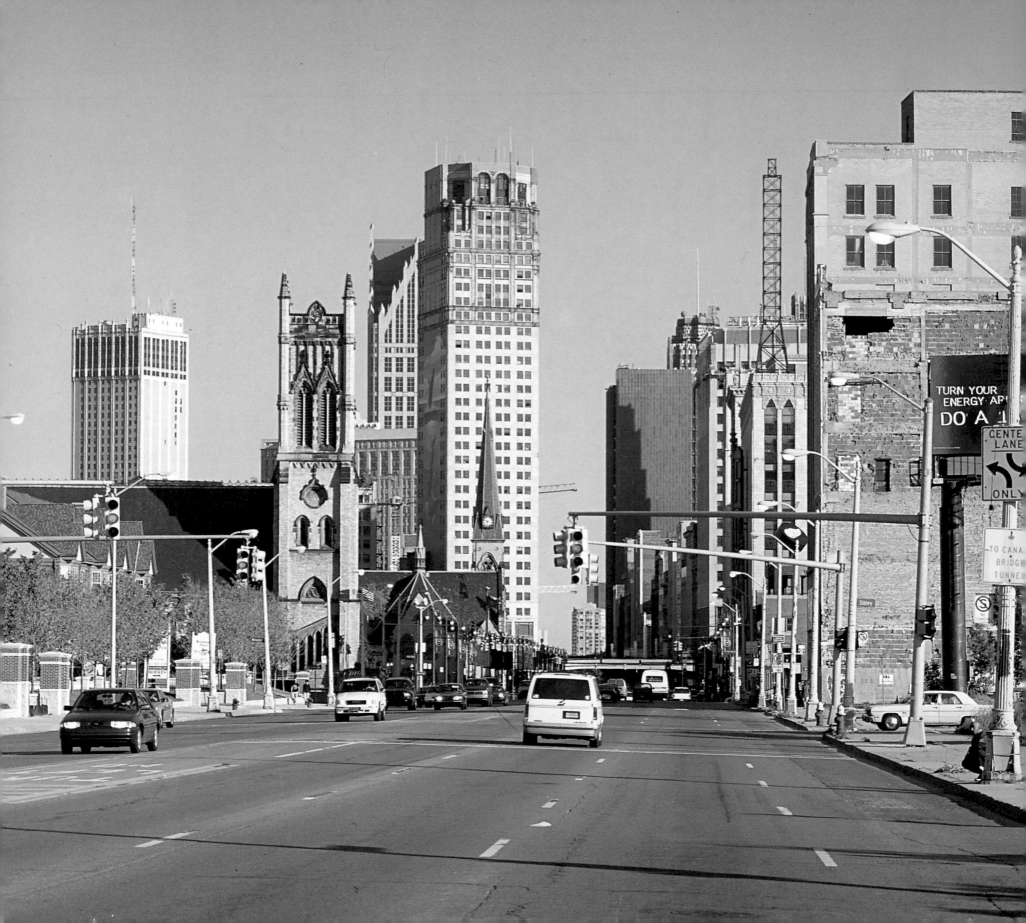

DETROIT
THEN & NOW

CHERI Y. GAY

THUNDER BAY
P·R·E·S·S

San Diego, California

Published in the United States by
Thunder Bay Press
An imprint of the Advantage Publishers Group
5880 Oberlin Drive, San Diego, CA 92121-4794
www.advantagebooksonline.com

Produced by PRC Publishing Ltd,
8–10 Blenheim Court, Brewery Road, London N7 9NY, England
A member of the Chrysalis Group plc

ISBN 1-57145-689-9

Library of Congress Cataloging-in-Publication Data available upon request.

Printed in China

1 2 3 4 5 05 04 03 02 01

To my mother, Frances L. Gay.

Acknowledgments:
I wish to credit the many who have gone before in documenting Detroit's history, including,
but not limited to: George B. Catlin, *The Story of Detroit*; Silas Farmer, *The History of Detroit and
Michigan*; W. Hawkins Ferry, *The Buildings of Detroit*; Philip P. Mason's article "Grace"; Dennis
Nawrocki, *Art in Detroit Public Places (1980 ed.)*; Arthur M. Woodford, *Detroit, American Urban
Renaissance*; and Frank B. Woodford, *Parnassus on Main Street. The Detroit Almanac: 300 Years of Life
in the Motor City*, by the *Detroit Free Press*, and the web sites of both the *Detroit Free Press* and the
Detroit News were particularly helpful. Thank you to David Poremba, manager of the Burton
Historical Collection, for making this project possible, for reading the text and making
suggestions, along with Patience Nauta, registrar at the Detroit Historical Museum and
photographic historian David Tinder for their input. A very special thank you to the past and
present staff of the Burton Historical Collection at the Detroit Public Library for their diligent
accumulation, indexing and preservation of the records of Detroit's history. And above all,
heartfelt gratitude to my husband, Giancarlo Castillo, for his patience, support and enthusiasm
as we careened around Detroit's streets together.

Photo Credits:
The publisher wishes to thank the Detroit Public Library for kindly supplying all the 'then'
images for this book. The original negatives all came from the Burton Historical Collection, and
were photographed for this book by Tom Sherry.

Thanks to Simon Clay for taking all the 'now' photography, with the exception of the
photograph on page 121, which was taken by Cheri Y. Gay.

The front cover photograph shows City Hall on Woodward Avenue. Supplied courtesy of
© Hulton-Deutsch Collection/CORBIS. The back cover photograph shows the same scene as it
appears today. Taken by Simon Clay.

The front flap photograph (top) shows: looking west on Jefferson from Woodward Avenue, circa
1891. Supplied by the Burton Historical Collection/Detroit Public Library (see page 18). The
front flap photograph (bottom) shows the same scene today, the One Woodward building
overlooking the Civic Center. Taken by Simon Clay.

The back flap photograph (top) shows: the Capitol Theater, built in 1922. Supplied by the
Burton Historical Collection/Detroit Public Library (see page 62). The back flap photograph
(bottom) shows the building undergoing renovation today. Taken by Simon Clay (see pages 19
and 63 respectively).

INTRODUCTION

Paris of the Midwest, City of Churches, City of Trees, Motor City, Motown—all of these names have been synonymous with Detroit, once pronounced "day-twah" (from the French *le détroit*, meaning "the strait"). Now Detroit city is gritty, hardworking, and yes, elegant, a city of heart and soul, never easy to capture in a single snapshot.

The Detroit River originally brought the French to its shores, and it is the river that the city tries to reclaim today. Where farms once stretched to its banks, industry and commerce, for the most part, now occupy some thirteen miles of river frontage. How did it all begin?

The credit goes to Antoine de la Mothe Cadillac. Stationed in Michilimackinac, a part of French-occupied Canada, Cadillac advocated establishing a permanent settlement on the Detroit River, an important link between lakes Erie and Huron. A settlement here would be crucial to controlling the lucrative fur trade, and would, incidentally, help keep the British at bay. On July 23, 1701, Cadillac and his entourage of trappers and *voyageurs* swept past what would become Detroit and spent the night on Grosse Ile, downstream. The next day he selected the narrowest part of the river and, on its high banks, built Fort Pontchartrain.

Only remnants of Detroit's French origins are left today, mainly street names and Ste. Anne's church (in its eighth building), founded at the same time as the city and the country's second oldest continuous parish. After the French, the British were here for over thirty years, often at odds with the Native Americans who brought their furs to sell and who moved their villages to the outskirts of the fort. In fact, Ottawa Chief Pontiac took such exception to the British treatment that he held the city in siege for five months.

In 1805, the city burned to the ground, effectively destroying any tangible link to the past. It was at this time that Father Gabriel Richard, pastor of Ste. Anne's, uttered what would become the city's motto, "We hope for better things; it shall arise again from the ashes." The city was rebuilt following a design laid out by Judge Augustus Woodward, and based on ideas of Thomas Jefferson and Charles L'Enfant, designer of Washington, D.C. Today we have Woodward Ave. as the main north-south artery from the river, a public area called Campus Martius several blocks north of the river, and a few blocks farther north, the semicircular Grand Circus Park. Though not followed entirely as Judge Woodward intended, the Woodward plan gave us the broad avenues and open spaces that make downtown Detroit distinctive.

Under the leadership of Lewis Cass, territorial governor from 1813 until 1831, land purchases were made from the Indians and what later became metropolitan Detroit began to materialize. Cass is credited with moving Detroit from wilderness outpost to burgeoning city. Settlers going west passed through Detroit via Buffalo. *Walk-in-the-Water* was the first steamship on the Great Lakes, making her maiden voyage from Buffalo to Detroit in 1818, but it wasn't until the opening of the Erie Canal in 1825 that Detroit really began to boom. The canal's completion reduced a two-month trip of bone jarring travel from the eastern seaboard, to four or five days of water passage, and introduced the first flood of immigrants to Detroit. The riverfront became a flurry of comings and goings, and Detroit was open for business.

As the fur trade and tanning industry wound down at the end of the 1820s, the iron industry and building of railroads became a major Detroit concern. By the time Michigan joined the Union in 1837, railroad lines replaced shipping as a means of transport, and Michigan Central Railway was the first to lay tracks from Detroit to Chicago. A major contribution to the operation of railroads was made by Detroiter Elijah McCoy who invented a self-lubrication system for locomotives.

During the Civil War, Detroit was an important station on the Underground Railroad, being across the river from Canada. Some estimate that as many as 45,000 passed through Detroit on their way to freedom. Detroit was also called the Tampa of the North because of its sizeable tobacco industry. A major producer of railroad cars, Detroit also was the largest stove manufacturer in the world, the maker of the famous Garland stove. At the end of the century, lumber, mining, and railroad industries gave Detroit the economic base and investment capital it would need to leap into the automobile industry.

Despite an economic depression in 1893, Detroiters had fun in the '90s. Bicycling was popular, as were ferry trips to Belle Isle to hear concerts. There was a high percentage of homeowners in the city and gardens were everywhere. Businessmen went home to lunch with families. By 1896, the Detroit Tigers were playing at the corner of Michigan and Trumbull and Fred Sanders had invented the ice-cream soda. A soda made with James Vernor's earlier creation of Vernor's Ginger Ale was called a Boston cooler. Why Boston? … nobody knows. As the last horse-drawn streetcar was operated on city streets in 1896, Charles Brady King drove the first automobile. The direction of Detroit history was changed forever.

Motor City became the moniker for the place that spawned Henry Ford and the Ford Motor Company, the first assembly line, the $5 a day wage, General Motors, Dodge Brothers, the UAW, and the place that would provide work to generations of auto factory workers. Always an immigrant city, it's important to recognize the variety of people who came to Detroit, some intending to stay, others who stayed longer than they intended. The German and the Irish were the earliest immigrants, followed by Polish, Mexicans, Middle Easterners, and Greeks. Between 1910 and 1930 the number of African-Americans increased from 5,000 to 120,000 as many migrated from the South for jobs and better social conditions.

During World War II the automobile industry played a crucial role in the manufacture of weapons and vehicles, earning the city yet another nickname, "The Arsenal of Democracy." It was at Ford's Willow Run B24 bomber plant that the nickname for women who worked in the war, Rosie the Riveter, originated. By 1946 the J. L. Hudson store filled an entire block downtown and was the world's tallest department store. Freeways began to crisscross the city, a boon to those with cars, a curse to the development of an effective public transportation system.

For a nonhistorian, history at first glance can seem a series of names, dates, and places. However, through these photographs, history becomes stories, as interesting, beautiful, or sad as the photographs themselves. These photographs represent a small portion of the wonderful images there are of Detroit, a place where "life is worth living." As Detroit rolled into the second half of the twentieth century it had, and still has, its share of big city problems. But today Detroit, "City of Champions," is ready for a comeback and the chance to recreate the city that it once was.

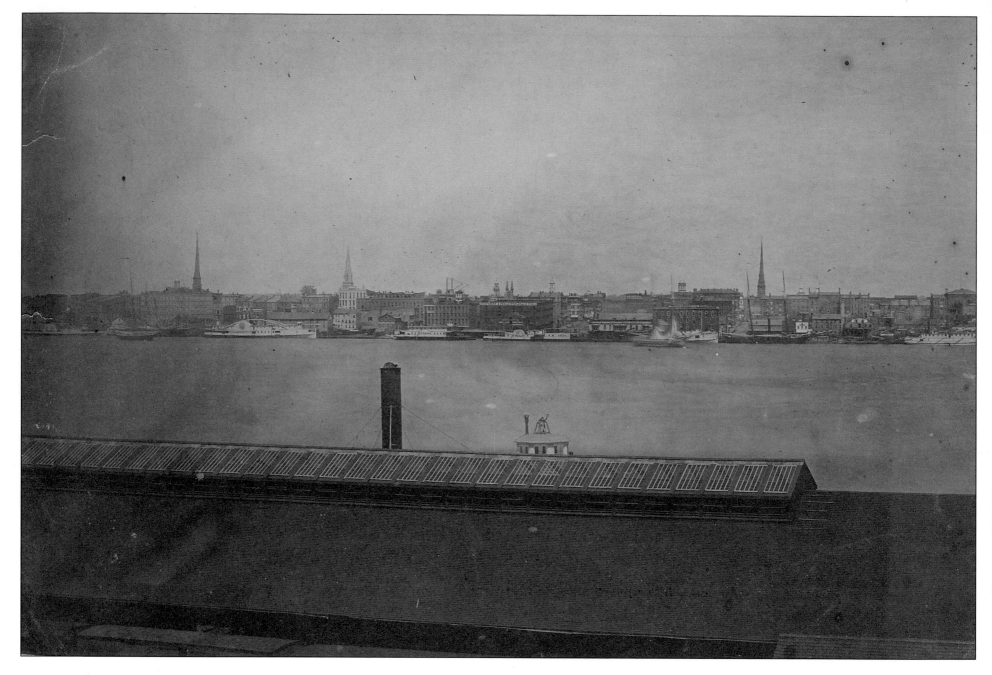

Church spires and sailing masts mark the landscape of 1860 Detroit as seen from its Canadian neighbor, Windsor, Ontario. From left to right are the steeples of Fort St. Presbyterian Church, St. Paul's Protestant Episcopal Church, the First Baptist Church, and the Gothic tower of the first St. Paul's. From the right side is Ste. Anne's Church with the double steeple, then the First Presbyterian Church, followed by the cupola of City Hall. The ferry *Ottawa* graces the dockside.

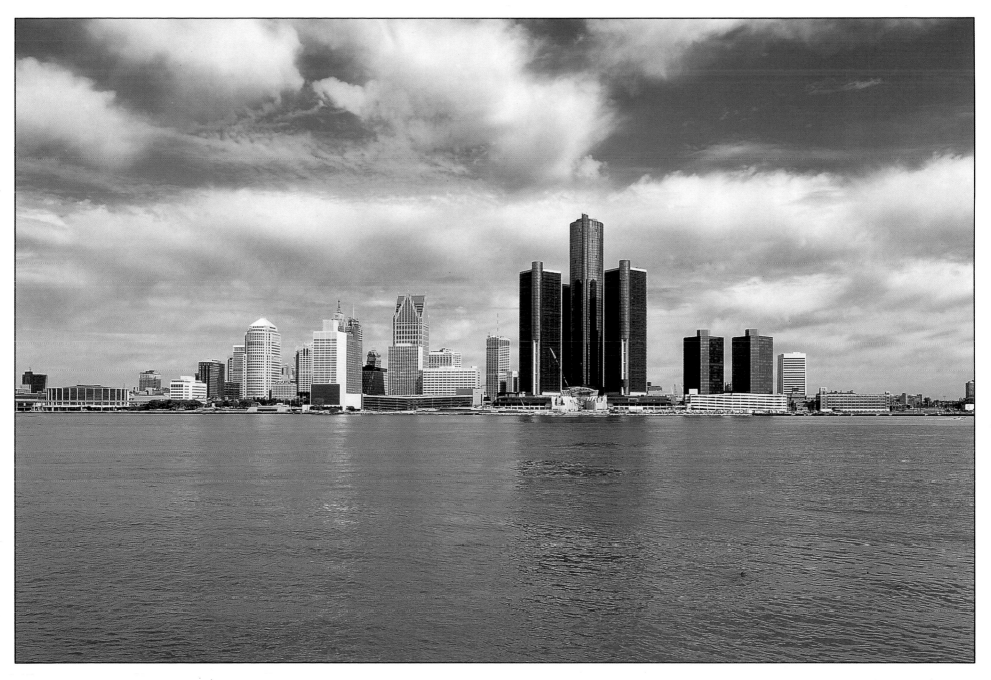

Though not visible here, only the Fort St. Presbyterian Church is in the same location today. Now office buildings replace church spires and barges replace steamboats. From left, the round profile of Cobo Arena is followed by the low white block of the Veteran's Memorial Building (now the UAW-Ford National Programs Center), then the taller 150 W. Jefferson, built in 1988. Ford Auditorium is the dark, low square in front of One Woodward (originally the Michigan Consolidated Gas Building), and the peaked facade of Comerica Tower is backdrop to the Coleman A. Young Municipal Building. Dominating the skyline are the mirrored silos of the Renaissance Center.

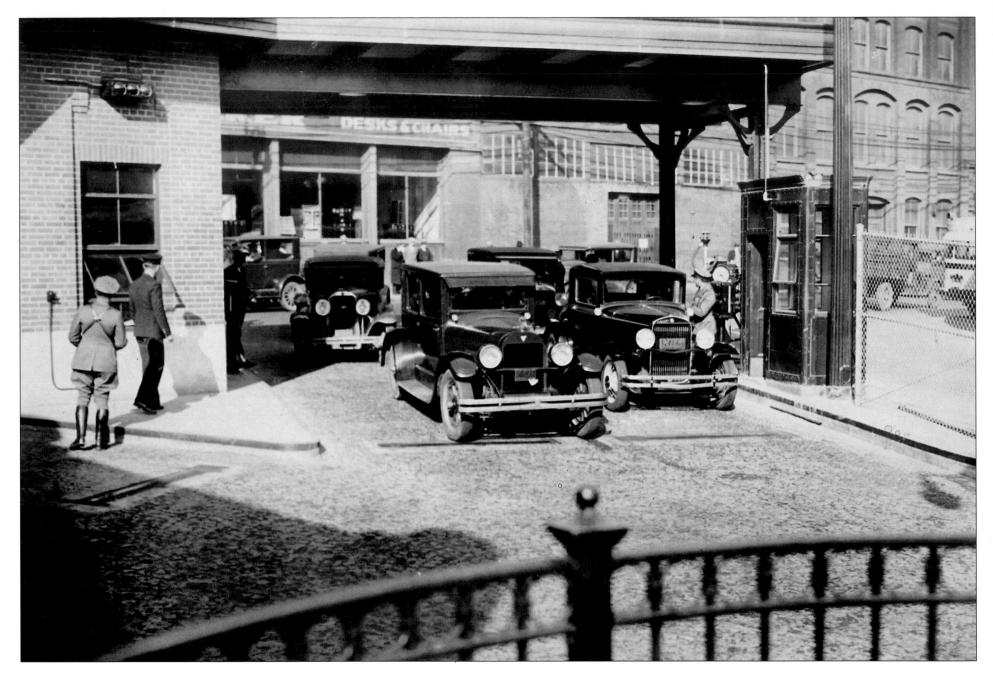

Work began on the tunnel in 1928 and was completed in 1930. A specially built steel tube was sunk thirty feet beneath the riverbed at its deepest part. Less than half of the tunnel's 5,135-foot length is under water. When the tunnel opened in 1930, about the time this photo was taken, the toll was 25¢. The tunnel entrance from Detroit was originally on Woodbridge Street.

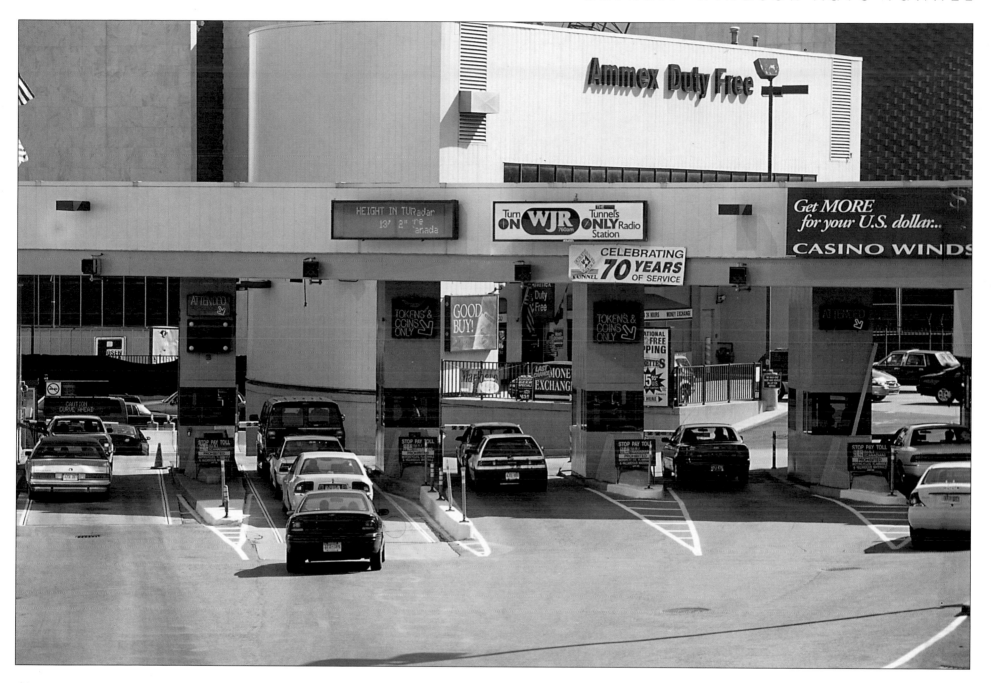

The Detroit—Windsor Tunnel is one of the few auto tunnels in the world between two countries. Twenty-two feet wide and almost one mile long from entrance to exit, it carries over nine and a half million travelers annually, in both directions, making the Detroit—Windsor border the busiest northern crossing in the U.S. Today, the tunnel is entered at a location just west of the Renaissance Center, and the toll, one-way, is $2.25 for a passenger vehicle.

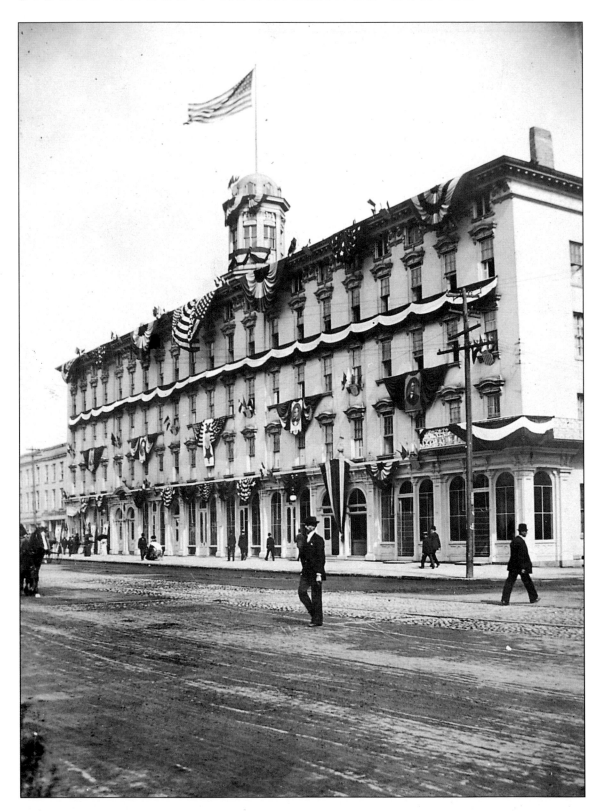

Standing at the southeast corner of Jefferson and Randolph, the Biddle House, built in 1849, was a leading hotel in Detroit— General Ulysses S. Grant attended a reception here during his visit to Detroit on August 12, 1865. The building was said to resemble the Tremont House in Boston, built by Isaiah Rogers. At the western end of the building was a balcony (covered by bunting) where various dignitaries greeted crowds over the years. The building was torn down in 1917. This photo was taken in 1891 during the encampment of the Grand Army of the Republic, an organization of Civil War veterans.

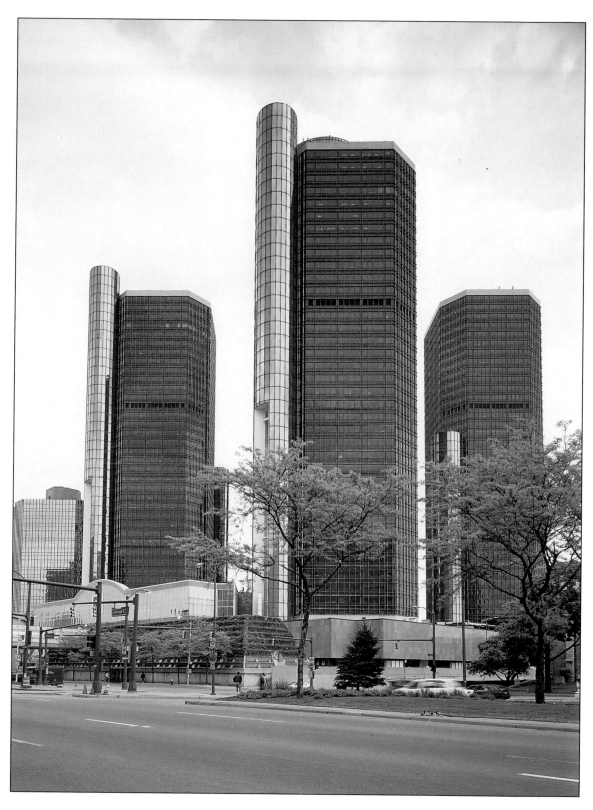

In 1977, the Renaissance Center arose from this site. The name was chosen to symbolize hopes that the new complex would revitalize the city. Built by a partnership spearheaded by Henry Ford II, the RenCen as it is called, never quite met expectations. Architect John Portman designed a complex that was immediately criticized for its labyrinth-like, cold, concrete interior. The berm outside hiding cooling equipment was seen as a barrier. In 1996, General Motors purchased the property for its world headquarters and has made the building more navigable, with plans to provide more public access to the Detroit River and to remove the berm.

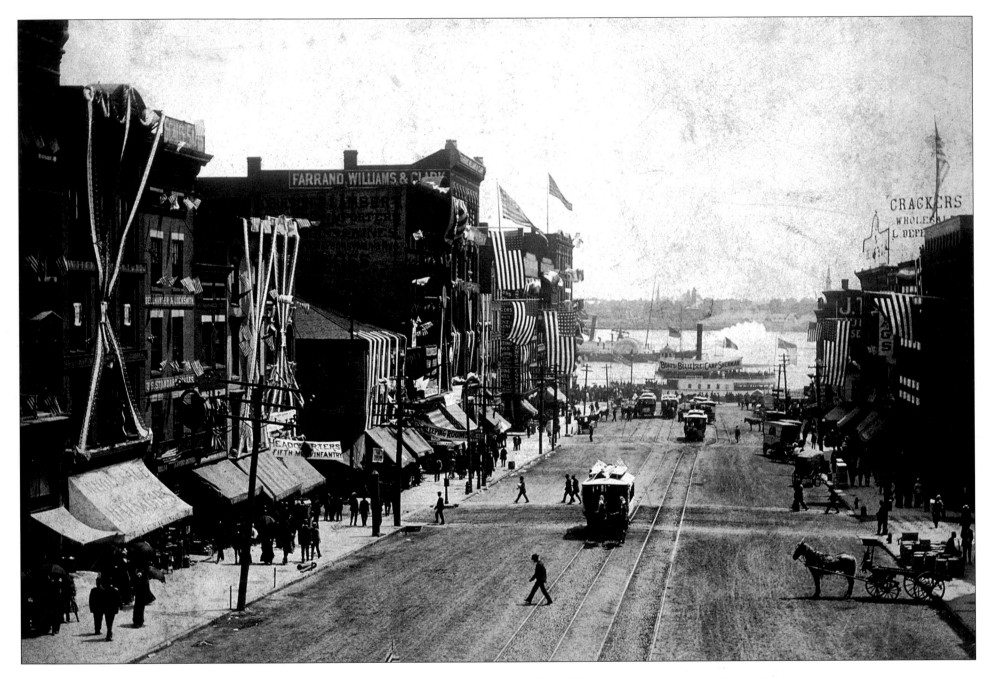

The foot of Woodward Avenue at the Detroit River was a busy wharf and dock area from about the 1820s until the mid-twentieth century, as this 1891 photo shows. Prior to that, all the action at the river was one or two blocks east. The flags and bunting were in place for the National Encampment of the Grand Army of the Republic, an organization of Civil War veterans. An estimated 100,000 people jammed the city the first week in August with parades and picnics. On the river, the boat closer to the wharf is the ferry to Belle Isle, farther out sits the U.S.S. *Fessenden*.

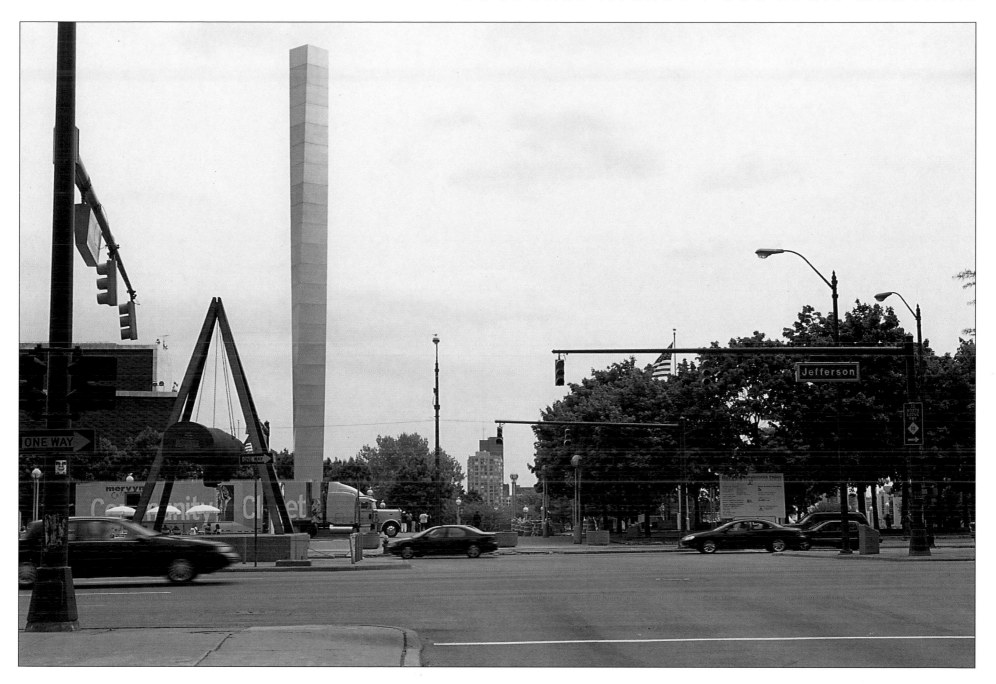

The city blocks south of Jefferson were razed to make room for the city's Civic Center. A gift to the city in 1987, the monumental fist of boxer Joe Louis dominates this intersection. Sculptor Robert Graham wished to create something different from the traditional statue and chose to make this twenty-four foot bronze arm and fist of the "Brown Bomber," suspended in a twenty-four foot high pyramid. Just beyond is Isamu Noguchi's stainless steel Pylon signaling the end of Woodward and the beginning of Hart Plaza, leading down to the Detroit River.

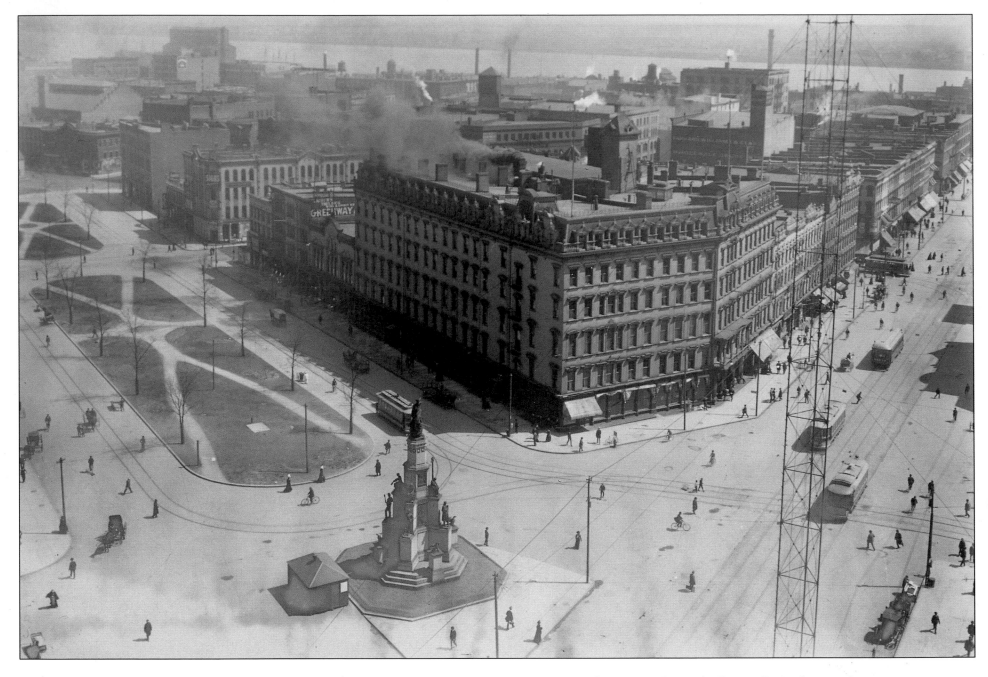

Looking southeast from Campus Martius to Cadillac Square, circa 1895. Campus Martius, meaning "field of Mars" or military ground, saw troops drill and parade here from 1788 through the Civil War. At its center is the Soldiers and Sailors Monument, designed by Randolph Rogers, and unveiled in 1872 to commemorate the 14,823 Michigan soldiers killed in the Civil War. It was one of the first Civil War monuments in the country. Facing the Detroit River, the sixty foot monument is topped by an armed female warrior, symbolizing Michigan. On the right, the Russell Hotel, built in 1857 and rebuilt in 1881, included among its guests the Prince of Wales, and stood for fifty years at Woodward and Cadillac Square.

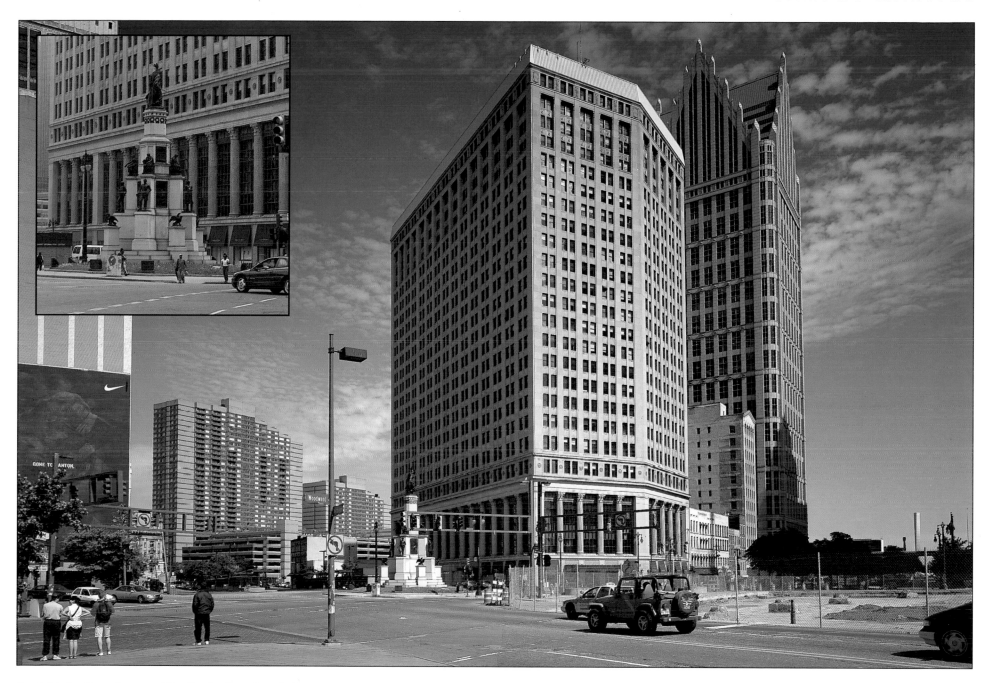

In 1920 the Pontchartrain Hotel, which replaced the Russell Hotel in 1907, was in turn demolished to make way for the National Bank Building, which today is First National. Behind it stands Comerica Tower. A city bus terminal has replaced the grassy boulevard. However, in a nice turnabout, the bus terminal is slated to be razed and the square returned to its former life as a public place. The Soldiers and Sailors Monument will leave its location of nearly 130 years for a space twenty feet south.

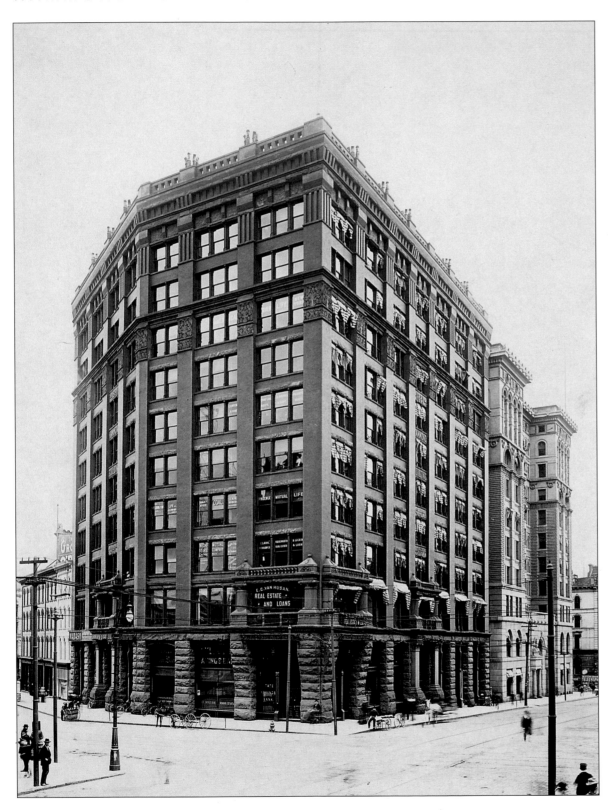

This 1904 image shows Detroit's first skyscraper, the ten-story Hammond Building at Fort and Griswold streets, designed by Harry W. J. Edbrooke of Chicago. When it opened in 1890 a tightrope walker traversed the distance between the new building and the City Hall. The architecture is composed of modern elements, eschewing the arches of the past. Inside, exposed ironwork and wooden floor joists were encased with fireproof tiles and concrete mortar. The Hammond Building was torn down in 1956 when the National Bank of Detroit needed space to expand.

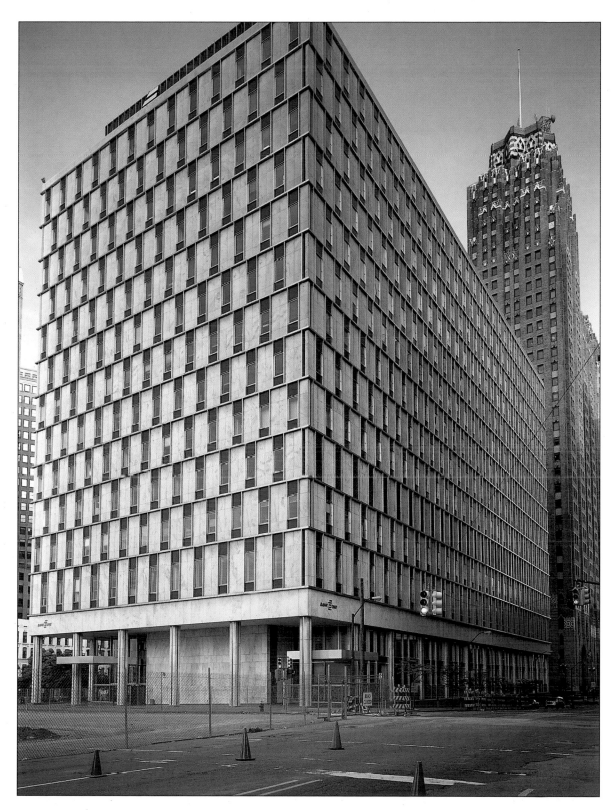

The new bank headquarters went up in 1959, taking up the entire block between Fort and Congress and three blocks on Woodward. Set back from the street, the Albert Kahn Associates design provided a landscaped walkway. The new building consolidated operations that had been spread among various out-of-date buildings, including the original main office, designed by Albert Kahn in 1922 and still standing across Woodward. The building's name has been changed to match the bank's current corporate identity, Bank One.

Below: Looking west on Jefferson from Woodward Avenue, circa 1891. This busy corner near the foot of Woodward and the Detroit River had the Chicago, Grand Trunk and Detroit, Grand Haven, and Milwaukee railway ticket office. Travelers could avail themselves of the Palace Sleeping and Dining Car Line to Chicago. Next-door, James Nall & Co. offered carpets, furnishings, and wallpaper, and beside him, Burnham, Stoepel & Co. sold dry goods.

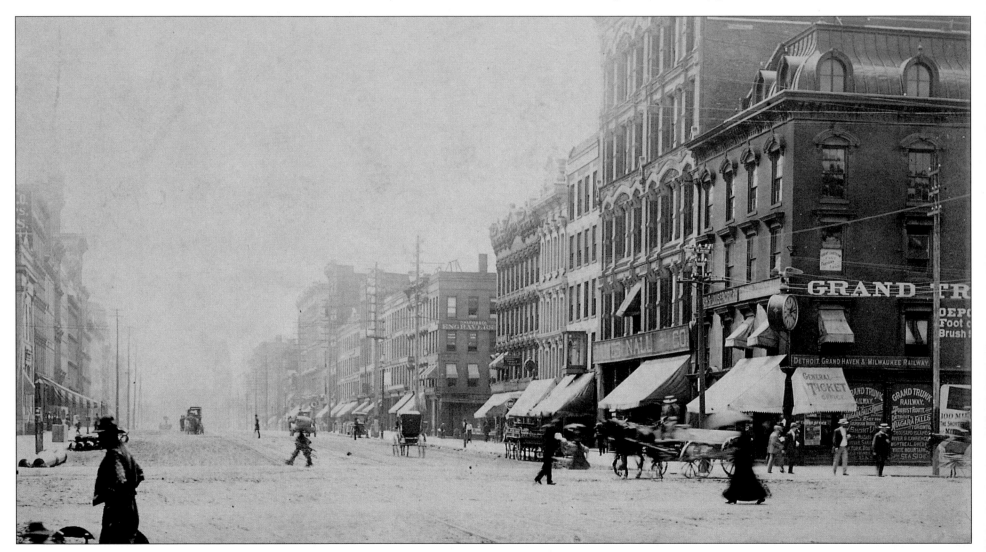

Right: Overlooking the Civic Center is the building now called One Woodward, designed by Minoru Yamasaki as the headquarters for Michigan Consolidated Gas company in 1963. The thirty-two-story tower occupies an entire block and is described "like something out of *The Arabian Nights*" as it rises from a marble platform surrounded by reflecting pools. Its Top of the Flame restaurant on the twenty-sixth floor gave diners a sweeping view of the Detroit River and Windsor. It closed in 1977.

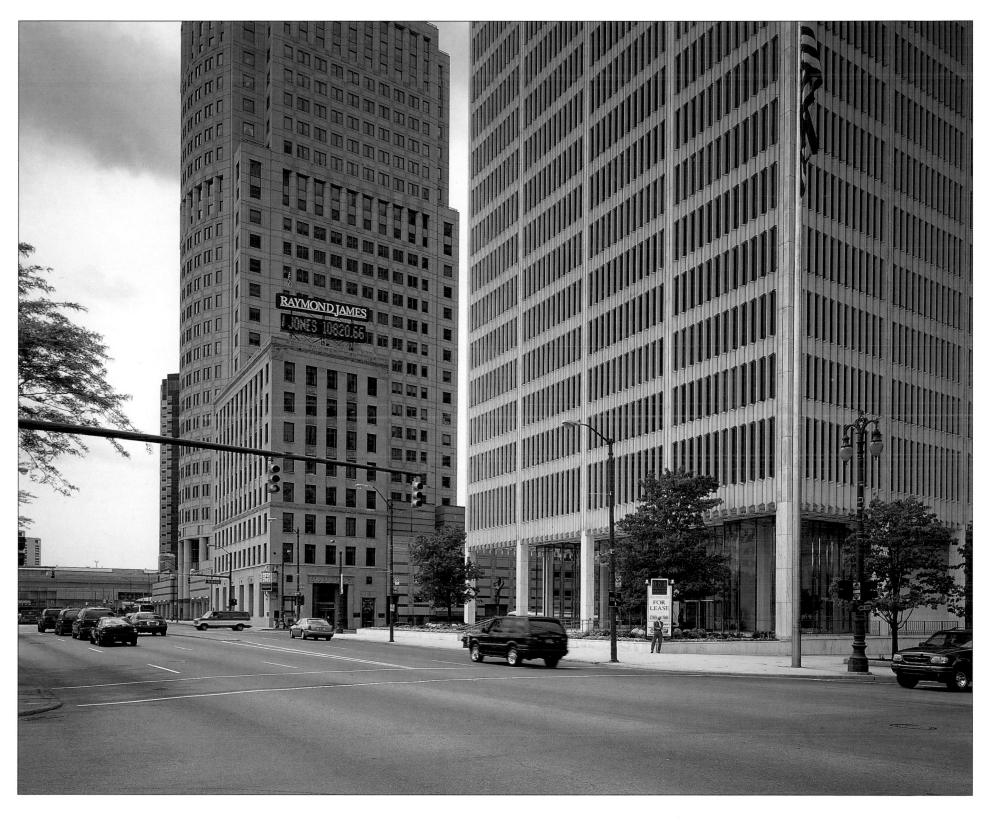

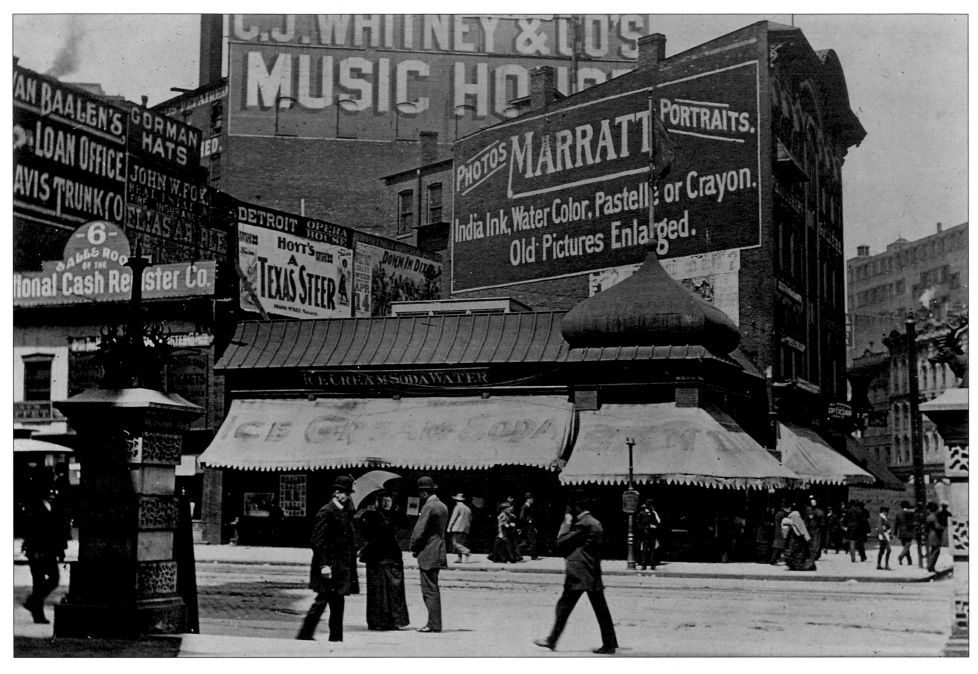

Taken at the end of the 19th century, the photo shows the northwest corner of Michigan and Woodward (facing Michigan), opposite Campus Martius. Under the Turkish-style ornament and the striped awning is the Sanders confectionery store, established in 1875. The ice-cream soda was invented here when a clerk ran out of sweet cream and used ice cream instead. To the right, the Fisher Block, built in 1860, housed several of the city's fifty photographic studios. The two decorative pillars framing the photo are on the plaza surrounding the City Hall.

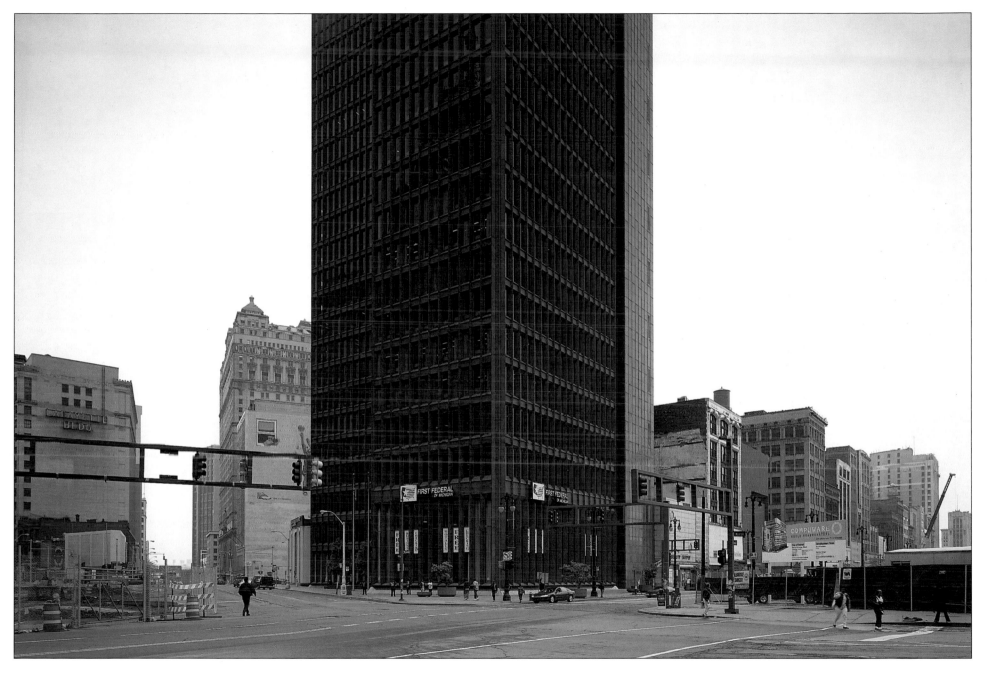

Prior to this modern structure, the imposing Majestic Building stood here from 1896 to 1961, its entrance facing the corner. When the First Federal Building went up in 1965 the architects decided to align the two towers with Woodward, giving the block a more unified look. Using granite, architectural firm Smith, Hinchman, and Grylls was able to keep costs down and create a distinctive building that stands out among its cement and stone neighbors.

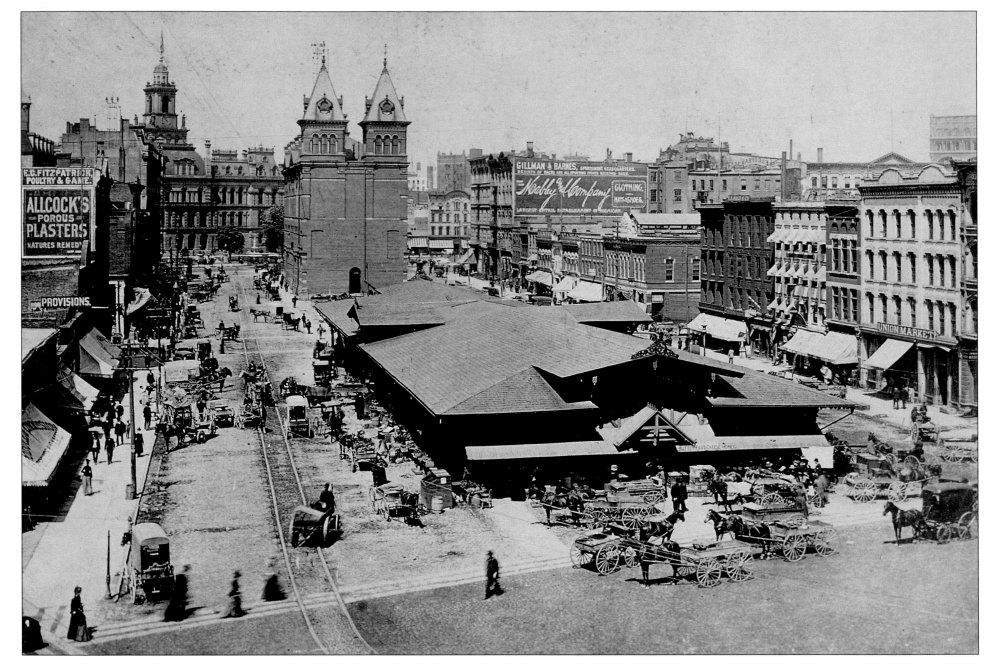

In this 1885 image we view the twin-peaked Central Market from its Cadillac Square side. It opened for business on September 11, 1880. Facing Woodward Avenue and the Campus Martius area, the first floor housed butchers, and the second and third floors, added subsequently, contained city offices and the superior court. The open-air Farmer's Market behind it began in 1843 and expanded over the years. The cupola to the left belongs to City Hall, on the west side of Woodward.

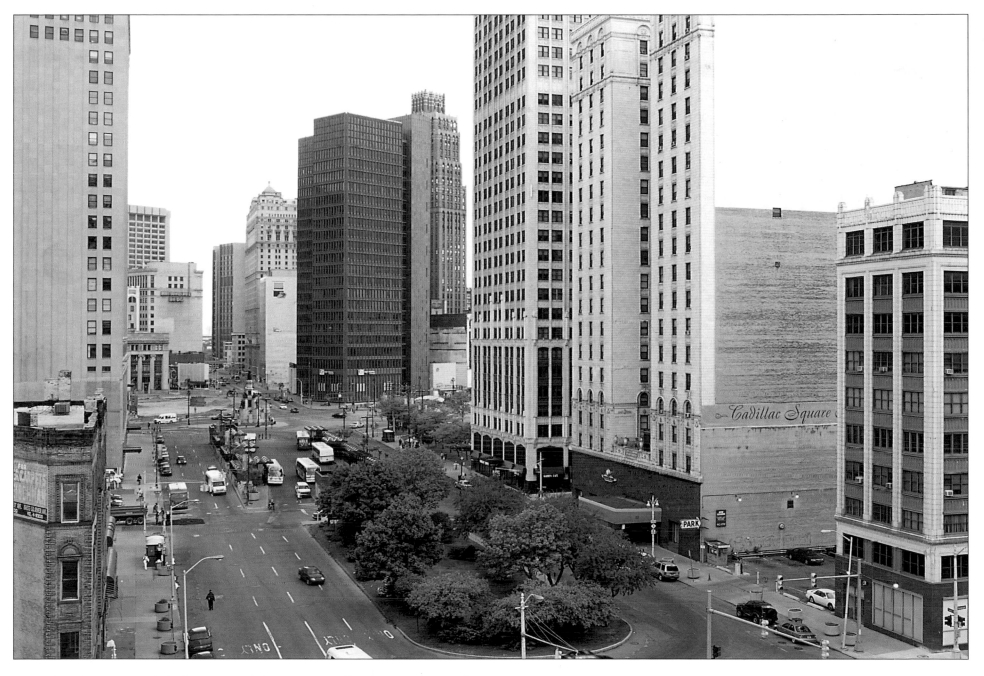

Central Market was demolished in 1889 and the open-air market shed moved to Belle Isle in 1893. Office buildings and a city bus terminal are the center of activity today, but not for long. Plans are for this area to be incorporated into the scheme of Campus Martius. On the right side foreground are the Cadillac Square apartments and the forty-story Cadillac Tower (formerly Barlum Tower). Farther back, the 1929 David Stott Building barely tops the dark rectangle of the First Federal Building. The left side is dominated by the First National Building.

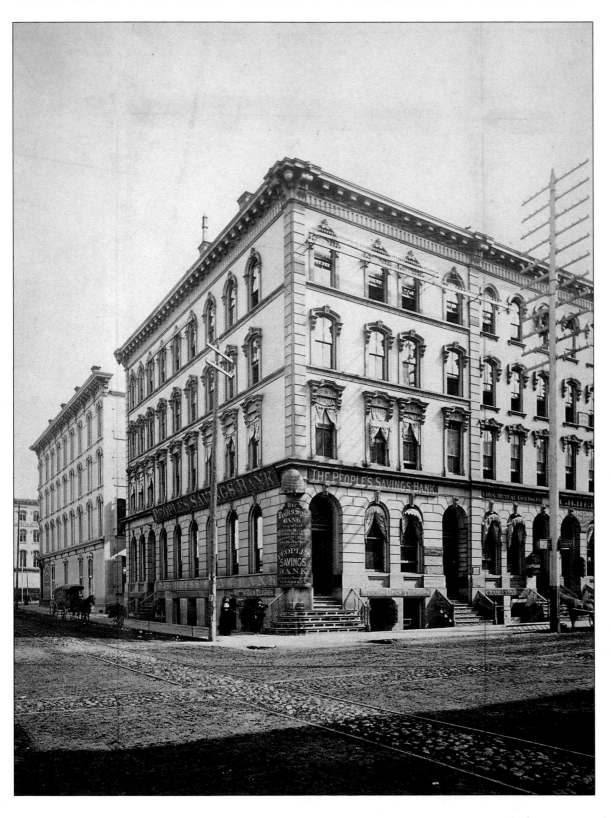

This photo of the People's Savings Bank, at the southeast corner of Congress and Griswold, was taken around 1881. It was part of the Telegraph block, built in 1872, that also contained a Western Union Telegraph company on the first floor and on the top, Michigan's first telephone exchange. The telephone company opened in 1878 with a switchboard and fifty-three telephones. The building was one of five demolished to make way for the Guardian Building.

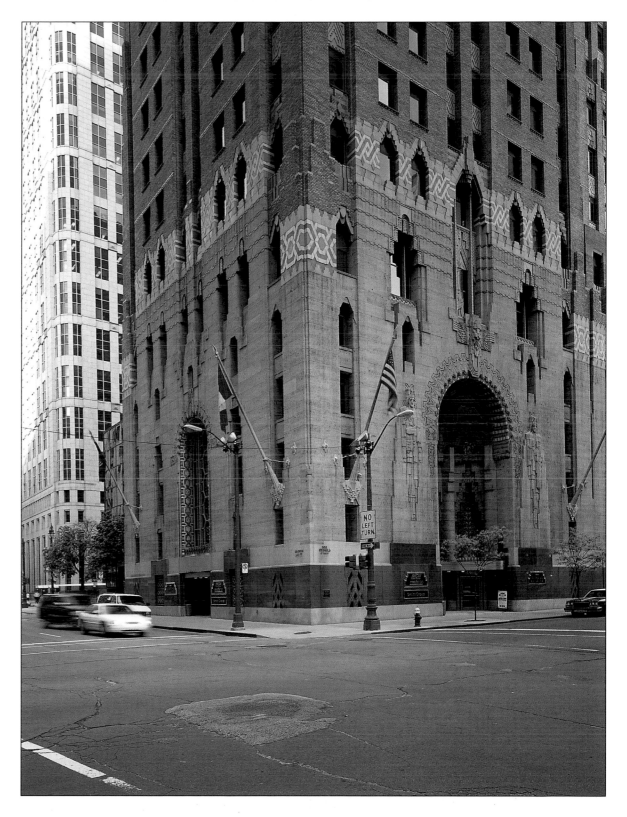

Built as the headquarters for the Union Trust Company, this "Cathedral of Finance" is unique among the more somber skyscrapers. The Guardian Building was completed in 1929 and is a dazzling display of brickwork, terra cotta, and Pewabic tile. The lobby of marble walls and floors, decorated with tiles of Rookwood pottery, is in its original condition. Architect Wirt Rowland was given carte blanche by the company president; he used color as an architectural statement because of its "vital power."

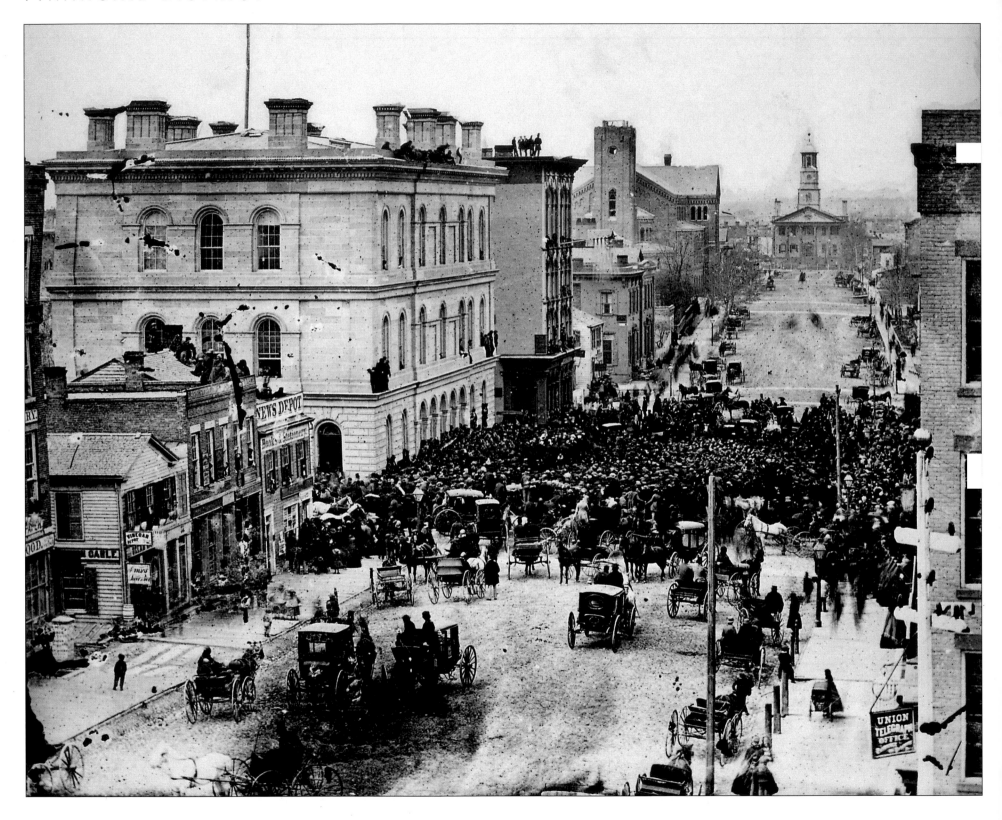

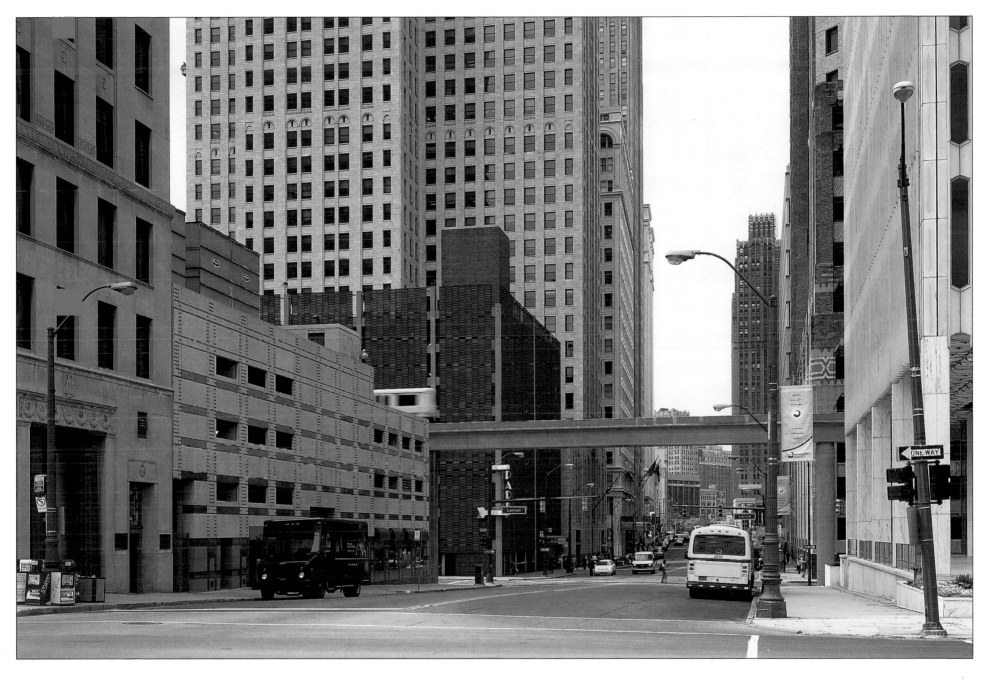

Left: This moment in history was taken by one of Detroit's most prolific photographers, Jex Bardwell. A crowd is gathered in front of the Post Office in 1861 to hear about President Lincoln's call to arms. In the distance, at the end of Griswold, is the old Capitol building, by this time serving as the first schoolhouse. To the right of the Post Office, later the U.S. Custom Building, is the First Baptist Church. The Post Office was built in 1860 on the northwest corner of Griswold and Larned streets, and served as a Custom House and Post Office until 1897.

Above: Today this corner is home to nothing more than a parking garage, a necessary part of any city landscape. Looking north on Griswold we see the canyon of tall buildings, the Buhl, the Ford, and Penobscot on the left, the Guardian on the right, and farther down the David Stott, giving the block its nickname of Detroit's Wall Street.

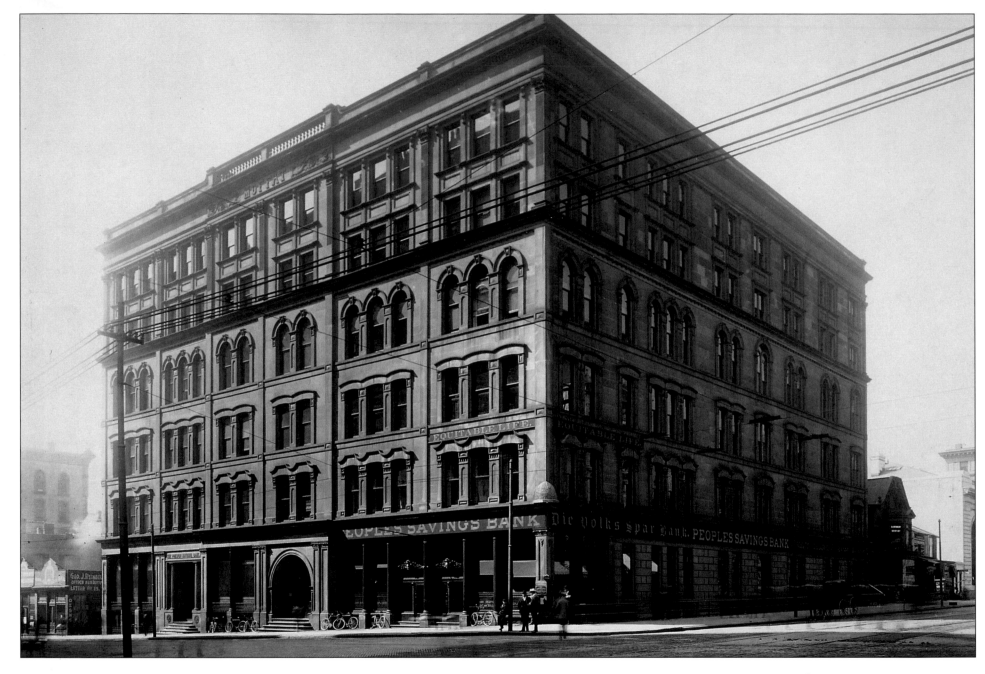

Constructed in 1871 by early Detroit builder and mayor, Hugh Moffat, the Moffat Building featured Detroit's first elevator. Located at the southwest corner of Griswold and Fort streets, the original building was four stories; two more were added in 1884. In this photograph, taken circa 1893, the People's Savings Bank has moved from its original location farther south on Griswold. The tenants of the spacious offices with high ceilings were "men whose names stand out in the story of the City's progress."

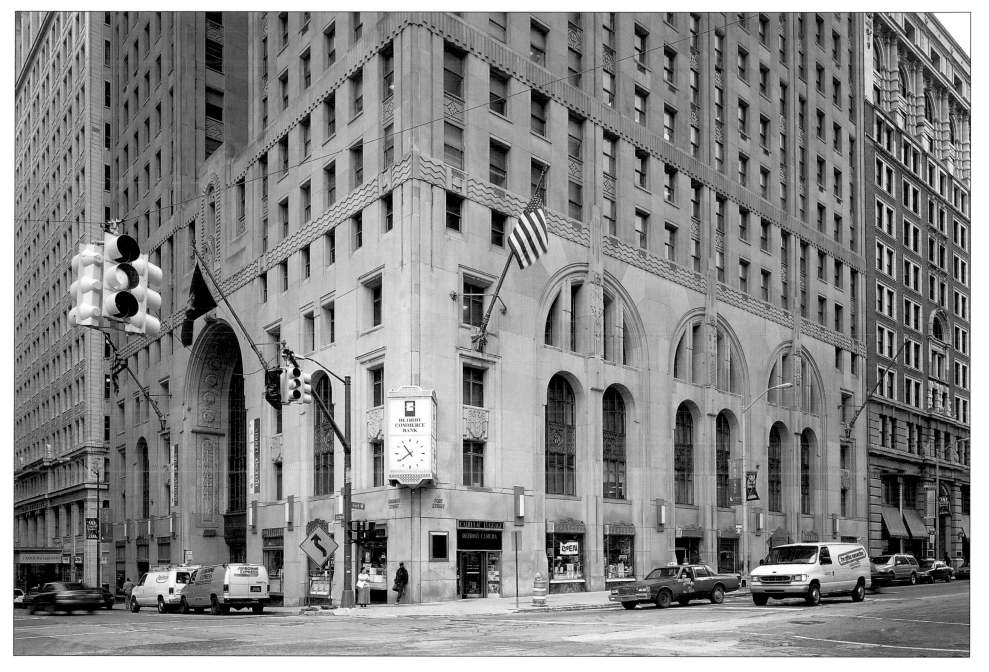

The Moffat Building was felled by the wrecking ball in 1926 to make room for the Penobscot Building. At the time, 1928, the forty-seven-story building was Detroit's highest, and the fifth highest in the world. The foundation of the building went to bedrock, the first in Detroit to do so. The Penobscot joined the Buhl Building (1925) and Ford Building (1909), to be followed by the Guardian Building in 1929, on Griswold, dubbed Detroit's Wall Street. The large mass of masonry designed by Wirt C. Rowland of Smith, Hinchman & Grylls, had few architectural details, its cubist composition topped by a twelve-foot neon orb visible for forty miles.

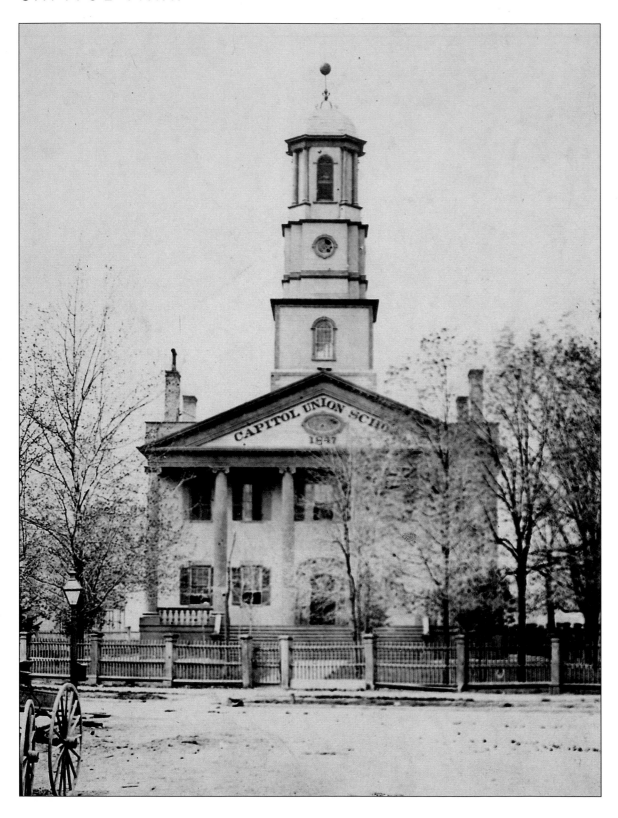

Built as the courthouse in 1828, this brick structure designed by Obed Wait combined features of Federalist, Greek Revival, and New England traditional architecture. This photo, taken circa 1870, shows the building as Detroit's first schoolhouse. Standing at the head of Griswold Street, the building was Michigan's capitol from 1837, when Michigan became a state, until 1847, when the capital was moved to Lansing. It housed the high school from 1863 until 1893, when it burned to the ground.

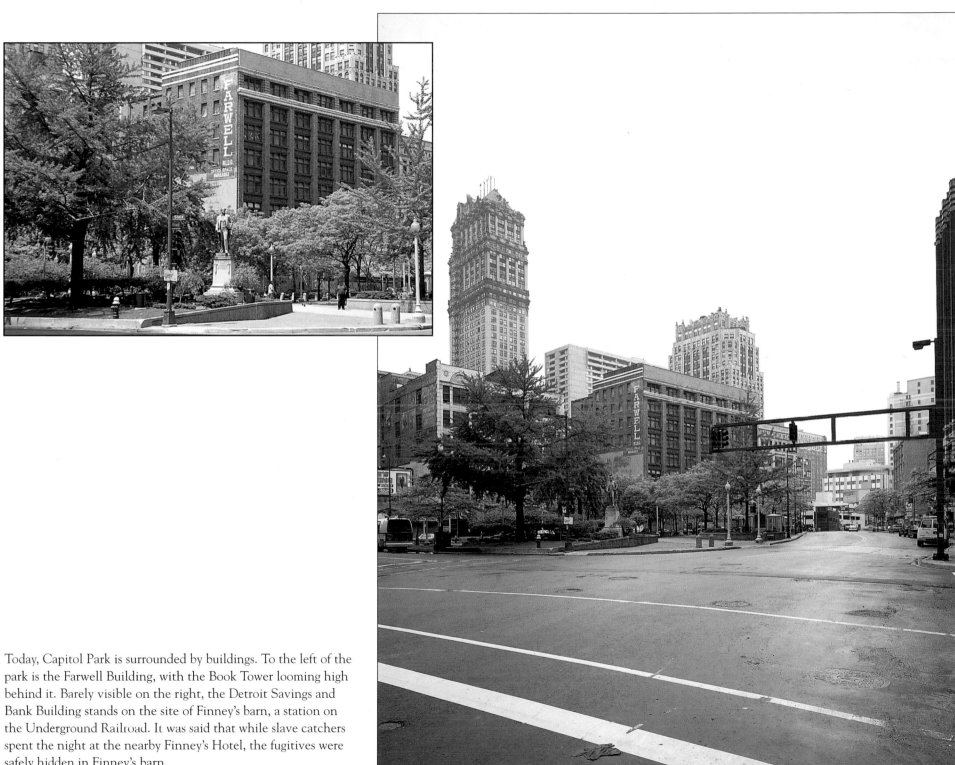

Today, Capitol Park is surrounded by buildings. To the left of the park is the Farwell Building, with the Book Tower looming high behind it. Barely visible on the right, the Detroit Savings and Bank Building stands on the site of Finney's barn, a station on the Underground Railroad. It was said that while slave catchers spent the night at the nearby Finney's Hotel, the fugitives were safely hidden in Finney's barn.

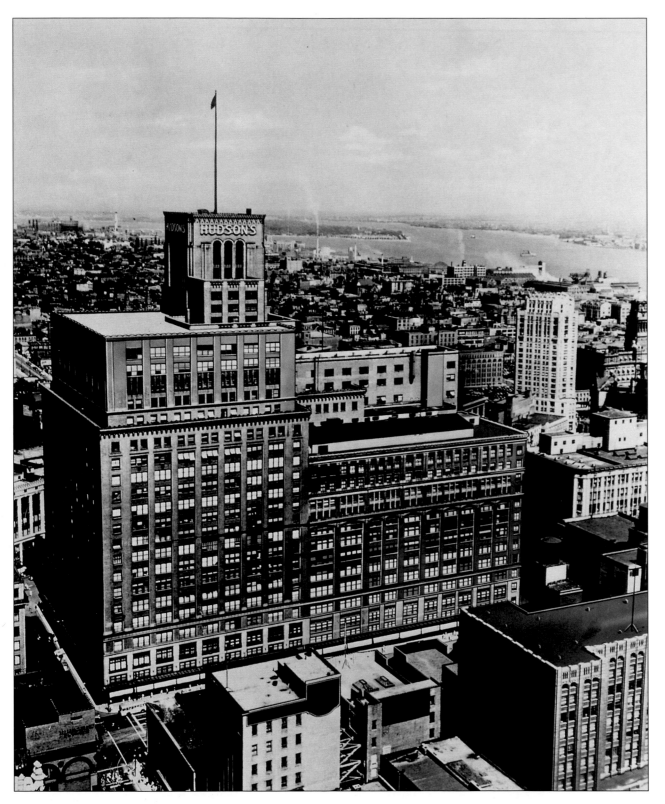

Joseph Hudson opened his first clothing store on the ground floor of the Detroit Opera House in 1881, then ten years later moved to his own store, an eight-story building at Gratiot and Farmer. That building occupied a small portion on the site of this structure, completed in 1929 by Smith, Hinchman & Grylls. It covered the entire block of Woodward, Grand River, Farmer, and Gratiot and became the focal point of downtown Detroit. In 1924 the store sponsored Detroit's first Thanksgiving Parade, still a tradition. This circa 1946 photo shows the J. L. Hudson company with its sixteen-story addition.

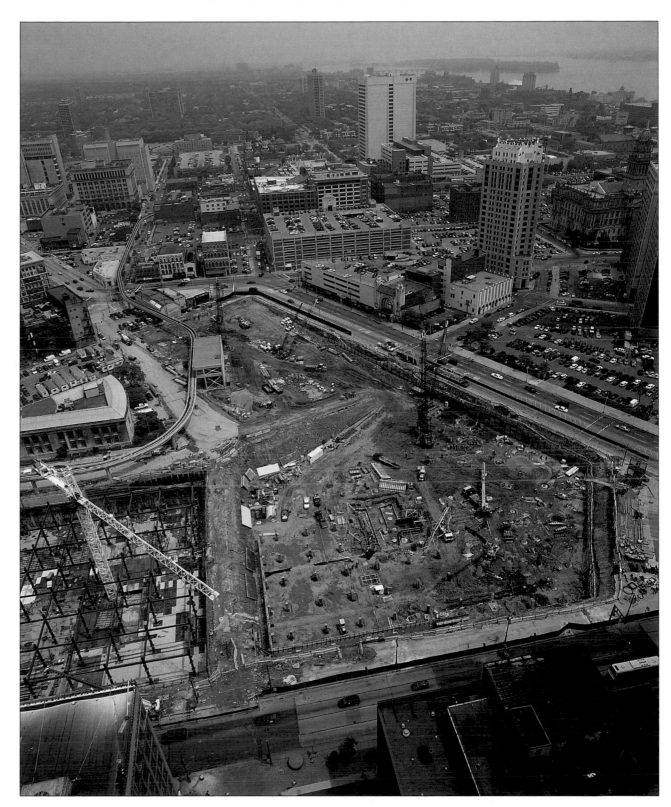

The downtown Hudson's store closed in 1983, though its suburban stores continue to flourish. The building stood vacant for fifteen years as attempts were made to find a use for it. Preservationists and city planners debated the historical value of the building and its potential for development. However, in 1998 time ran out for the building that had made memories for so many, and the huge, 2.2 million square foot store was imploded to make room for the city's new office and parking complex for Compuware.

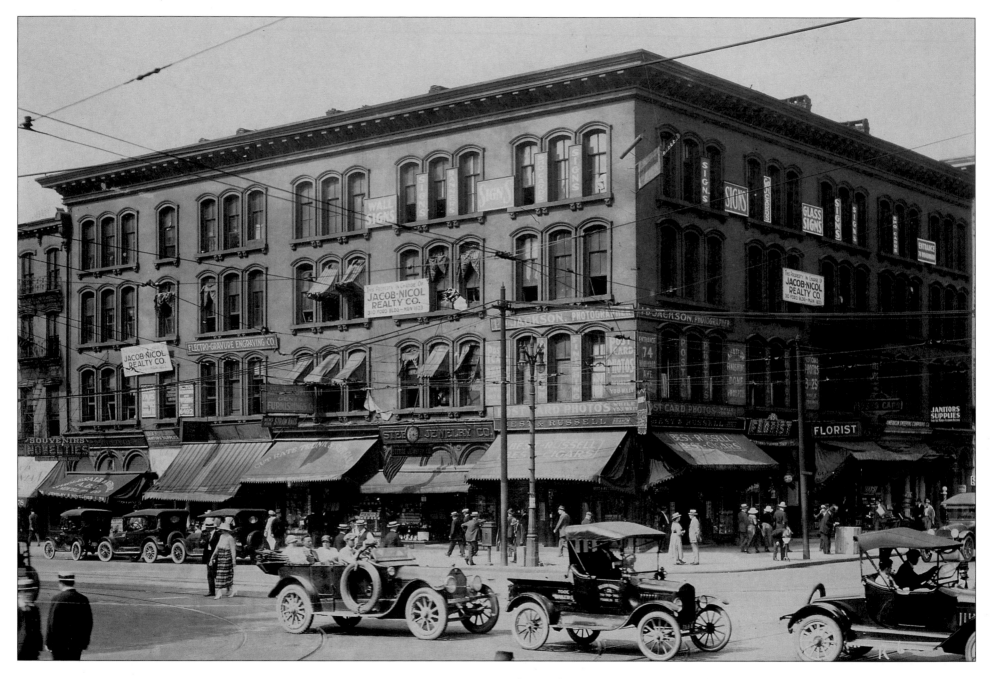

There's plenty of commerce on this busy northeast street corner of Woodward and Jefferson avenues in 1918. The flow of traffic is toward the river. A gentlemen's furnishing store, a jeweler, a cigar store, and, around the corner, a florist shop, all were doing a brisk business. During this period, Detroit's population zoomed to close to one million, doubling in ten years.

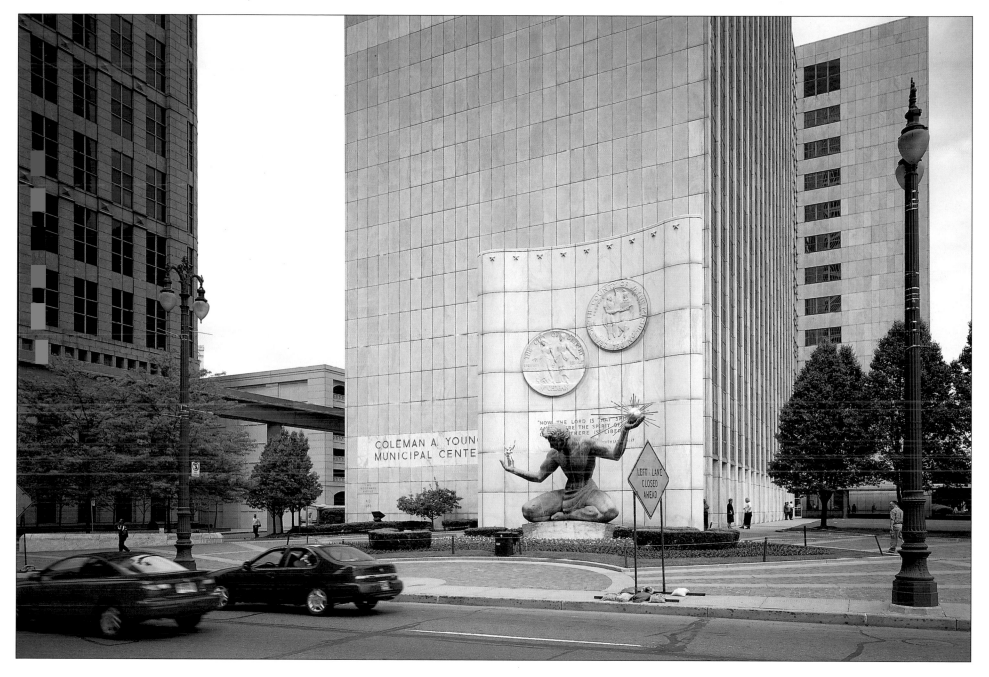

In 1955 the City-County Building opened as part of a larger plan to develop the area at the foot of Woodward as the Civic Center. Nine square blocks were razed for the project. The sixteen-foot high sculpture is the *Spirit of Detroit* by Marshall Fredericks, holding in his right hand a family, symbolic of human relationships and in his left, a gilt bronze sphere with rays to symbolize God. The building was recently renamed to honor former mayor Coleman E. Young.

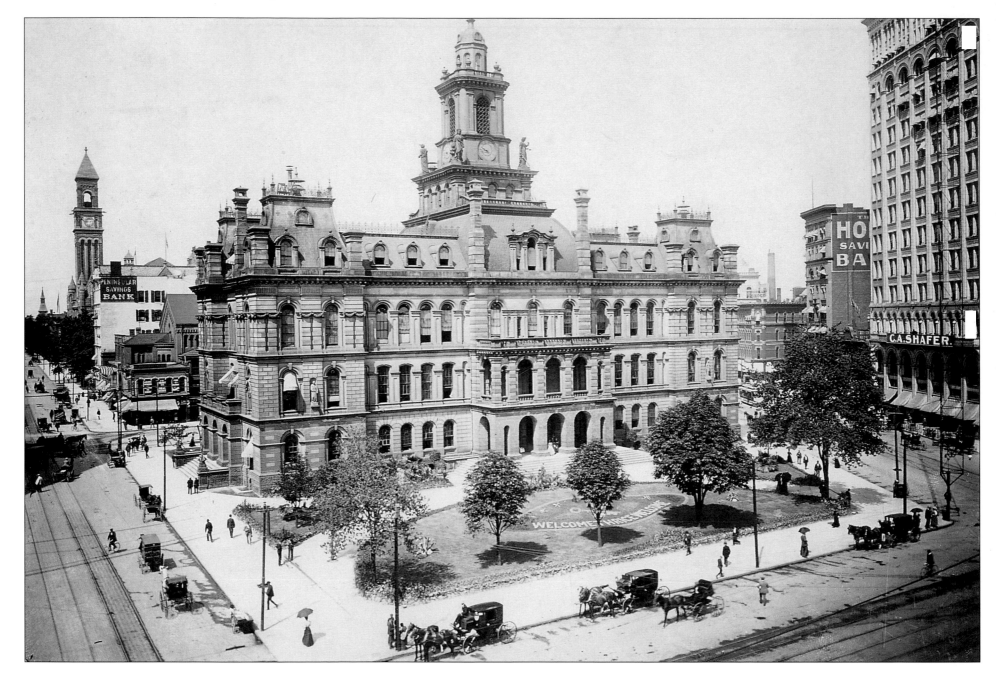

In 1871, this sandstone structure, a combination of Italianate, French, and Georgian architectural styles, replaced an earlier City Hall that was directly across Woodward. Sculptor Julius Melchers created sandstone embodiments of Justice, Art, Industry, and Commerce for the clock tower, and later modeled three of the four figures of Marquette, Cadillac, La Salle, and Father Richard to fill the four niches on the front of the building. In this 1899 photo the clock tower to the left is the Federal Building.

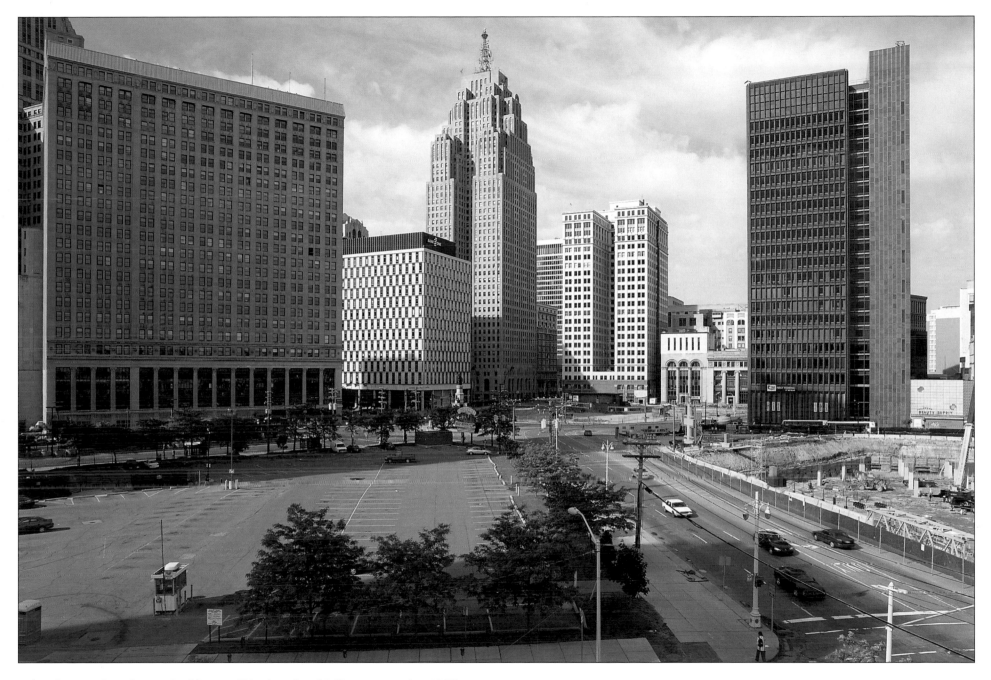

After the new City-County Building on Woodward and Jefferson opened in 1955, City Hall was deemed "inefficient" and razed in 1961. It was replaced in the mid-1960s with Kennedy Square, a civic plaza with underground parking, which today is being incorporated into the public assembly area in construction around Campus Martius. The four statues that adorned City Hall were removed to the campus of Wayne State University. The twin-towered structure in the background is the 1910 Dime Building that stood directly behind old City Hall.

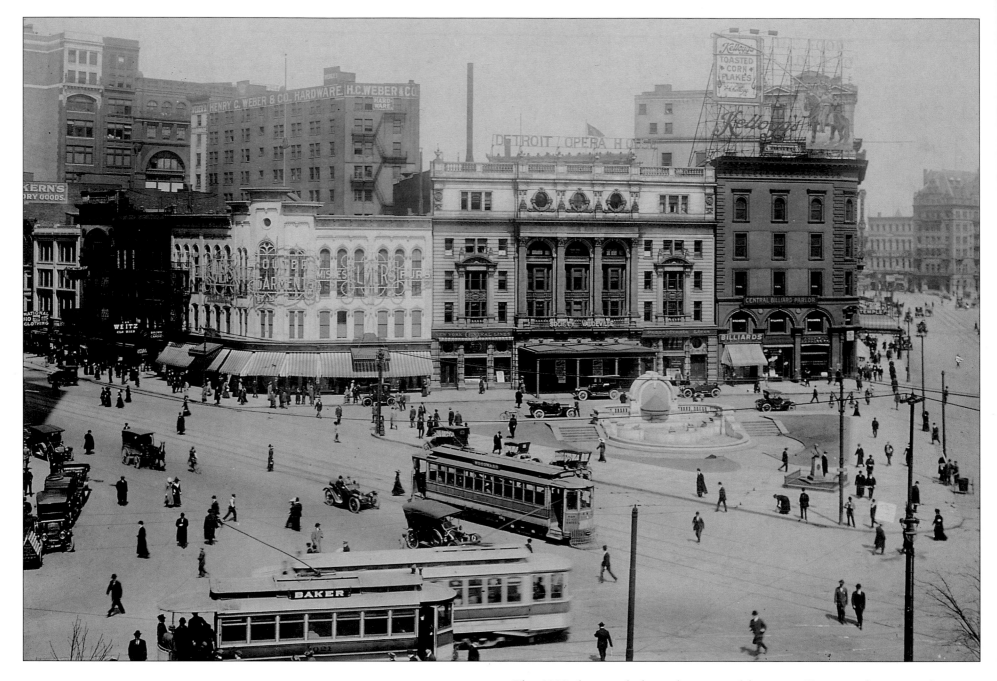

This 1909 photograph shows the center of downtown Detroit at the corner of Woodward Avenue, on the left, and Monroe. Its focal point is the lovely Merrill Fountain, commissioned in 1901 by Lizzie Palmer to commemorate the memory of her father, lumberman Charles Merrill, and designed by New York's Carrere and Hastings. Directly behind it is the Detroit Opera House, opened in 1869 and rebuilt in 1897 after a fire. It later served as a department store, then was torn down in 1966.

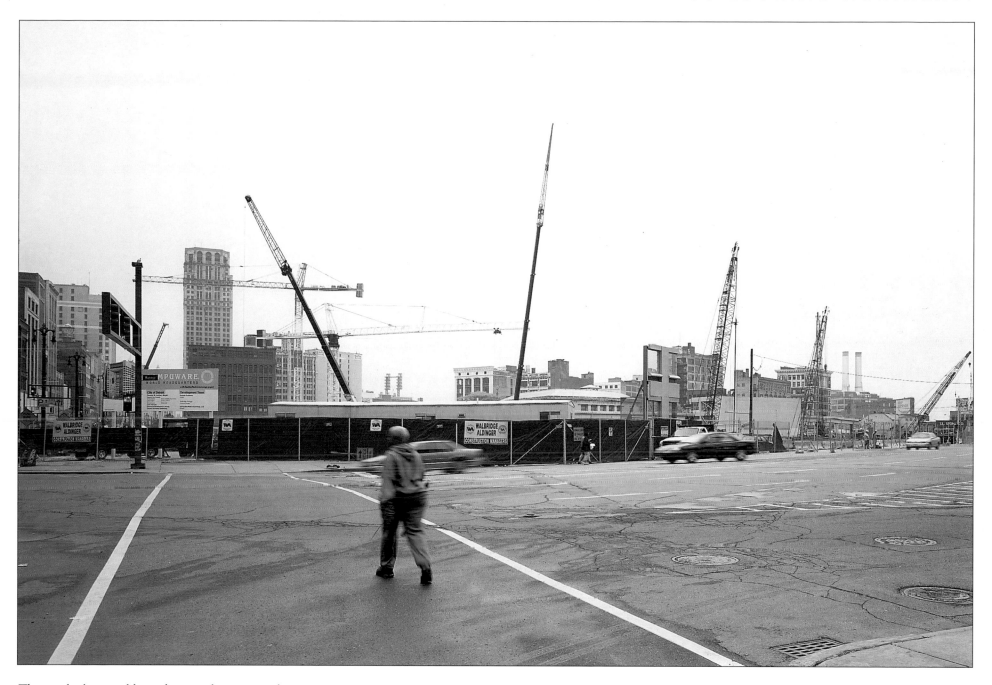

There is little resemblance here to the scene eighty-two years ago. In 1925, the Merrill Fountain was moved to Palmer Park, 120 acres of land north of the city, donated in 1893 by Senator Thomas Palmer, husband of Lizzie. All the buildings to the left of the Opera House were eventually torn down and the space added to the J. L. Hudson store, which itself was torn down in 1998. Campus Martius is the heart of a major development project for the city of Detroit, which includes the construction of a 1.2 million square foot headquarters for Compuware.

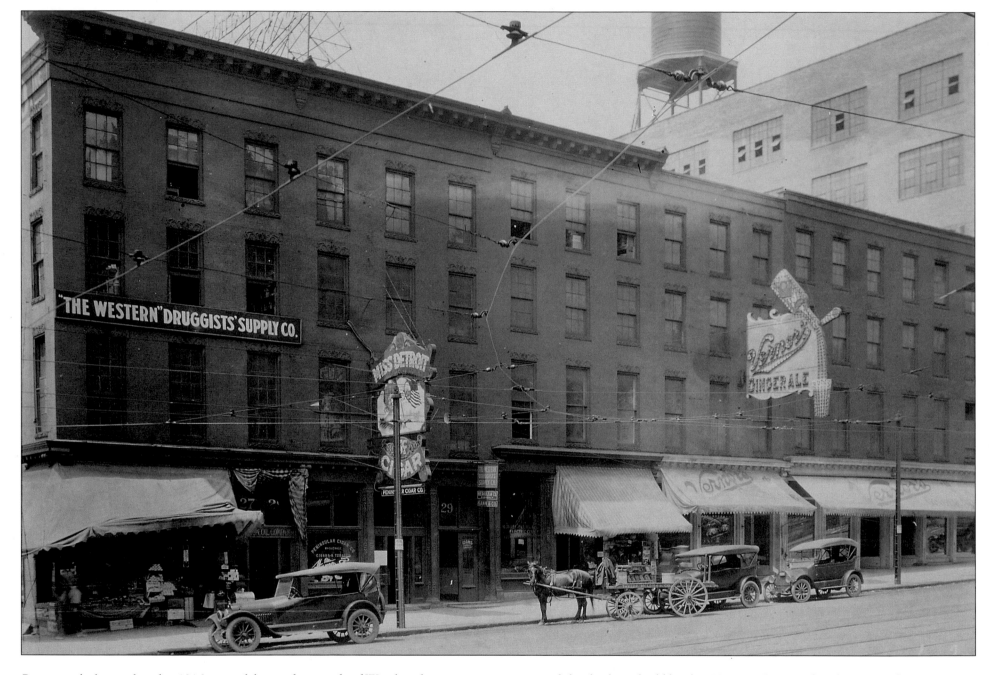

Prominently featured in this 1916 view of the northwest side of Woodward near Atwater is the Vernor's Ginger Ale sign. The beverage came about accidentally when chemist James Vernor went off to the Civil War and left behind a wooden keg of his nineteen-ingredient secret mixture. Returning in 1866, he discovered that aging had improved the drink, and sold his first Vernor's Ginger Ale. The Peninsular Cigar Store on the corner sold cigars named "Charles the Great," "Dime Bank," "Miss Detroit," and "Humo," just a sample from Detroit's large tobacco industry, which had well over one hundred cigar manufacturers at the time.

Although Mayor Hazen Pingree first broached the idea of a civic center at the foot of Woodward in 1890, it wasn't until 1947 that Saarinen, Saarinen & Associates were charged with developing a plan. The Veterans Memorial Hall (now the UAW-Ford National Education, Development, and Training Center), was the first building completed in 1950. The Cobo Conference/Exhibition Center was completed in 1960 and has since been expanded, increasing its total space to 2.5 million square feet. The Horace E. Dodge and Son Memorial Fountain by Isamu Noguchi, is the focal point of Hart Plaza, named for U. S. Senator Philip Hart.

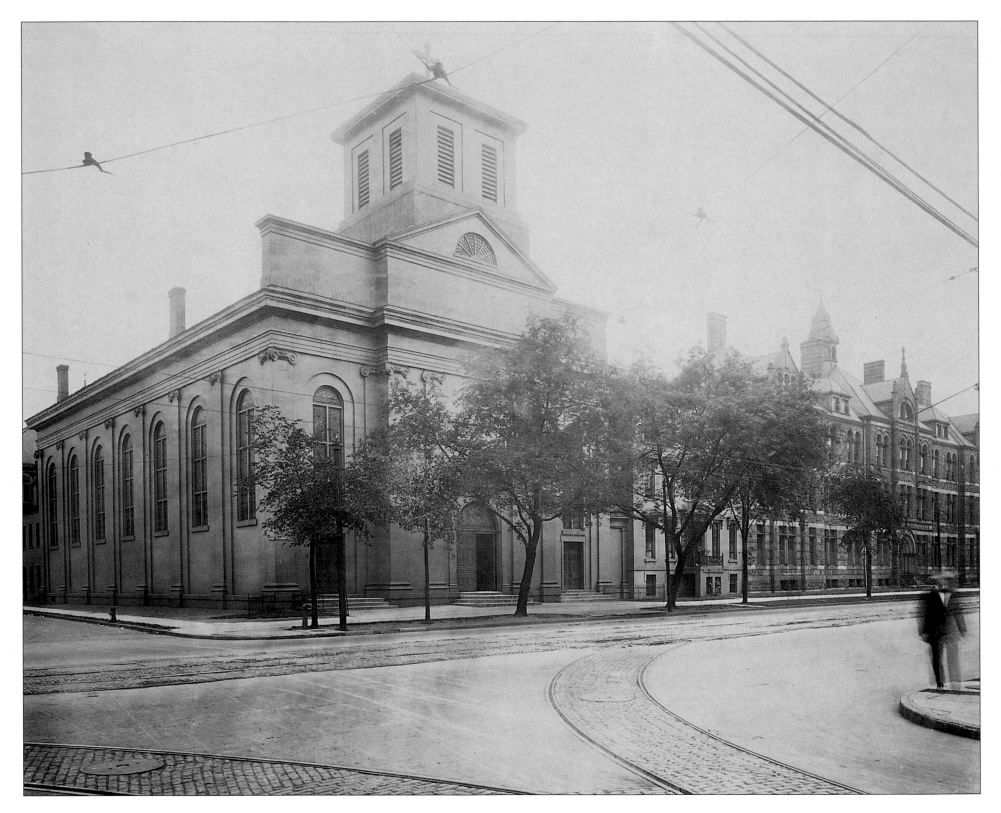

Left: Built by architect Francis Letourno in 1848, the Church of Saints Peter and Paul is the oldest existing church structure in the city. Located on Jefferson Avenue at the corner of St. Antoine, its plainness is reminiscent of a New England–style church. To the right is Dowling Hall, completed in 1890, shortly before this photo was taken. This was the first new building for Detroit College, founded in 1877 by the Jesuits. In 1911 the name was changed to the University of Detroit.

Right: Today the church looks much the same as when it was built. In 1998, for its 150th birthday, it was completely repaired. In 1927, the University of Detroit started a new campus at another location and Dowling Hall along with additional buildings contained just the schools of engineering and law, and, later, dentistry. Today they serve as the University of Detroit Mercy College of Law, part of the university's Renaissance Campus.

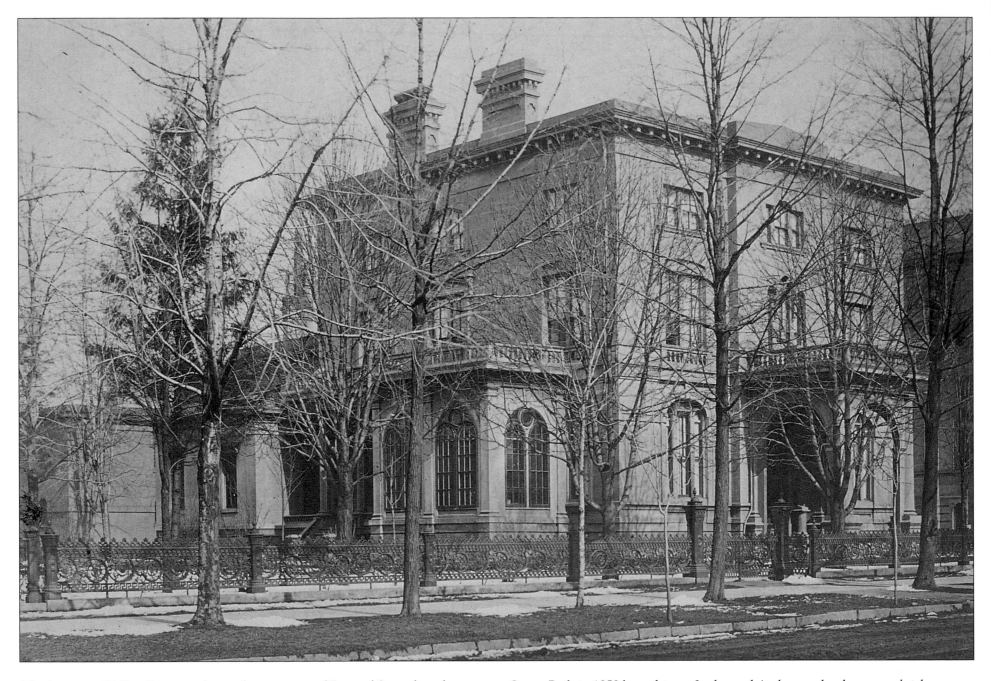

This house at 174 Fort Street on the northwest corner of Fort and Second was home to Senator Zachariah Chandler, an early abolitionist and mayor (1851–52). Chandler was one of the founders of the antislave Republican Party from which he was elected U.S. Senator in 1857. He also served as Secretary of the Interior under President Grant. Built in 1858 by architects Jordan and Anderson, the three-story brick building was covered with stucco and was a combination of New England traditional style with a touch of Italian Renaissance in the sun porch. This 1881 photo shows the residential history of what is now the downtown area.

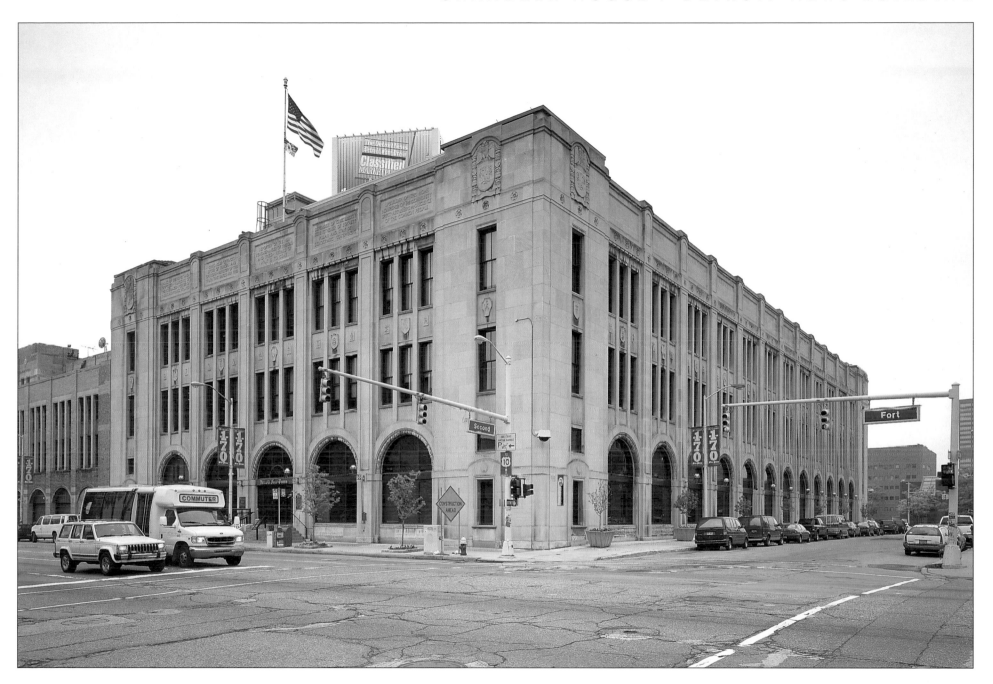

In 1917 the *Detroit News* moved to this building, which occupies the entire block of Second, Lafayette, Third, and Fort streets. Its design by Albert Kahn was closely supervised by newspaper president George S. Booth, an advocate of the Arts and Crafts Movement. The three-story reinforced concrete structure with its heavy stone arches apparently satisfied his taste for both the modern and the medieval. The building now serves as offices for the *Detroit Free Press* and the *Detroit News*; the two formed a joint operating agreement in 1989.

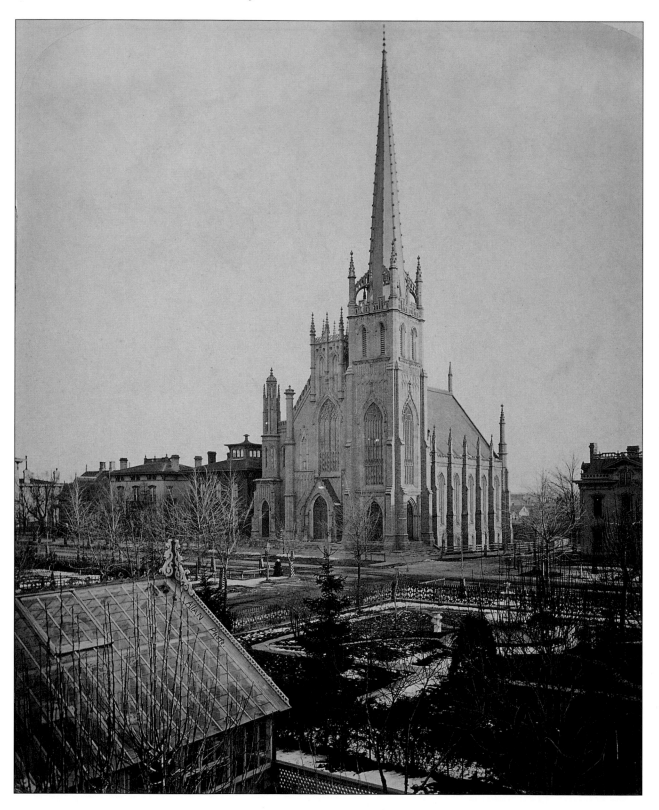

Organized in 1849, the Fort Street Presbyterian Church was the second Presbyterian group in Detroit. The church building was completed in 1855 of limestone from a quarry in Malden, Canada, in a Gothic Revival style patterned after the great cathedrals of Europe. This 1870 image is of the building before its first fire in 1876. The building faced a second fire in 1914 but remained substantially unchanged. The lot at the corner of Third and Fort streets cost $7,000, and the original building designed by Albert Jordan cost ten times that. The spire is 265 feet high from the ground up.

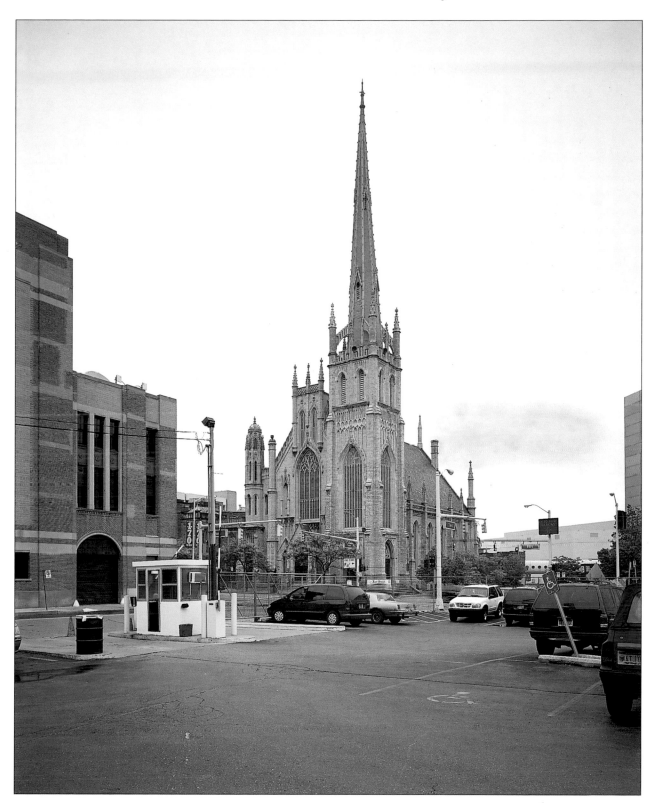

Over the years the church has adapted to meet the needs of the community. In 1907 the smaller building to the left, Church House, was built on land donated by James Joy and enabled the church to assist low-income families moving into the area. The gymnasium, which served as a dormitory for servicemen during World War II, today provides shelter for hundreds of homeless people.

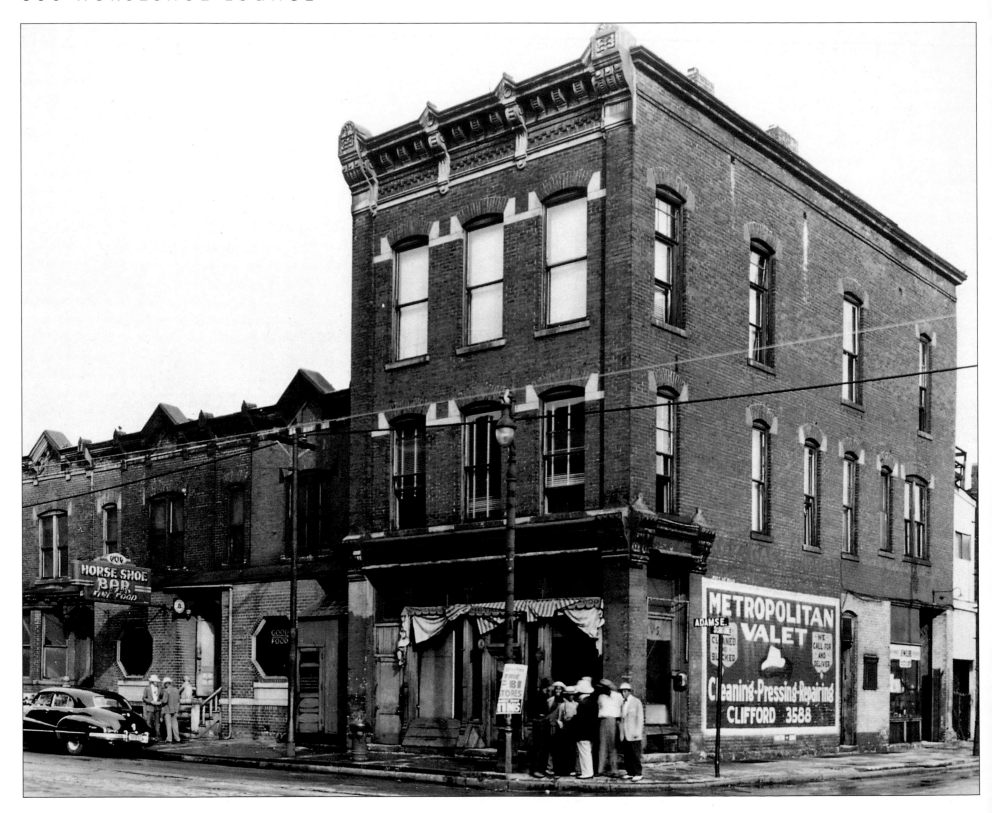

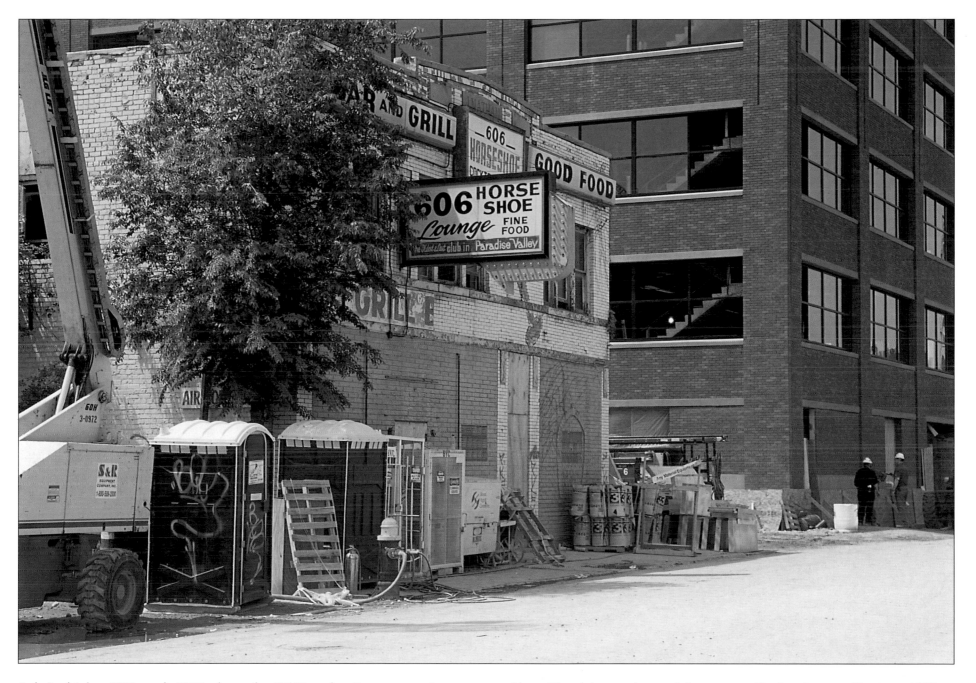

Left: In this late 1930s, early 1940s photo, the 606 Horseshoe Bar was an active part of the neighborhood known as Paradise Valley. Paradise Valley was the African-American entertainment district, adjoining and overlapping the African-American neighborhood called Black Bottom. The district drew such names as Billie Holliday and Duke Ellington during this era. This is the club's second location, here on Adams near the corner of St. Antoine.

Above: The club moved around the corner to St. Antoine near Gratiot in 1968, closed in the mid-1990s, and is now owned by the Detroit Wayne County Stadium Authority. Originally scheduled to come down to make way for the Detroit Lions' new stadium, Ford Field, it still stands thanks to appeals on its behalf and two other structures of "the Valley." Ford Field, a 65,000-seat stadium, has incorporated the old Hudson's warehouse, the red brick building next to the bar, into its design, and is scheduled to open in 2002.

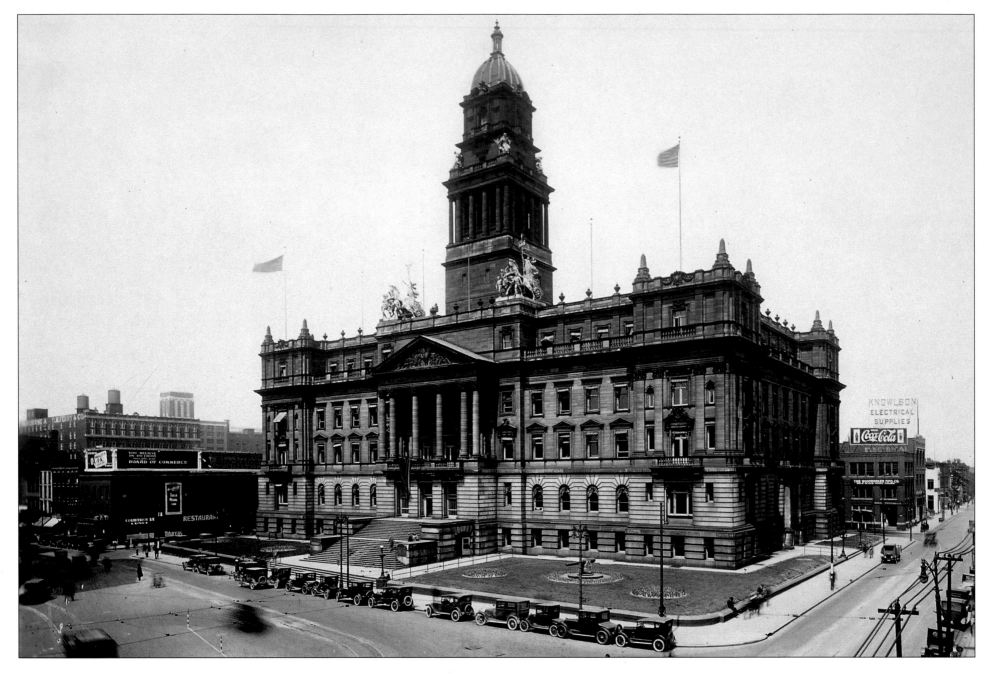

Above: It's difficult to imagine a more stately municipal building than this ode to the baroque. Six years of construction, terminating in 1902, resulted in this courthouse that functioned as the center for Wayne County government into the twentieth century. The granite and sandstone building at Randolph, between Fort and Congress, has an elaborate interior of marble, mahogany, and mosaics. Bronze sculptures representing Law, Commerce, Agriculture, and Mechanics, as well as a carved stone relief of "Mad" Anthony Wayne decorate the facade and tower. This photo is circa 1921–22.

Right: In the 1950s many of the county offices moved to the new City-County Building and the courthouse began to be neglected. At one time there was thought of demolishing it, but a private partnership in conjunction with historic preservationists restored the building, erasing decades of grime from the facade, and removing dropped ceilings to reveal original cornicework. Today the Wayne County Commissioners have offices here, along with other county departments.

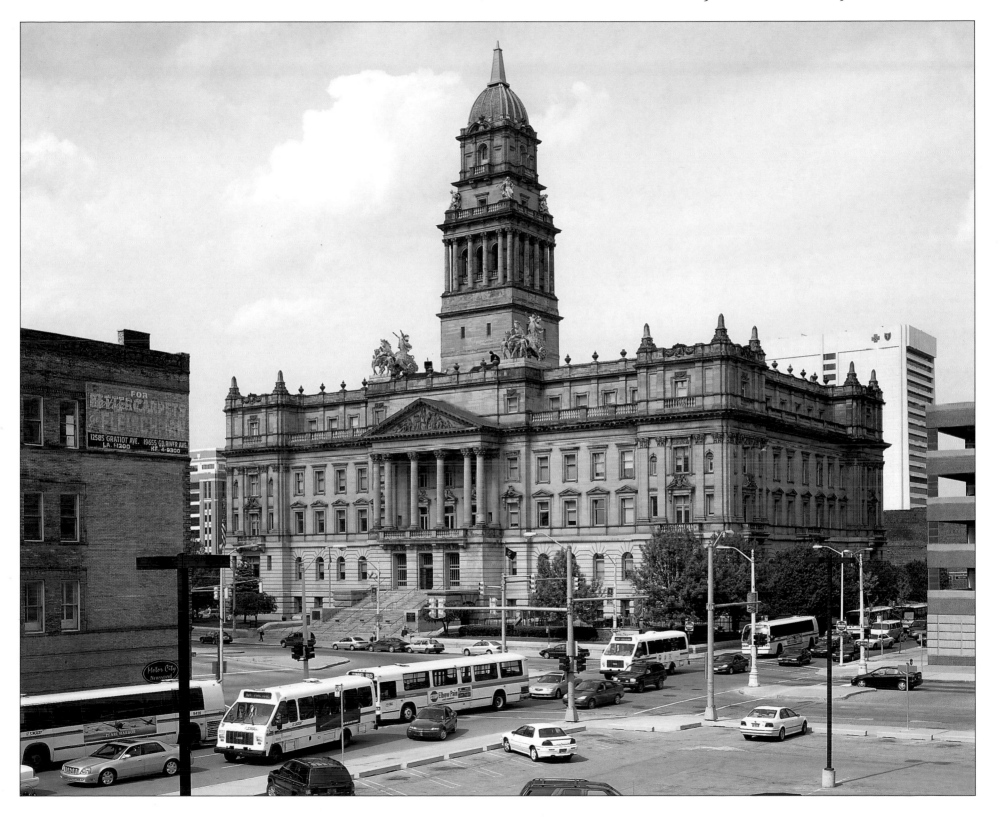

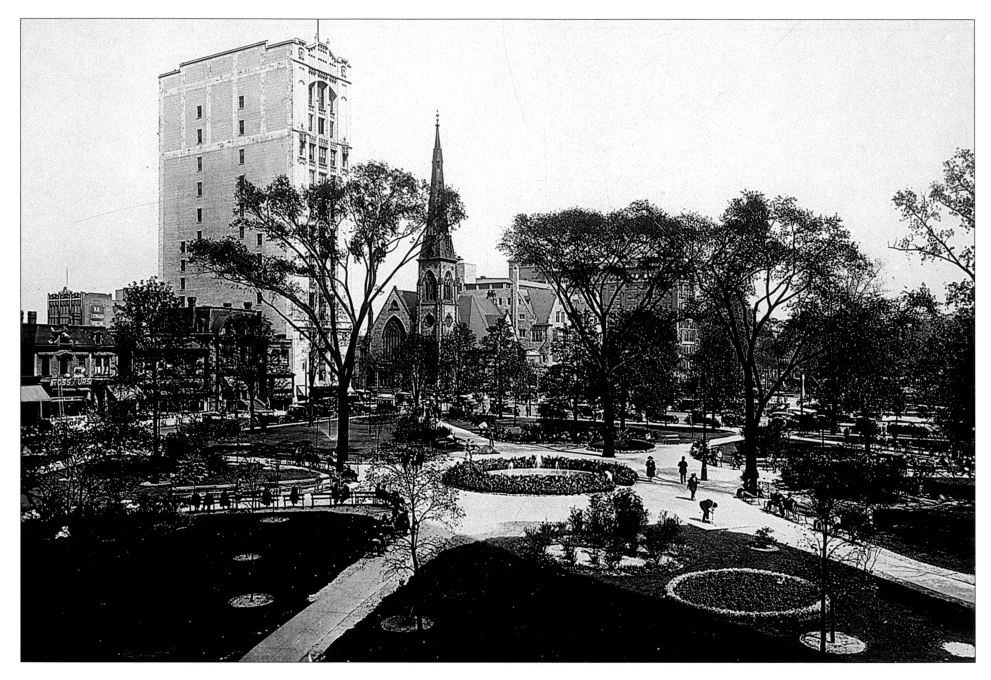

Grand Circus Park is the apex of the 1807 street design of Detroit by Augustus Woodward. The park originated when the land was drained, filled, and raised in 1844. Landscaping began in 1853. This 1920s view, probably taken from the Hotel Statler on the park's west side, shows the park as an oasis of greenery within the city. The Fyfe Building to the left stands at the northern end of the park on the west side of Woodward. Across the street on Woodward and Adams, the northern boundary to the park, is the Central Methodist Episcopal Church. Covered by the trees at the end of the block is the Women's Exchange. The last visible building is the YMCA.

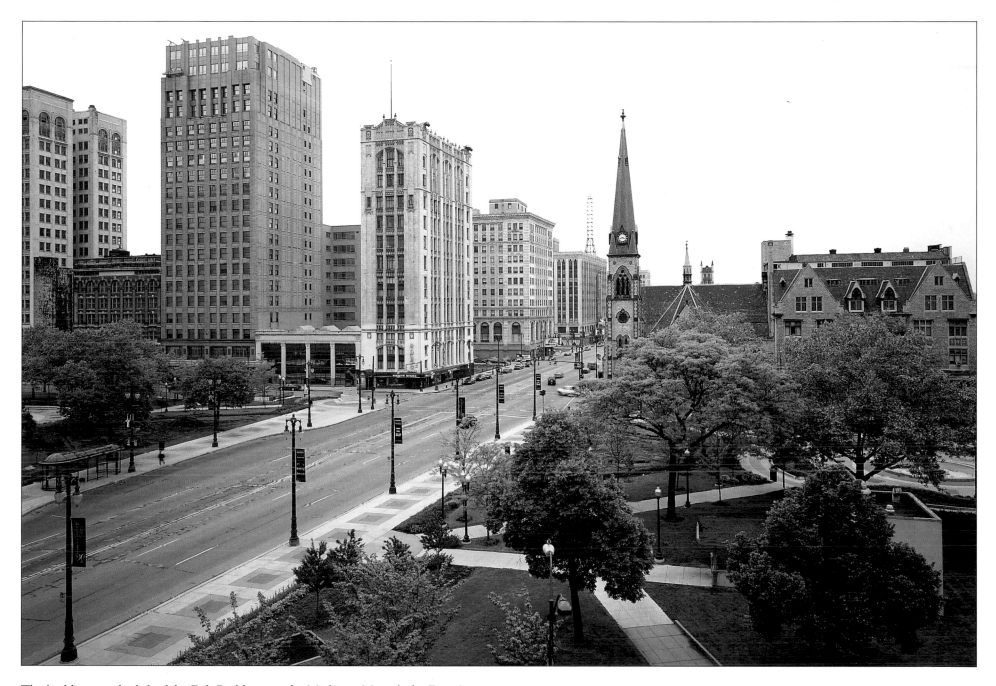

The buildings to the left of the Fyfe Building are the Michigan Mutual, the Fine Arts, and the Kales buildings. The three were slated to be razed for Comerica Stadium parking, but were rescued and are to be developed as loft condominiums. The YMCA was demolished to make way for Comerica Park. Two doors down from Central Methodist, the Women's Exchange is being developed with a first-floor restaurant and loft offices.

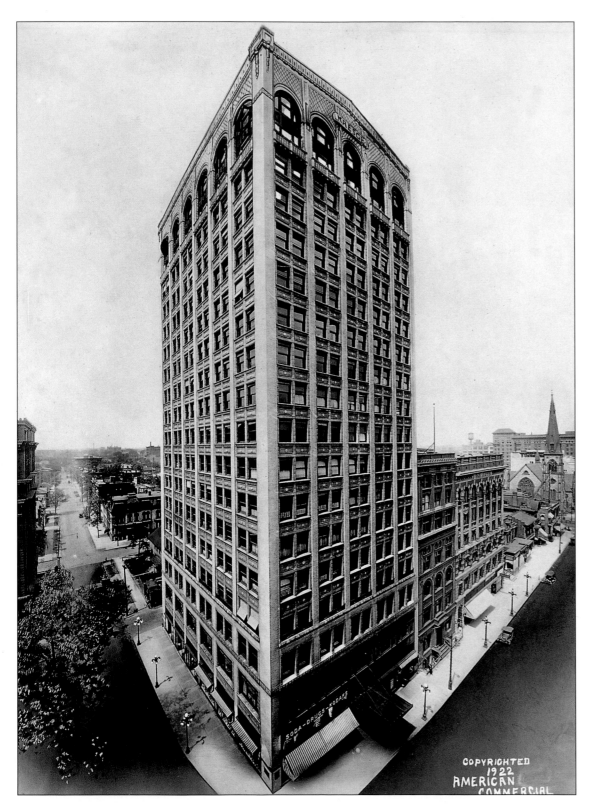

In this 1922 photo, the Kresge Building, at the corner of Adams and Park avenues, is a striking edifice across from Grand Circus Park. Designed by Albert Kahn in 1914, the eighteen-story building is of simple design, faced with white brick. It served as world headquarters to the Kresge Company until 1930, then housed mainly medical offices. In the distance to the right is the steeple of the Central Methodist Church and behind it, the YMCA.

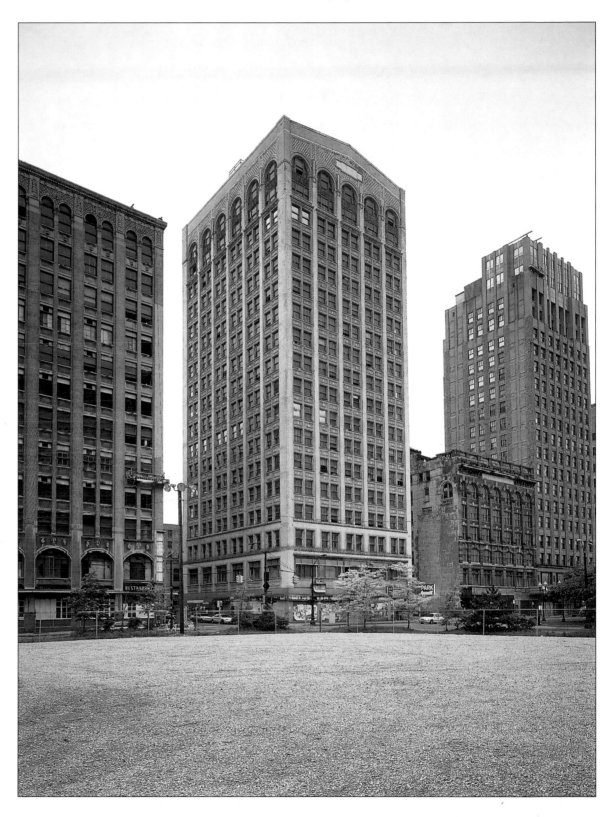

The Kresge Company became the Kmart Corporation and moved its offices from Detroit to the northern suburb of Troy in the late 1970s. Now called the Kales Building and unoccupied since 1986, the elegant structure is due to be turned into eighty-five residential lofts, with retail stores on the first floor.

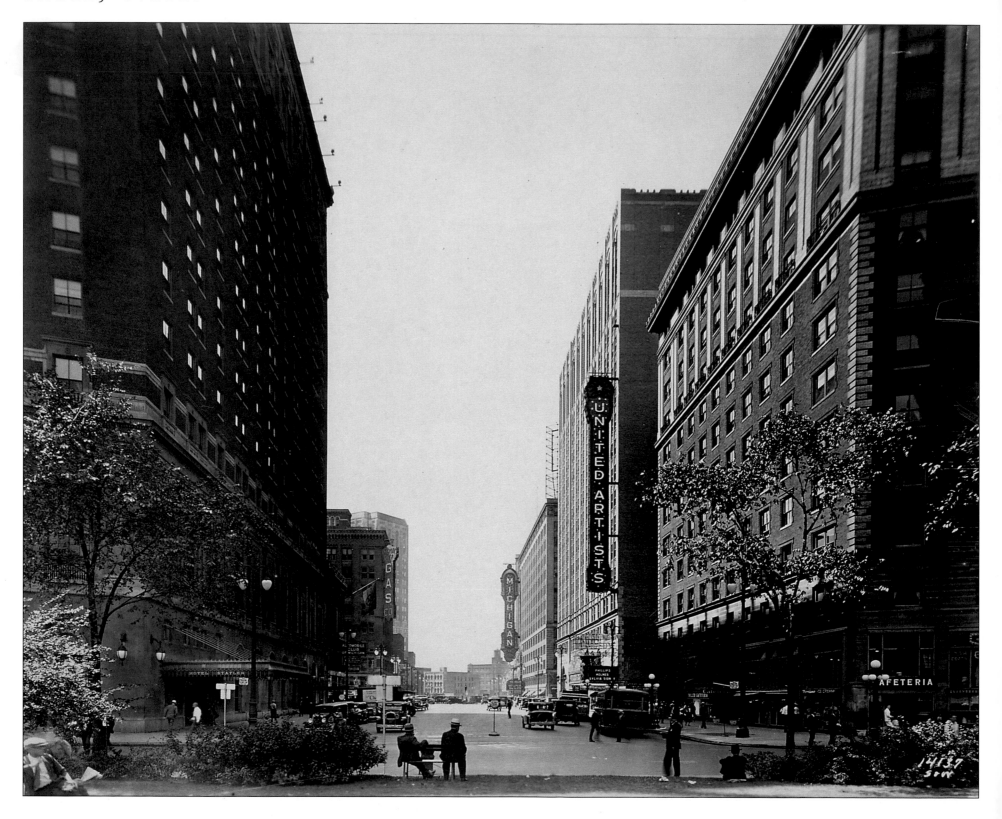

Left: Radiating from the west side of Grand Circus Park, Bagley Street was home to two of Detroit's 120 theaters. This view from the 1930s looks west to Grand River, with the Hotel Statler on the left, a luxury hotel when it opened in 1914 and the first in the country to have central air conditioning. Each of the eight hundred rooms had a bath, unlike the Pontchartrain Hotel on Campus Martius. On the right, next to United Artists, is the Hotel Tuller, opened in 1902.

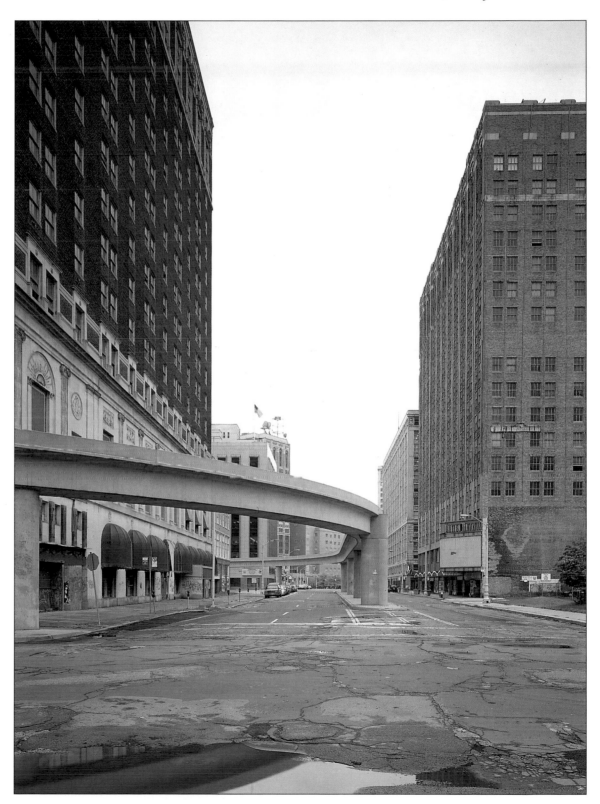

Right: Built in the 1920s, the Michigan Theater closed its doors in 1972 and the Spanish Gothic style United Artists in 1973. Now the People Mover curves in front of the Statler Hotel, which closed in 1975. The Tuller Hotel, which closed in 1976, came down in 1991.

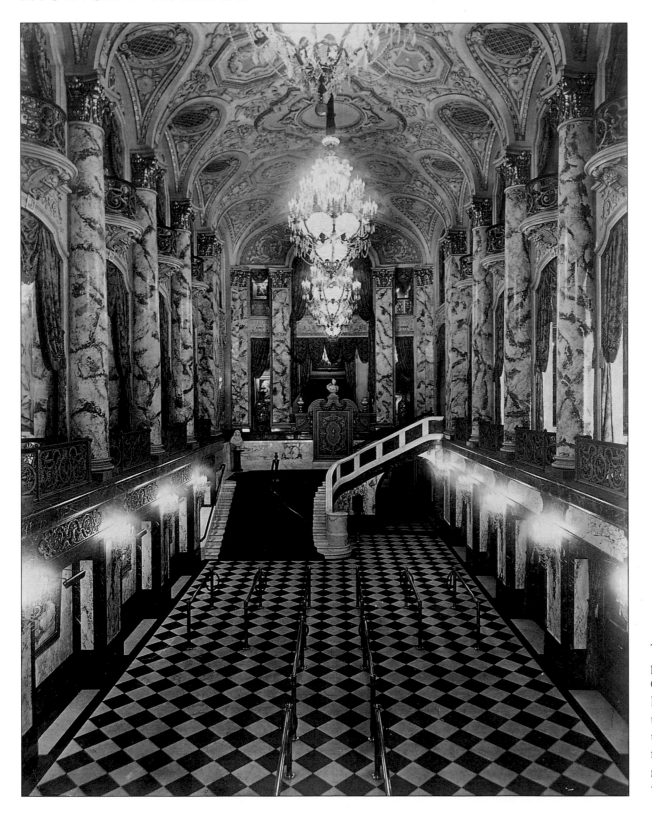

This opulent, 5,000-seat theater opened in 1925 and was part of the Michigan Building. It was designed by C. W. and George L. Rapp of Chicago, and featured a four-story high lobby with marble staircases and oil paintings hung between the columns. It was here, a few years before this 1943 photo, that Sammy Davis, Jr., in a warm-up act for Tommy Dorsey, first met Frank Sinatra, the band's vocalist. It is ironic, given the use of the theater today, that Henry Ford's shop where his first car was made stood on this site.

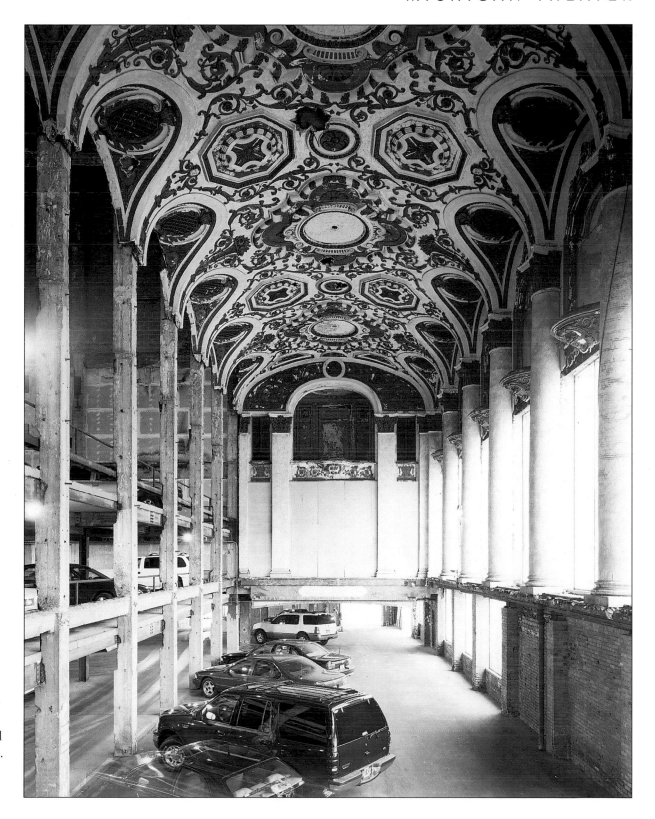

Fate has not been kind to the Michigan Theater.
Converting from a first-run movie house to a nightclub to a
rock concert stage, the theater finally closed in 1972.
Purchased with plans for a parking lot, the theater would be
gone today except its demolition would have weakened the
adjoining office building. Instead the theater was gutted and
turned into a three-floor parking garage for building tenants.
Today the ornate and fanciful theater lobby and auditorium
have only parked cars for an audience.

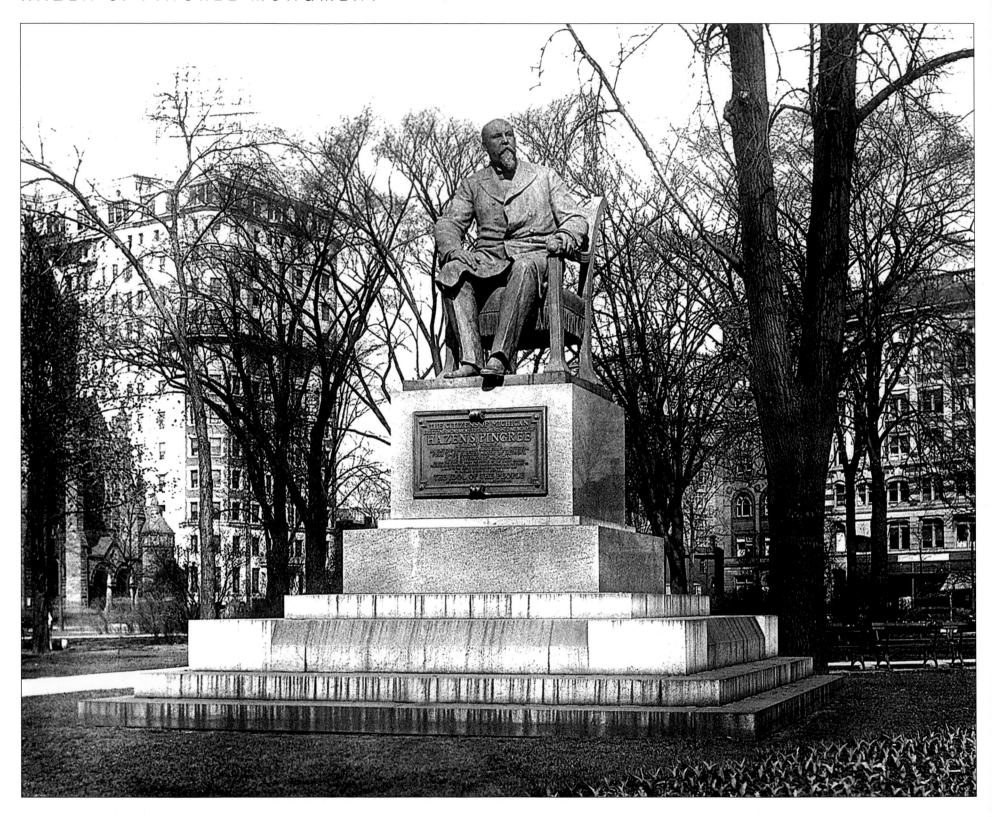

Left: The Hazen Pingree monument pays homage to a man elected four times mayor of Detroit (1890–97) and twice governor of Michigan. The statue, designed by Rudolph Schwarz, was built in Grand Circus Park in 1903 with nickels and pennies contributed by his admirers. Seated on a plain parlor chair, this "idol of the people" presents the comfortable demeanor that endeared him to Detroiters at the turn of the century. The Church of Our Father is to the far left with the Hotel Tuller next to it. To the right is the Fine Arts building.

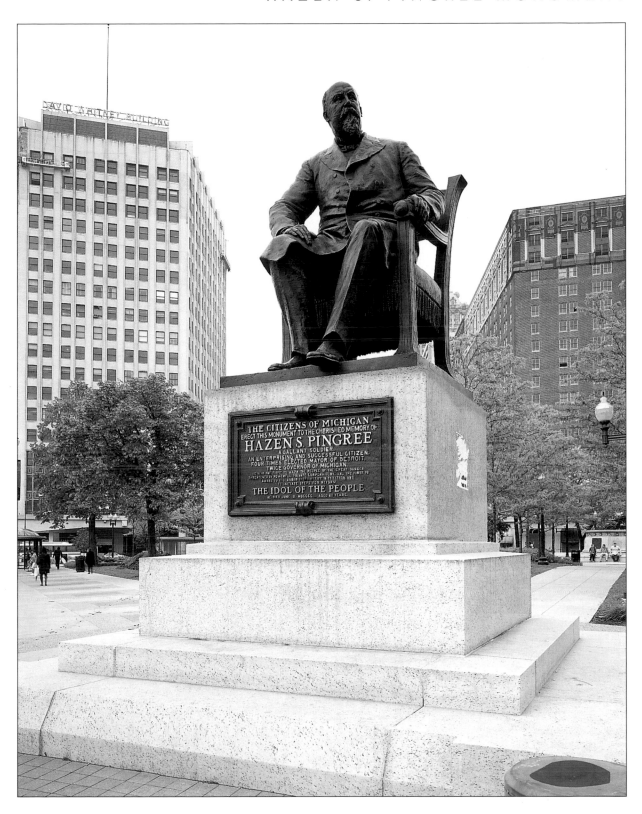

Right: The statue was restored in 1985 and in 1997 moved to a new location in the Park. A different backdrop is behind the mayor today, including the David Whitney Building on the left and the Statler Hotel on the right. The tall building peeking up behind the Statler is the Book Tower. Built as an addition to the Book Building in 1926, it was designed by Louis Kamper.

Below: The Capitol Theater, built in 1922, was one of 250 theaters in the United States designed by Howard C. Crane. Italian Renaissance in style, this simple, elegant 4,250-seat theater, shown here around 1927, was one of the largest playhouses in America. Part of a six-story store and office building, its auditorium embraced "the newest ideas in theater construction, done by special artists brought in from the east." Over the years, it opened and closed under various names, undergoing changes along the way, until finally closing in 1985.

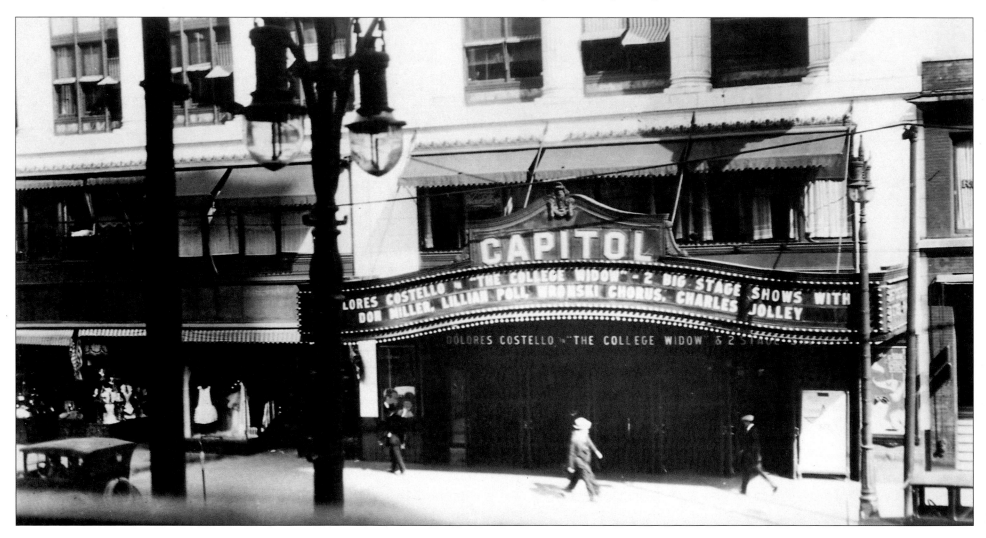

Right: In 1996, the acoustically magnificent theater made a highly successful comeback as the Detroit Opera House. Using additional parcels of land, and restoring or recreating many of the theater's original features such as frescoes and marble staircases, the theater was incorporated into a 75,000 square foot complex, home to the Michigan Opera Theater. The building, located at the corners of Madison and Broadway in Grand Circus Park, is undergoing renovation on the Broadway side to restore the terra-cotta facade to its original condition

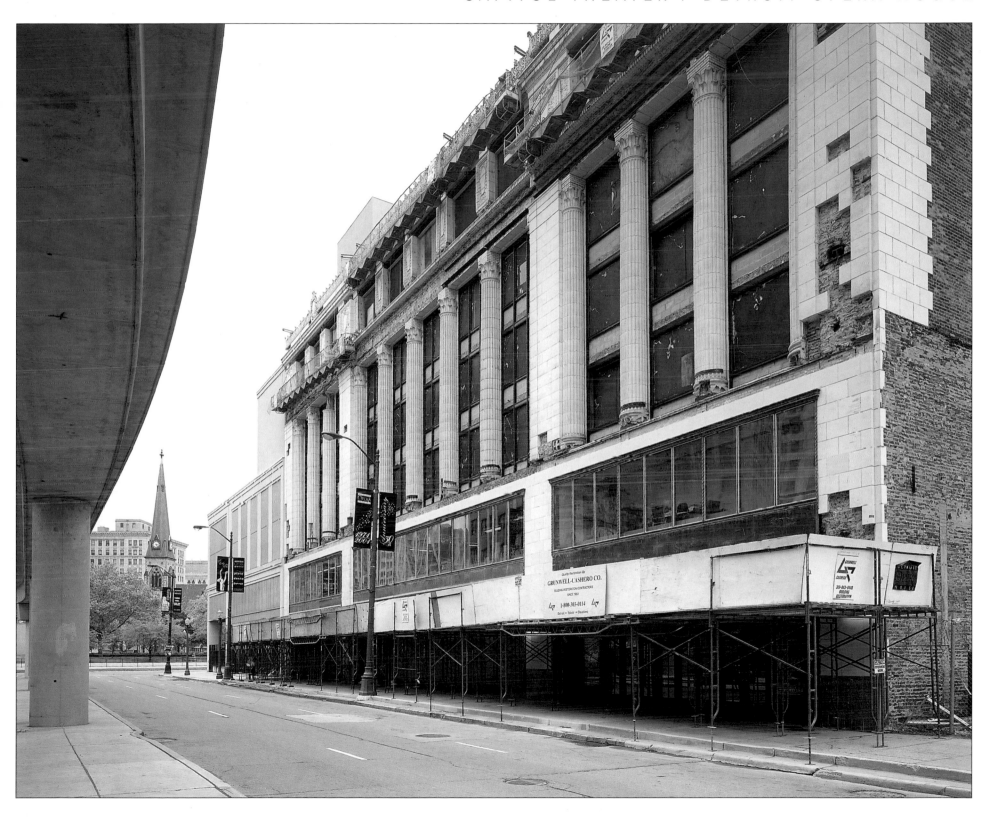

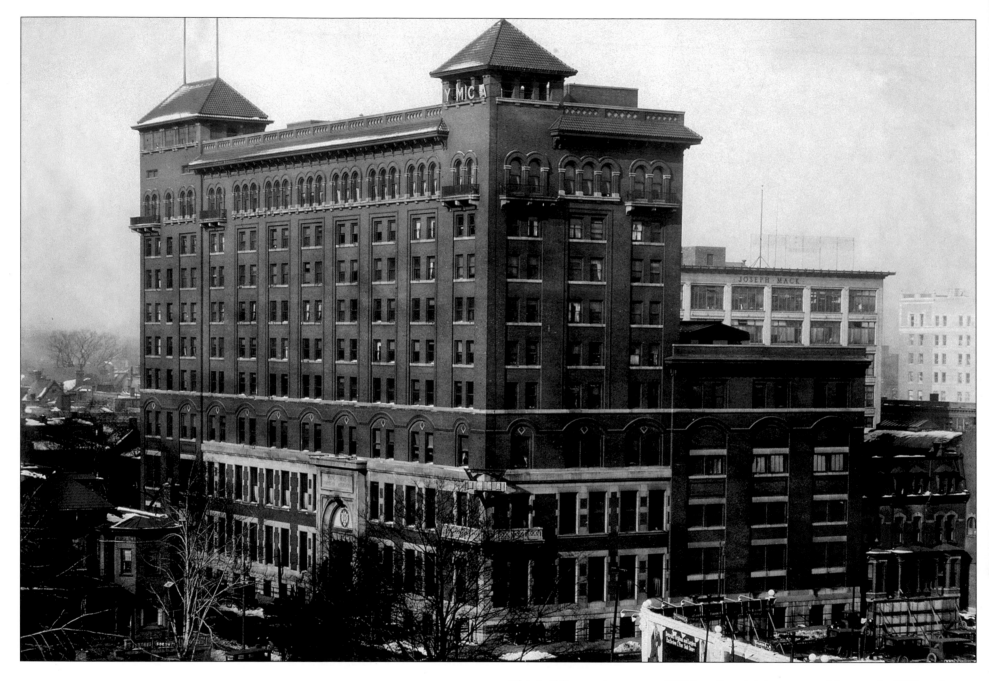

This building at the corner of Witherell and Adams opened January 1, 1909 and was the second owned by the Young Men's Christian Association. By the time this mid-1920s photo was taken, the downtown YMCA had a daily attendance of close to 3,000, with well over 100,000 individuals using the gymnasium annually. The facilities included seven handball courts, thirty-one showers in a "Palace of Baths," six electric cabinet baths with two masseurs, and a six-chair barbershop.

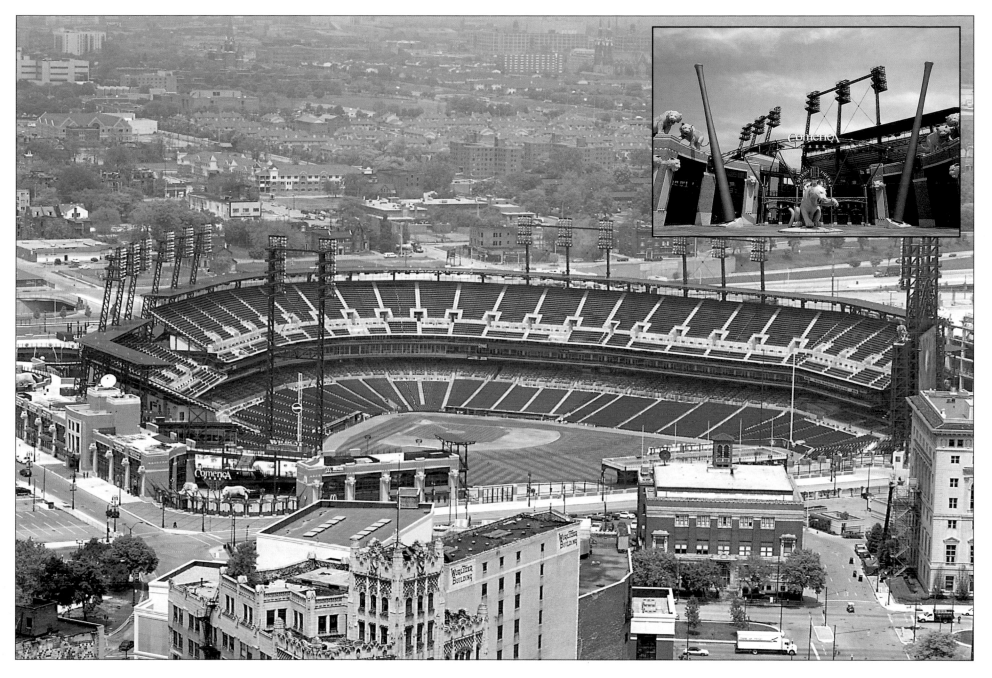

Purchased by the Stadium Authority in 1996, the building came down in 1998 to make way for the new baseball stadium, Comerica Park. The $361 million stadium has the biggest scoreboard in the world and is adorned with statues of Tiger greats.

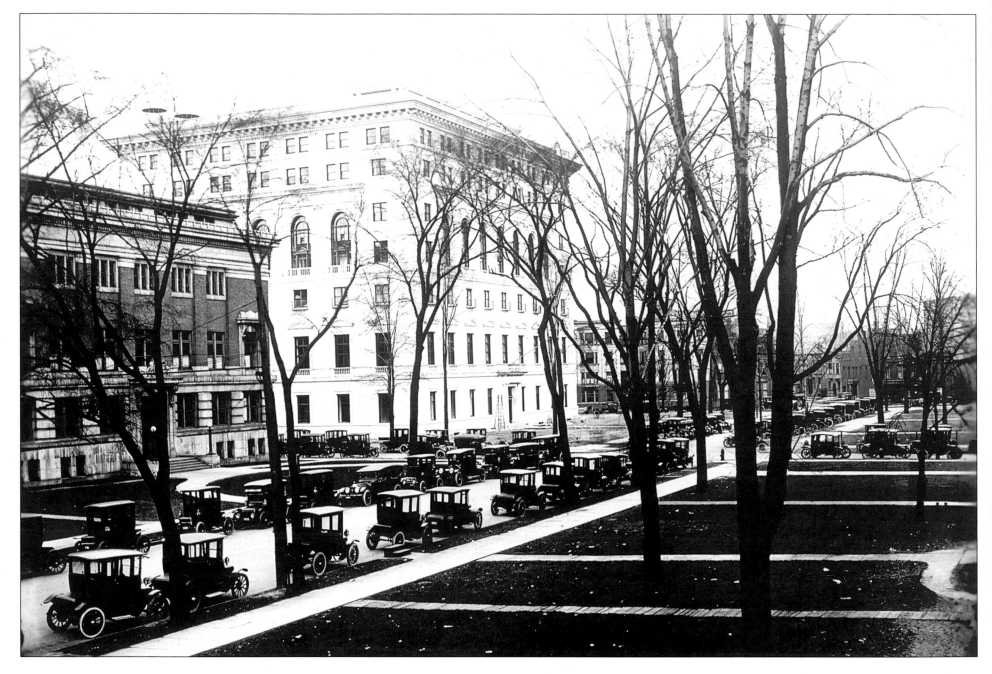

Described as the "meeting place of the automobile industry elite" when it opened in 1915, the Detroit Athletic Club, or D.A.C., as it is more popularly called, is an elegant, solid testimony to the movers and shakers who have met here over the years. An Albert Kahn design, the building reflects his interest in Italian Renaissance architecture. The arched windows on the fourth floor encompassed the dining room. This photo was taken shortly after the club opened.

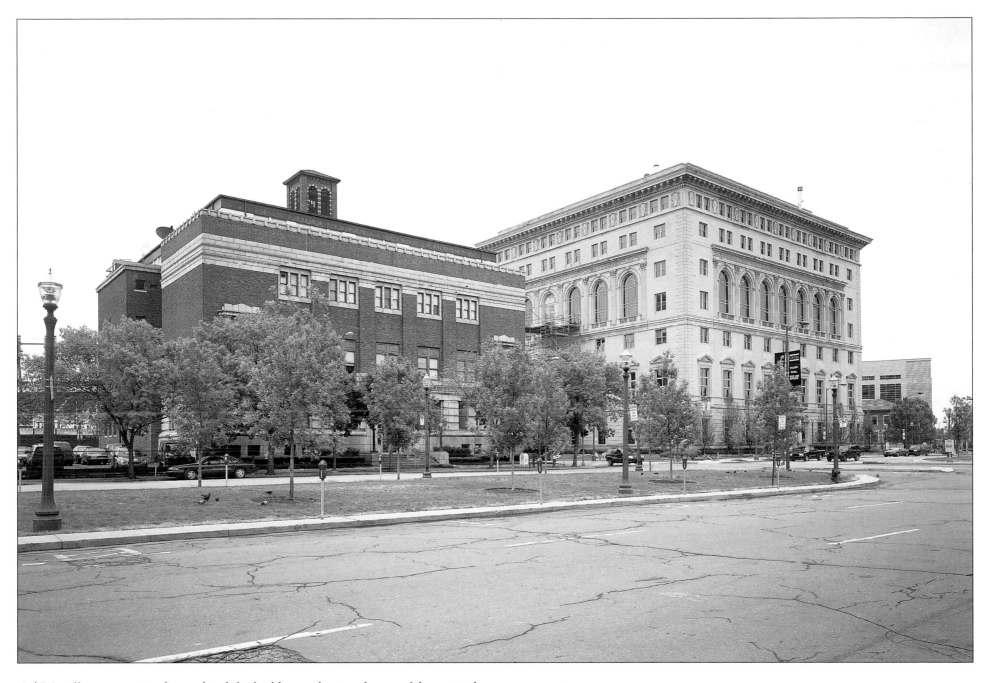

A $7.2 million renovation has updated the building and restored some of the original design. Ceiling tile in the Grill Room and dining room was removed and original frescoes recreated. As membership is up, two and a half floors were added to its parking deck. On the right there is a new neighbor, the Gem Theater, built in 1928 as the Little Theater and moved here, in 1997, from its former location on Columbia Street to allow parking for the new baseball stadium.

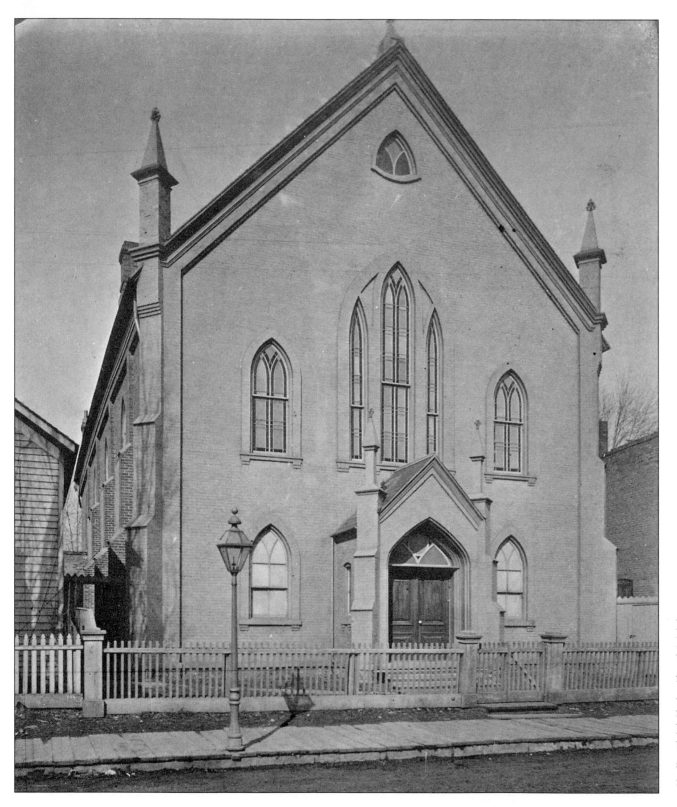

Established in 1836 by former slaves, the Second Baptist Church was an important station on the Underground Railroad. Before that, the church founded the first school in Detroit for black children. After the Civil War it was instrumental in helping freed slaves who migrated to Detroit to find jobs and housing. Located on Monroe and Beaubien, this building burned in 1914. When this photo was taken, around 1870, Monroe Street was named Croghan; the name changed in 1891.

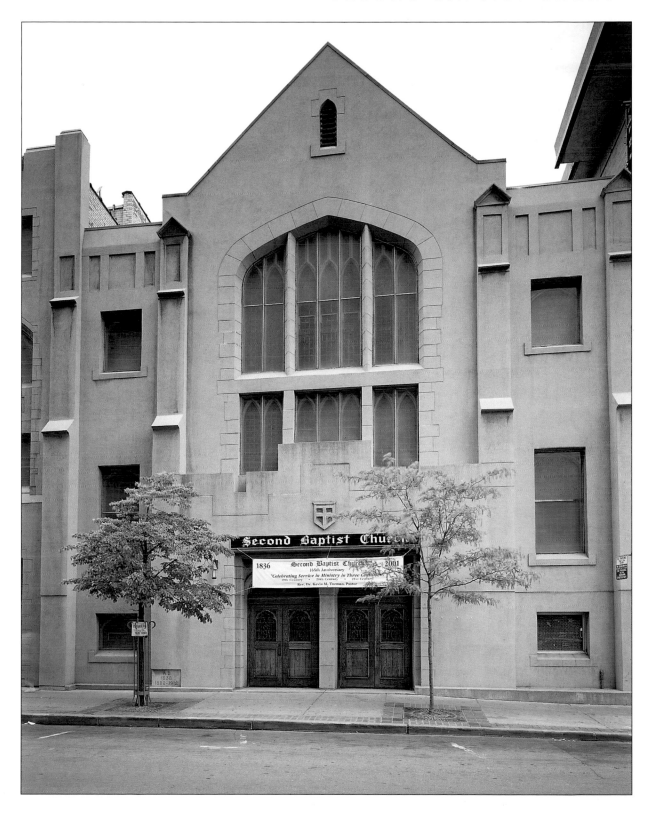

The church was reconstructed in 1914 at its original site on Monroe Street, a block from a bustling Greektown. Its growing congregation required two additions, in 1926 and 1968, on either side of the church. In 1987, the church restored the twelve-by-thirteen-foot basement room that sheltered fugitive slaves and opened it to the public. The church helped as many as 5,000 people on their way to freedom.

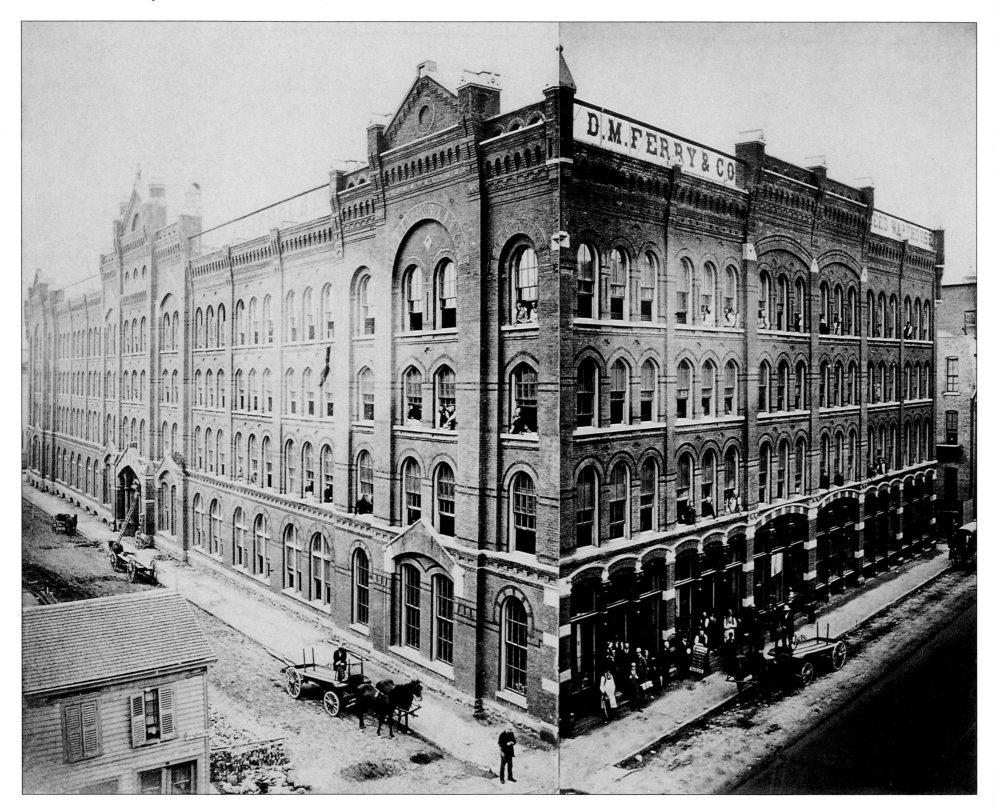

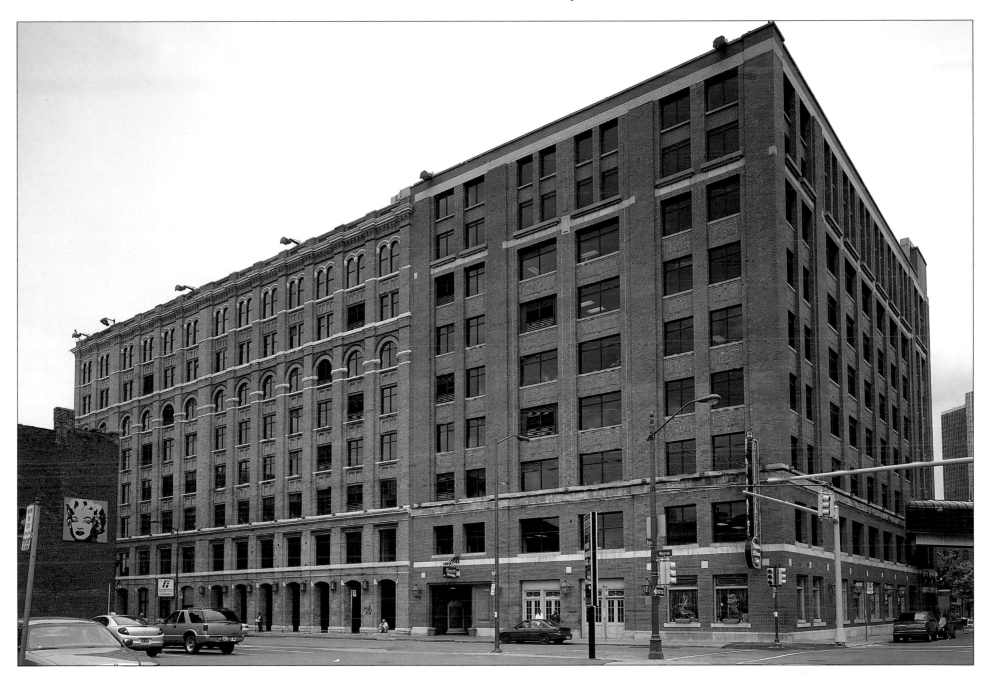

Left: D. M. Ferry and Company was established in 1867, though Dexter Ferry had been selling seeds in packets since 1856. This 1883 photo shows workers ready to fill delivery wagons at the block long building on Brush Street, between Lafayette and Monroe. The seed warehouse, built in 1881, was equipped with an early automatic sprinkler system, but nevertheless fell victim to a fire in 1886. A new warehouse replaced it the following year.

Above: After standing vacant for twenty years, the building was purchased in 1984 by two investors and is now the International Center. Part of a vibrant Greektown, the building hosts a restaurant and offices. The entrance was shifted from Monroe to Beaubien and a part of each floor was removed to create an eight-story atrium with a 114-foot waterfall sculpture, the world's highest indoors.

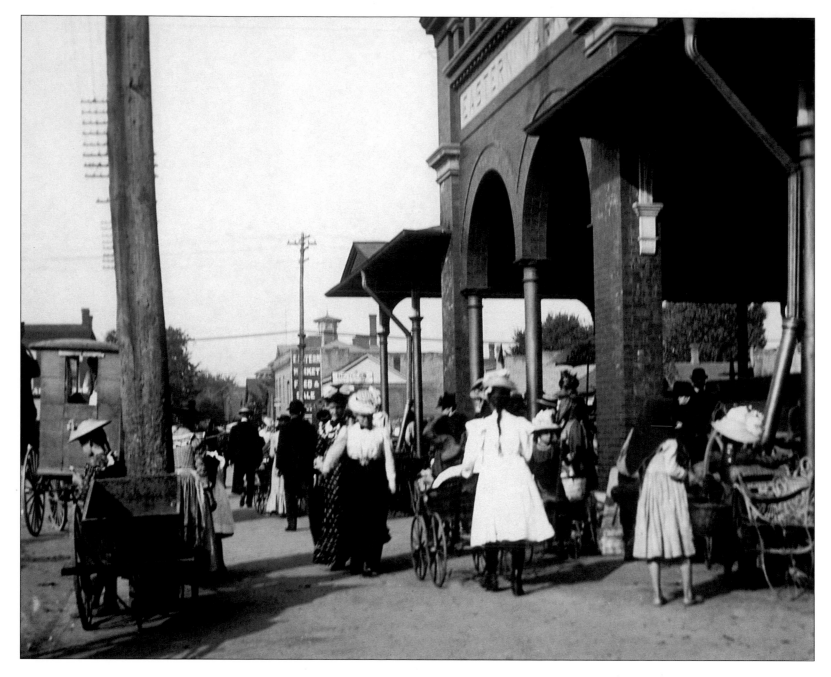

Built upon the Russell Street Cemetery, the Eastern Market is the last survivor of three open markets in the city. The first buildings were erected along Gratiot Avenue, a main thoroughfare radiating east from downtown, and in 1891 the open-air market moved here from Cadillac Square. In this 1900s photo, shoppers browse along the open stalls that face Winder Street. Not visible here are some of the nineteenth-century structures such as the Ciaramitaro Brothers Wholesale Produce Commission House and the 1893 Rudolph Hirt Jr. Building.

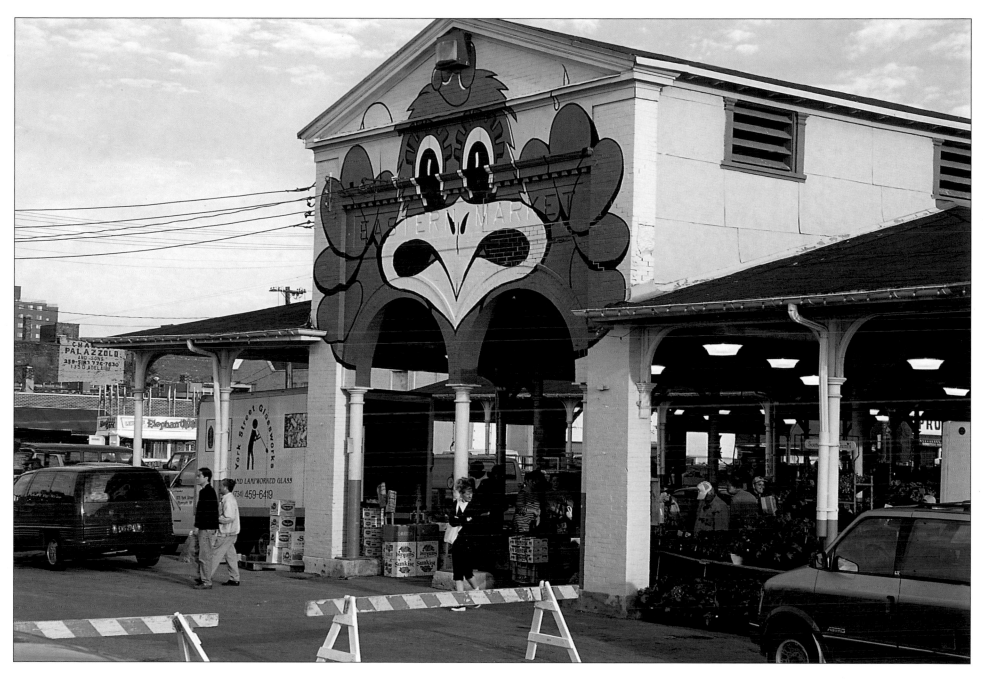

The brightly colored murals that decorate the stalls are the main change undergone by the market, one of the few remaining in a metropolitan area and described as the largest open-air market of its kind in the U.S. The murals were the brainchild of city planner Alex Pollock, charged with the task of renovating the area in 1972. Visit the Eastern Market on any Saturday and you will witness throngs of shoppers from miles around strolling among over 150 food stalls and businesses that occupy the forty-three-acre market area.

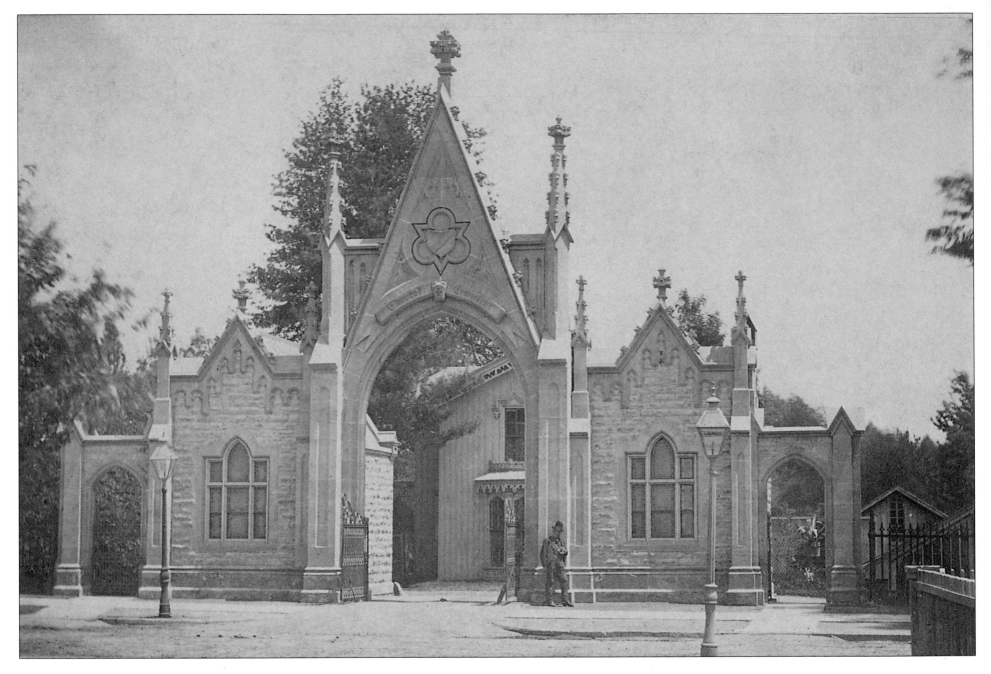

Opened in 1846 with land purchased by subscription, the original grounds were forty-one acres. Planners incorporated the ideas of Frederick Law Olmsted in this informally landscaped cemetery. The stone gateway at Croghan cost $6,000 when it was built in 1870. By the time this picture was taken in 1880, there were 21,000 bodies interred.

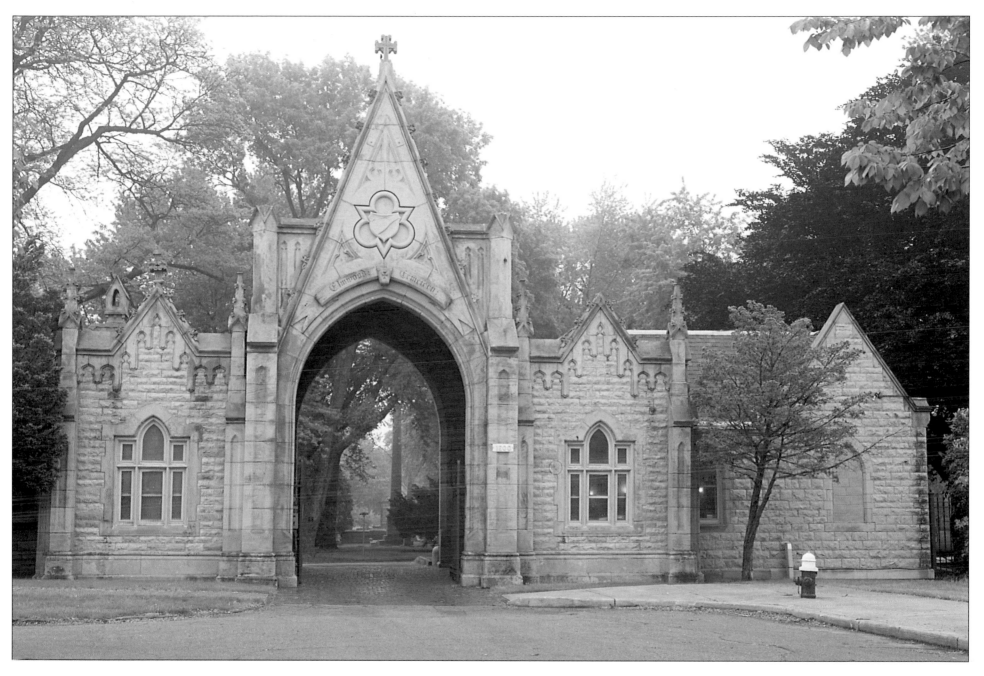

Parent's Creek, renamed Bloody Run in 1763 when an ambush by Chief Pontiac left 160 British dead as they crossed the creek, still winds through the garden-like setting. Many famous Detroiters are buried here including General Russell Alger, Governor Lewis Cass, and George DeBaptiste, organizer of the U.S. 102nd Colored Infantry.

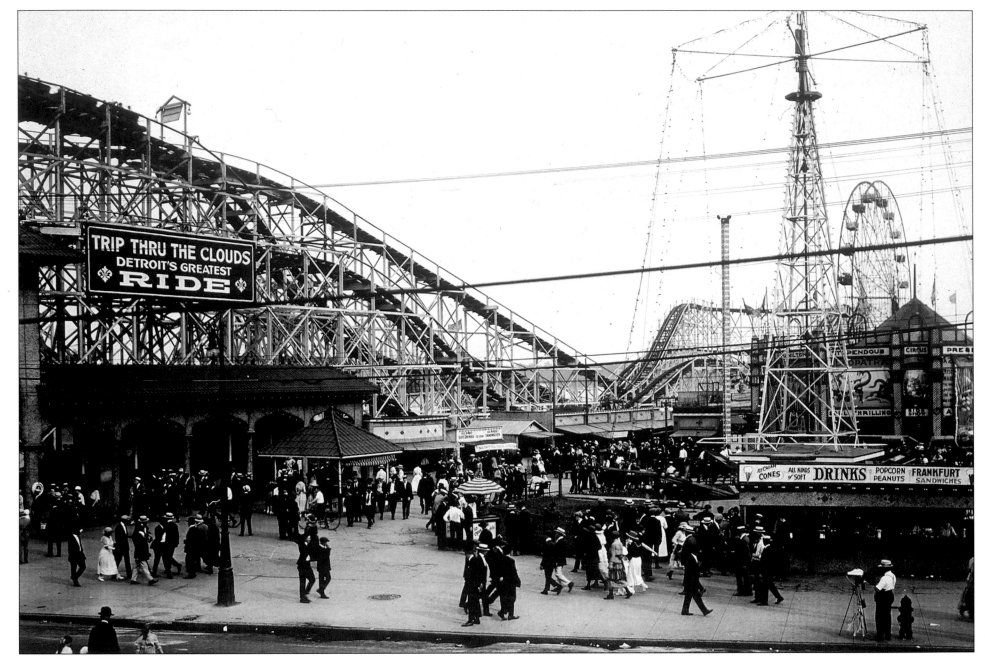

This photograph was most likely taken in the early days of Electric Park, which opened in 1906. Located near the Belle Isle Bridge, between Jefferson Avenue and the Detroit River, Electric Park was known by many names, including Riverview or Riverside Park, and Jefferson Park, before it closed in 1928. Here a roller coaster called "Trip through the Clouds," a Ferris wheel, and an aerial swing provide the thrills. Circus acts and ballrooms were other components of the park. Of the Pier Gardens Ballroom it was said to be "Famous for beauty, music, and conduct."

After the amusement park was condemned and razed in 1928, it became a public park named after Father Gabriel Richard in 1936. Part of the plans to improve Belle Isle include a recommendation for a pedestrian promenade along the river that would stimulate foot traffic between Gabriel Richard Park and adjoining riverside parks.

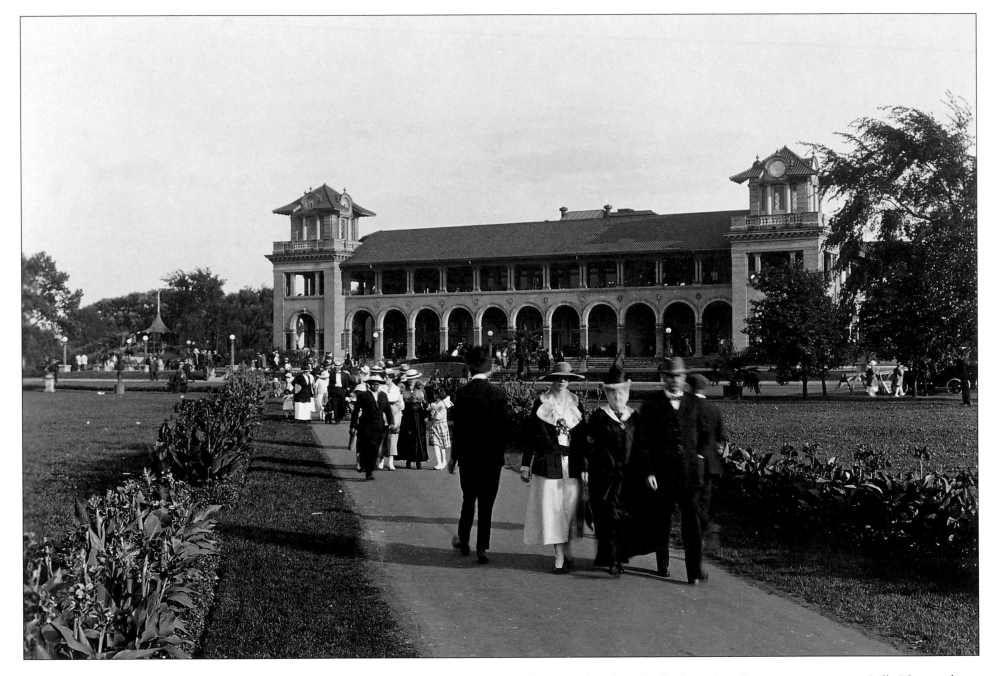

Taking a stroll in their Sunday best, these Detroiters are enjoying Belle Isle on a day in 1910. Located in the Detroit River just east of downtown, Belle Isle was called *Wah-na-be-zee* ("White Swan") by Native Americans and *Ile aux Cochons* ("Hog Island") by the French. The island was purchased by the city in 1879 with much controversy, and the name was officially changed by ordinance to Belle Isle in 1881. This Spanish-style casino replaced the original one in 1908 after a fire and was a popular gathering spot and venue for weddings and other parties.

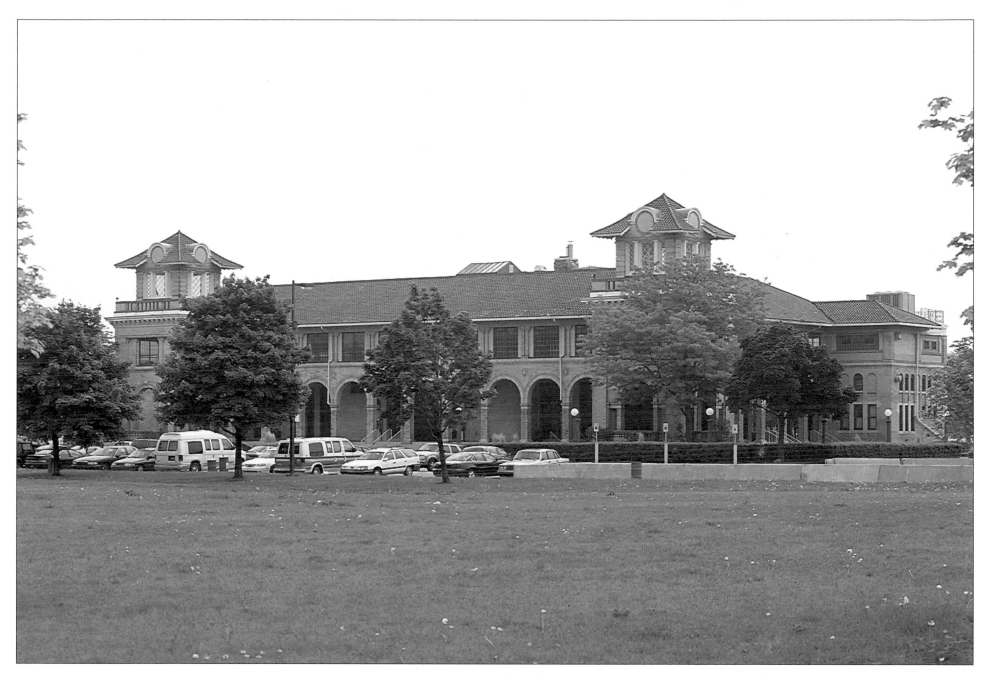

Located at the western end of the island, the casino was refurbished in 1990 and is used for a senior center and general meeting place. A $180 million master plan of the island calls for further renovations, including a full-service kitchen and an event planning coordinator, and promises to return the 982-acre park, designed by Frederick Law Olmsted, and its structures to their former glory. Today you will still find people strolling around the park's numerous trails and lanes, along with joggers and people cruising in their cars.

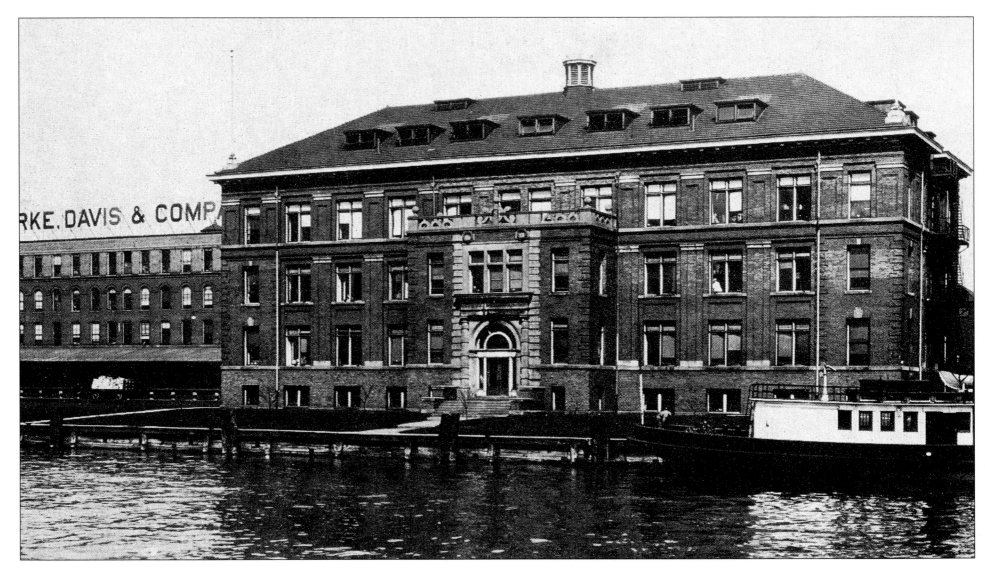

Built on the Detroit River in 1902 for easy access to transportation, the Parke Davis pharmaceutical laboratory was the first structure used for such purposes in the U.S. The company began building its complex at the foot of Joseph Campau Avenue in 1870 and by 1955 had constructed a complex of laboratories and other buildings covering over fourteen acres.

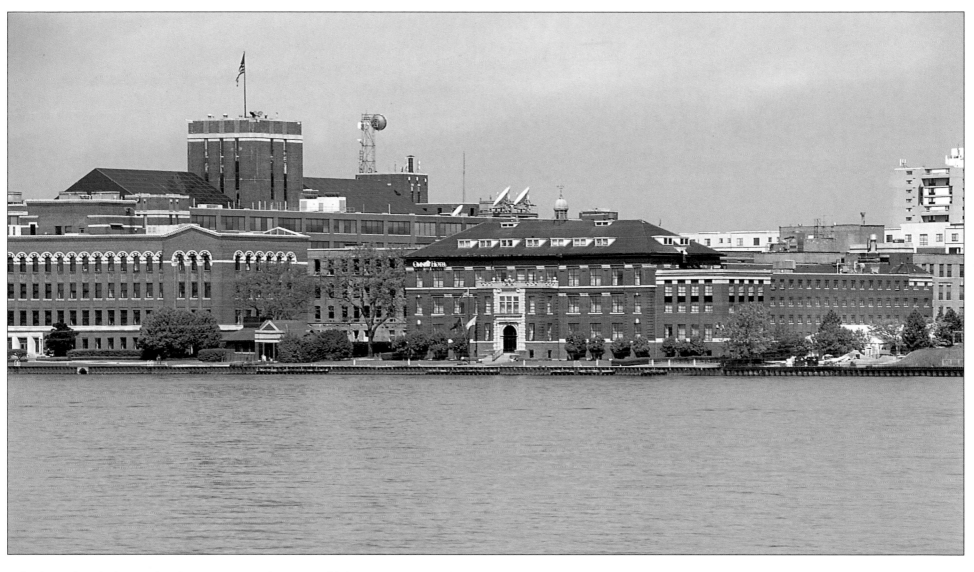

After being bought by another firm in 1970, Parke Davis sold the property to a real-estate developer in 1982. Now known as River Place, the twenty-six converted and restored buildings contain a 108-room hotel, offices, residences, and the well-known Rattlesnake Club restaurant.

SCOTT FOUNTAIN

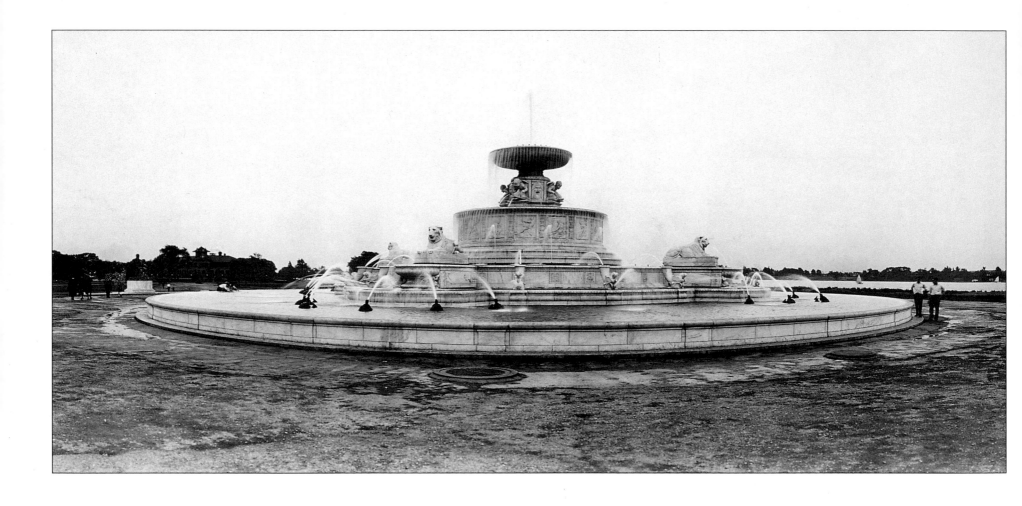

This graceful fountain on the western end of Belle Isle was built with money left for the purpose by real-estate magnate James Scott. Because of his reputation as a rogue and scoundrel, the project was surrounded by controversy. It was fifteen years between the time a design by Cass Gilbert was selected and the completion of the fountain in 1925. The western end of the island had to be extended 1,000 yards to make room for the fountain and an accompanying reflecting pool. Across the river to the right is the city of Windsor, Ontario. This photograph was probably taken in the 1940s.

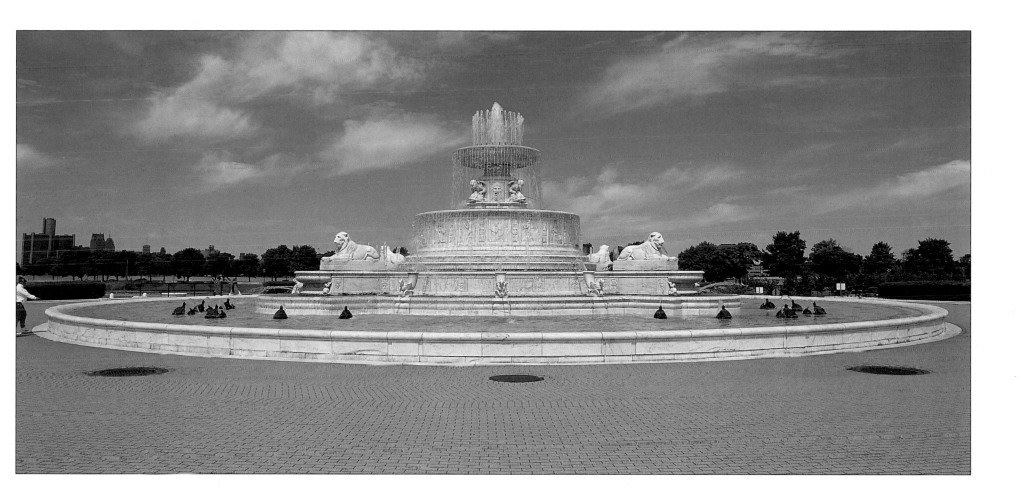

The renovated fountain is the jewel of the island. A forty-foot-high column of water falls into a series of receptacles of white Vermont marble. Water sprays from 109 outlets shaped as dolphins, turtles, human heads, and lions. At night, multicolored lights dazzle onlookers. In this view, downtown Detroit is in the background with the Renaissance Center at the far left

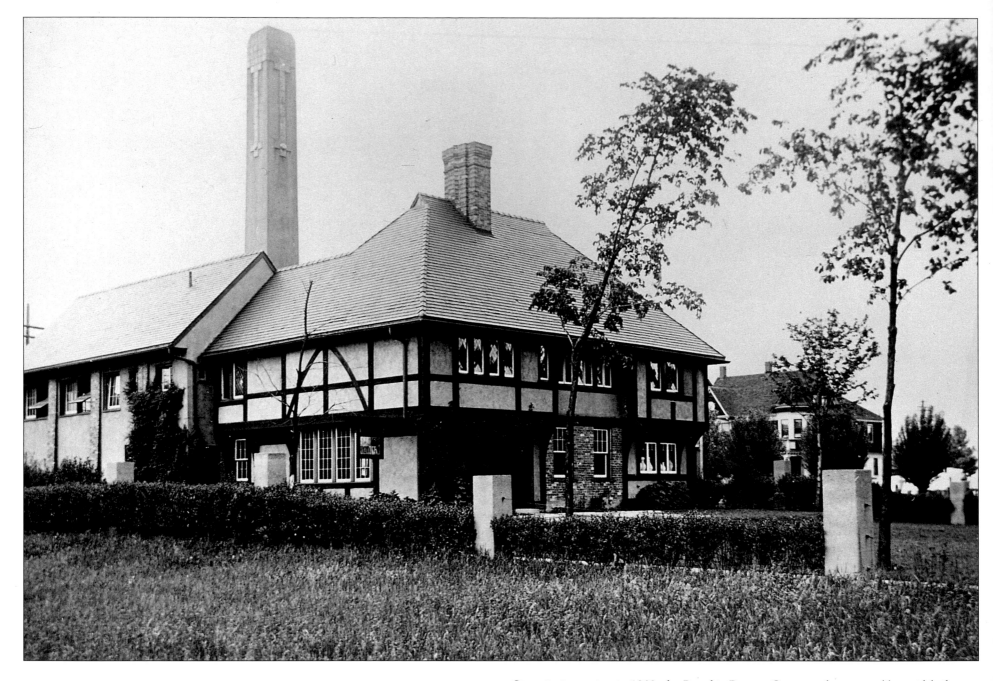

Since its inception in 1903, the Pewabic Pottery Company has created beautiful tiles and pottery for homes and buildings in Detroit. Pewabic comes from an Ojibwa word for the copper-colored clay used. In 1907, company founders Mary Chase Perry and Horace James Caulkins commissioned William B. Stratton, president of the Society of Arts and Crafts, to create this pottery works building. The English-style cottage on East Jefferson across from Waterworks Park incorporates varying size windows, different materials, and planes that add interest to this tile factory. This photo is from around 1915.

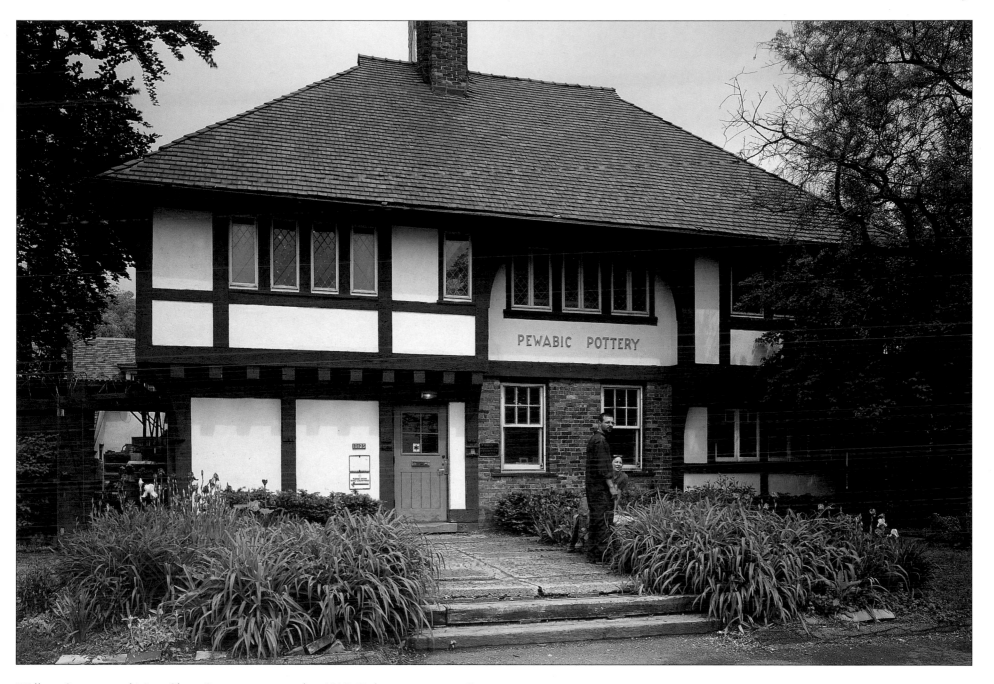

William Stratton and Mary Chase Perry were married in 1917. Today ceramicists still use the original cabinets, tables, clay-making machine and dumbwaiter, and the building remains largely unchanged. The unique, iridescent glaze developed by Mary Chase Perry Stratton is also still in use. Pewabic Pottery was designated a National Historic Landmark in 1991. Pewabic tiles can be found in many Detroit buildings such as the Guardian, the Detroit Institute of Arts, the Detroit Public Library, and lining the reflecting pool of Scott Fountain.

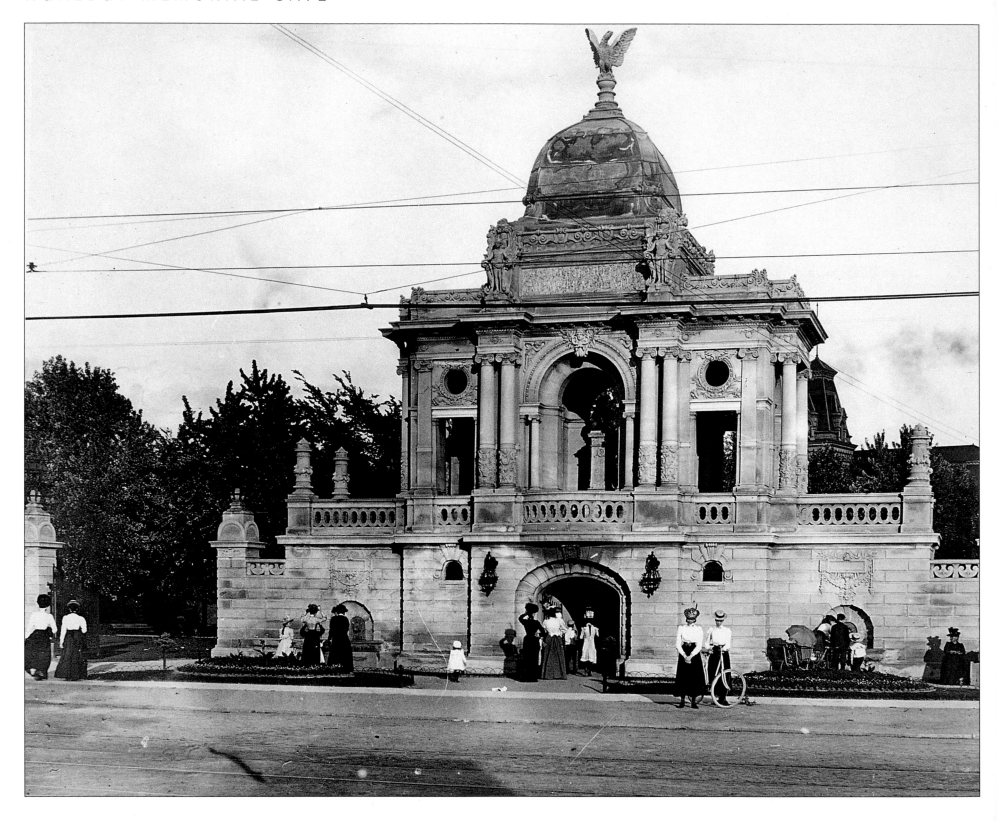

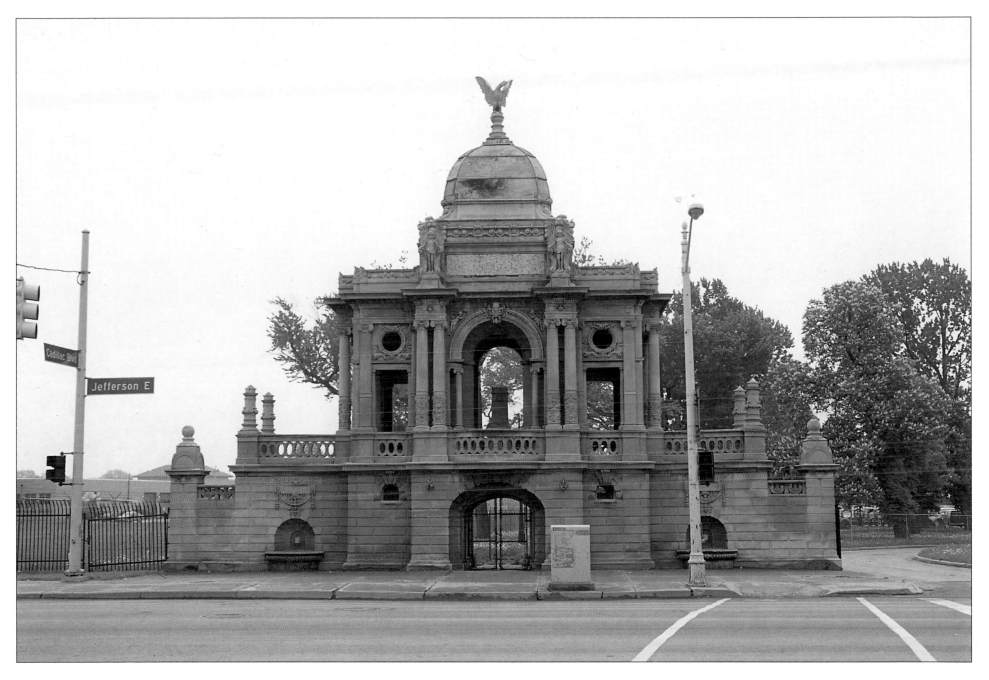

Left: This nineteenth-century monument stands at the entrance of what was Waterworks Park. Its namesake, long-time Water Board president Chauncey Hurlbut, left most of his estate for beautifying the 110-acre park on the Detroit River. Built in the Beaux Arts tradition by local architects Herman A. Brede and Gustave A. Mueller, the monument is fifty feet high and 132 feet long with stairways at both ends. Peeking from behind the gate is Pumping Station No. 1 built in 1879. As this 1890s photo shows, the park was a popular spot for family outings.

Above: In 1974 the granite bust of Chauncey Hurlbut was stolen from the arched niche under the dome, and there has also been damage from vandalism. The stairways are no longer accessible, so climbing to the terrace for a view of the river is impossible. In 1990 the monument was found to be structurally unsound and two years later citizens rallied to raise funds to restore and save this symbol of an elegant past.

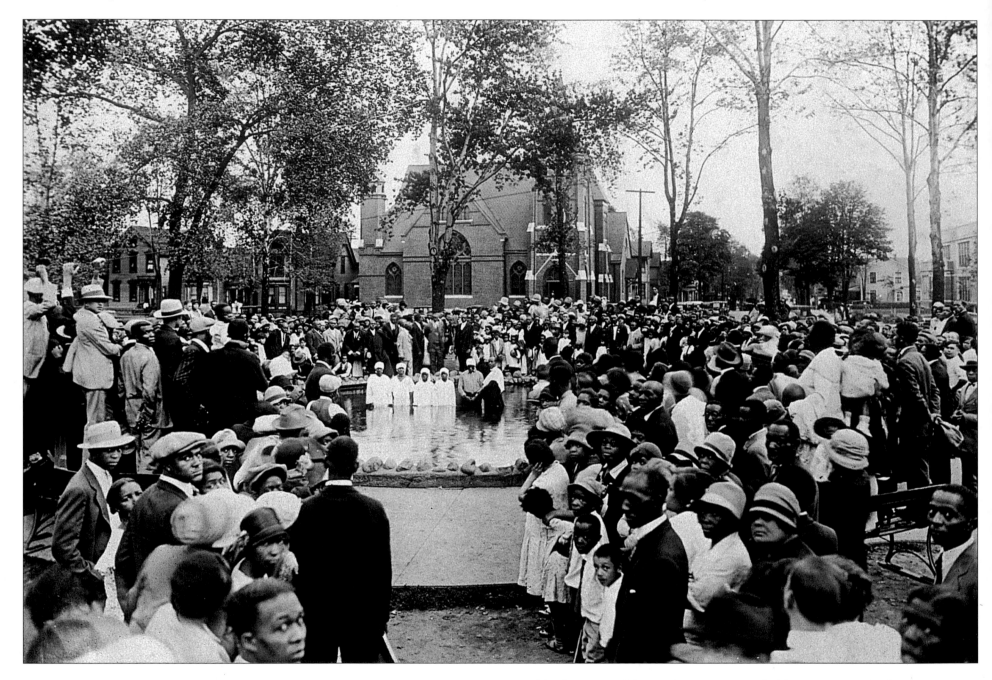

In 1927 the National Baptist Convention was held in Detroit, with a baptism service in front of the Calvary Baptist Church on Clinton at Joseph Campau. This photo was taken by Harvey C. Jackson, an African-American photographer who captured many of the educational and social groups of his community on film. The church was founded in 1919.

The intersection of Clinton and Joseph Campau no longer exists, replaced by large housing developments and a city recreational center. This photo of homes in the Franklin Wright Village approximates the location where the old church stood. Ground was broken for the new Calvary Baptist Church in 1975, a block from here next to the entrance of Elmwood Cemetery.

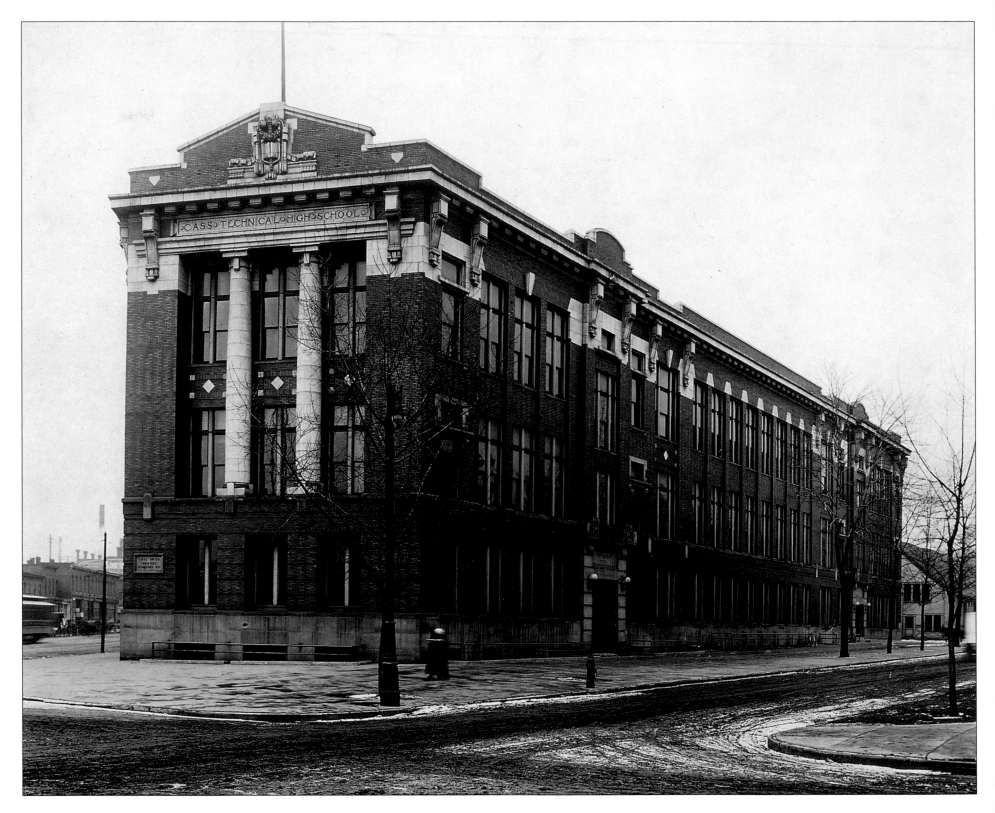

Left: Named after Michigan territorial governor and Secretary of State Lewis Cass, the school had its beginnings at Cass Union School in 1907. Existing under various names of High School of Commerce and Cass Union High School, this building is the second built on the site, the first having burned in 1909. It was torn down in 1963 to make way for the Fisher freeway.

Above: This eight-story structure built in 1922 by Albert Kahn was linked to the first by an archway until the first was torn down. Now home to over 2,500 students, the building may not be long for this world. Although "for much of the twentieth century it has educated Detroit's smartest kids," according to the *Detroit Free Press*, plans are underway to close the school and build a new one because it would cost too much to repair the original structure. Cass Tech has educated many famous people, including singer Diana Ross and comedian Lily Tomlin.

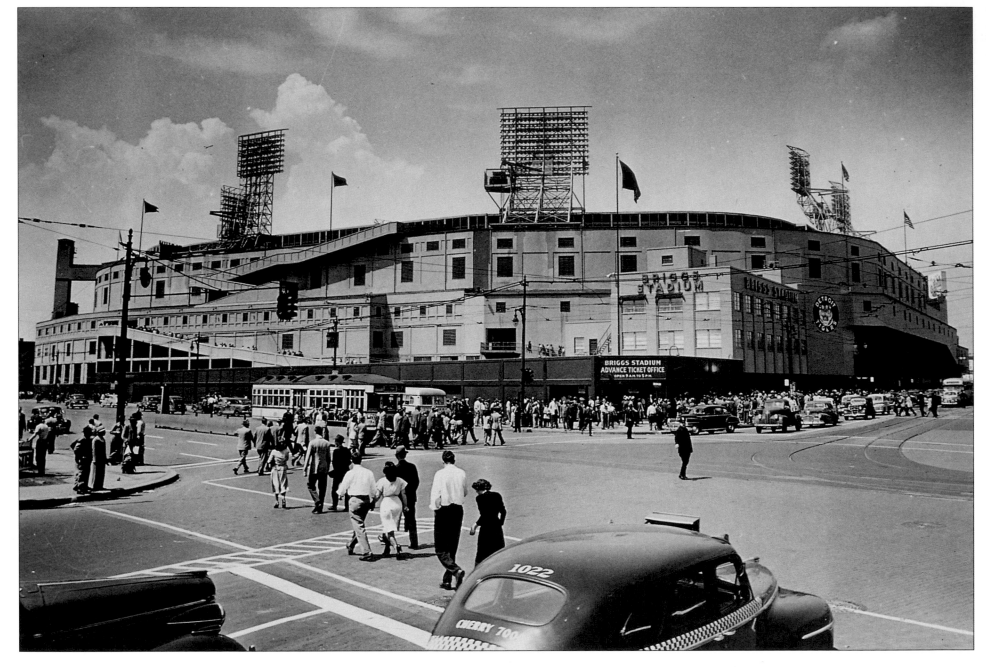

A 1940s picture of Michigan and Trumbull captures the anticipation of a summer's day. Tiger Stadium started as Bennett Park in 1896, then became a stadium called Navin Field in 1912. A second deck was added in 1923, then Navin Field became Briggs Stadium in 1938. Renamed Tiger Stadium in 1961, it is, along with Boston's Fenway Park and Chicago's Wrigley Field, one of the remaining historic concrete and steel ballparks.

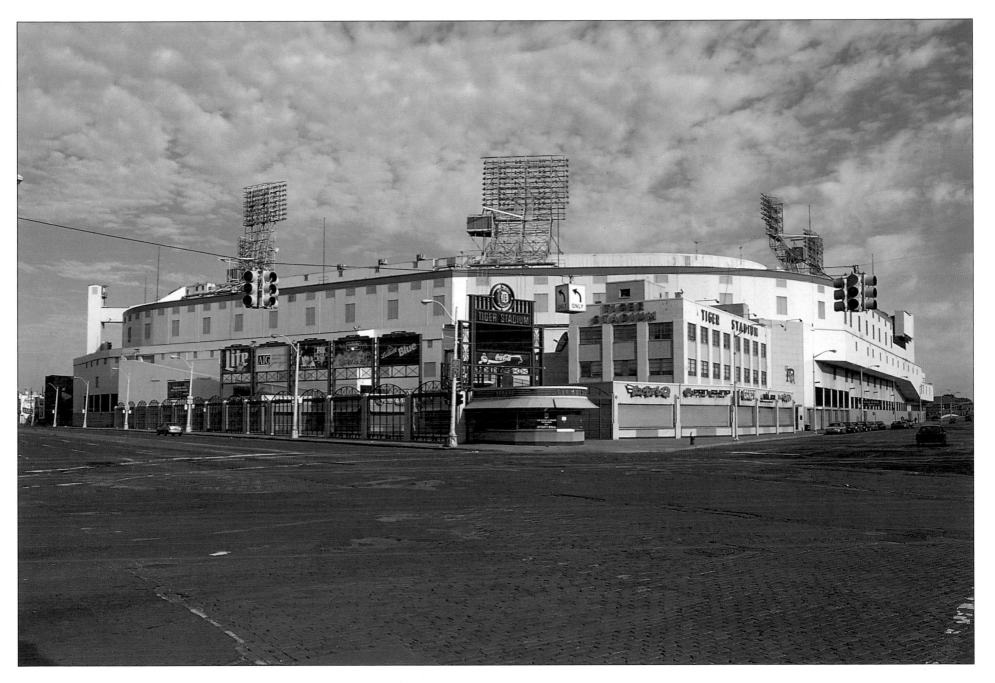

Although professional baseball games are no longer played here, the old stadium at the corner of Michigan and Trumbull still harbors the ghosts of Ty Cobb, Hank Greenberg, and Charlie Gehringer. Tiger Stadium hosted its final game on September 27, 1999. Listed on the National Register of Historic Places, the ballpark's future is uncertain. Plans for the stadium's use include development as a condominium, office, and shopping complex.

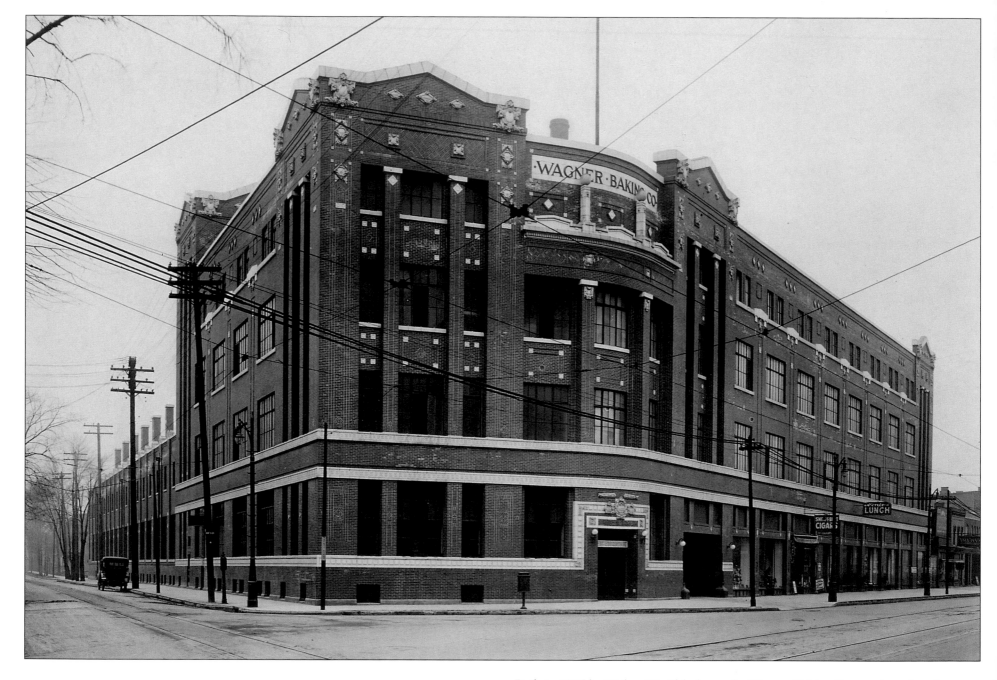

Built in 1915 by Walter W. Ahlsclager, the Wagner Baking Factory introduced Wonder Bread to the public in 1921. When Continental Baking bought the company, Wonder Bread went national, introducing the public to sliced bread in 1930. Fifty-five years later the factory closed. This is a 1917 photo of the company on Grand River and Temple.

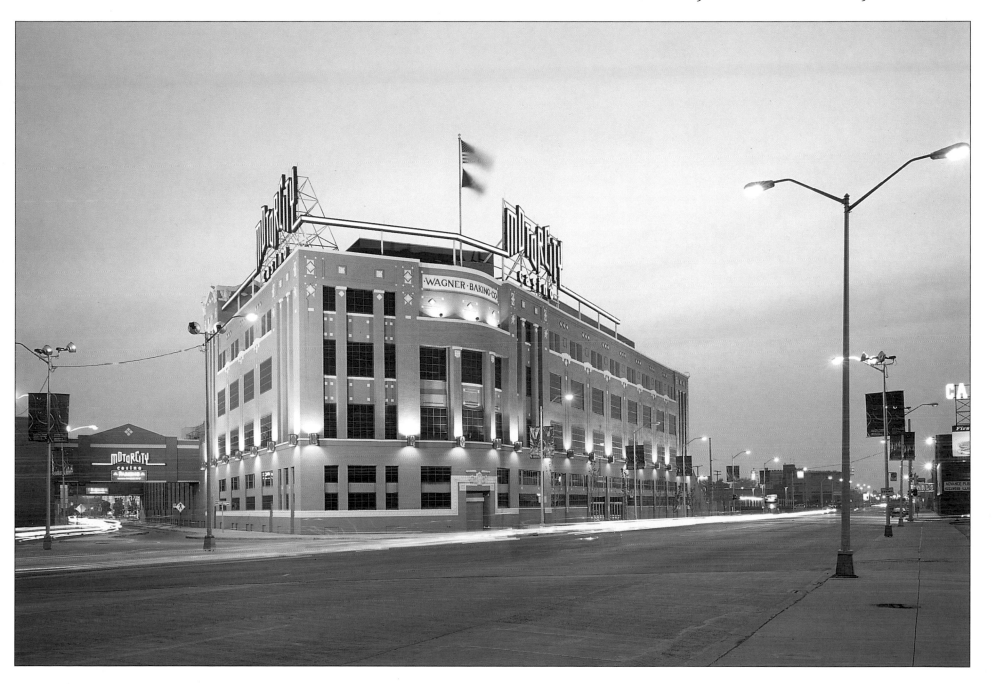

Reincarnated in 1999 as the MotorCity Casino, the old bakery is smelling sweet again. The exterior architecture was left intact, and the interior décor, such as murals of assembly lines, hood ornament statues, and moving gears on slot machines, makes it a Motor City experience. Originally planned as a temporary location, the casino will remain here permanently.

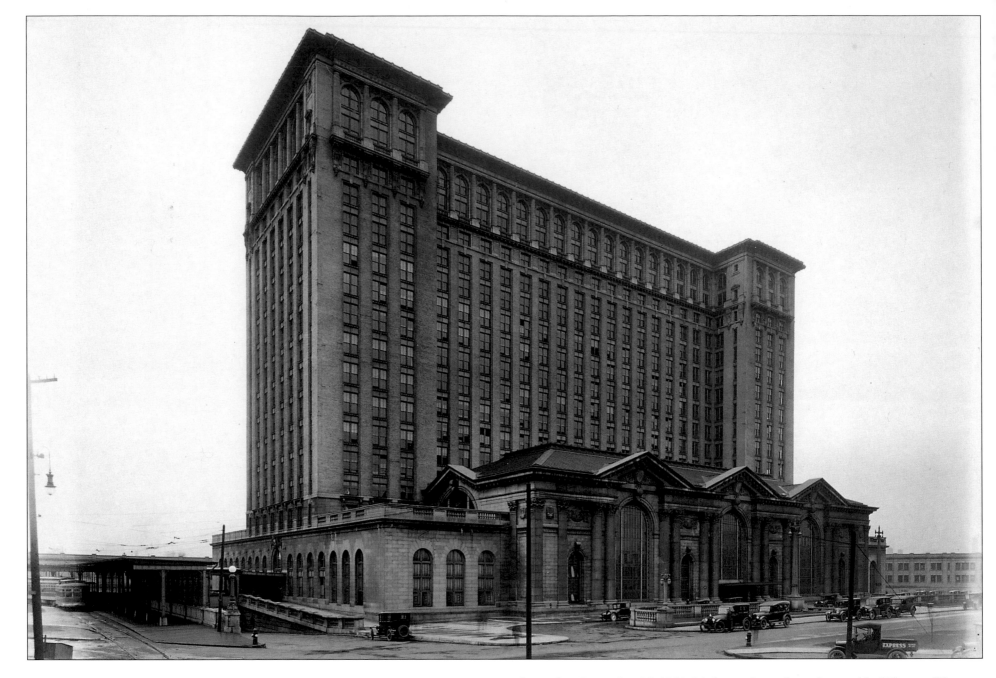

Opened on December 26, 1913, Michigan Central was designed by Whitney Warren and Charles D. Wetmore, the same architects who built New York's Grand Central Station. A Roman-style waiting room with marble columns and arches is connected to the sixteen-story office building. At one time, more than forty-three trains passed through the depot daily. This photograph, circa 1920s, shows the station from the south side, overlooking what would become Roosevelt Park.

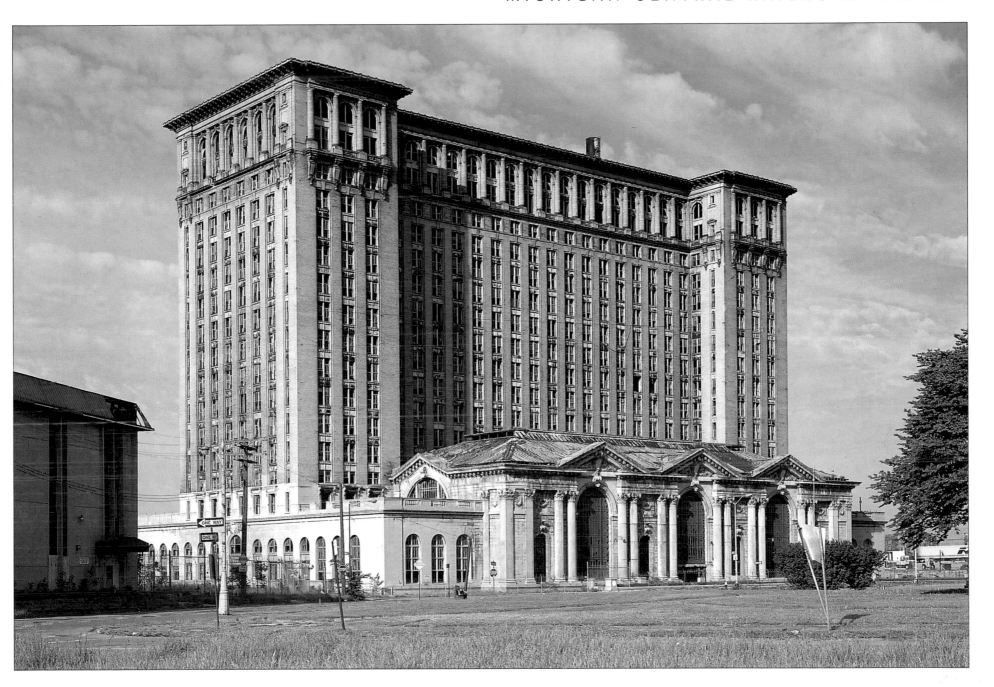

The now-vacant building has been left unprotected to the ravages of time, elements, and the unscrupulous. Amtrak closed its offices in 1988 and since then various owners and developers have proposed uses for the building such as casino, retail center, and athletic club. The current owners are proposing an International Trade Processing Center for the building, which is currently on the city's dangerous buildings list.

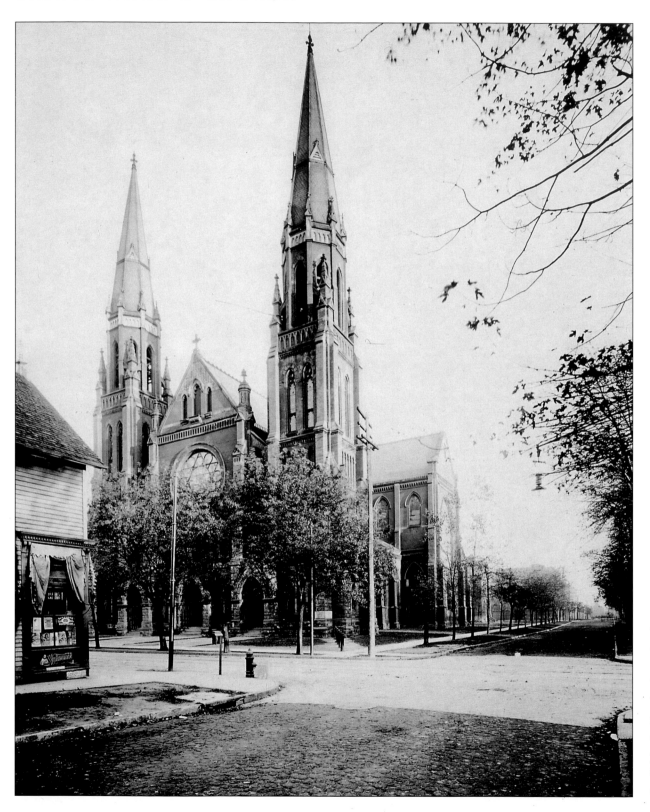

This is the eighth structure of the oldest parish in Detroit, the second oldest in the U.S. Built in 1887 at Howard and 19th streets, the parish moved away from its downtown location where it had been since its founding in 1701. The brick church, designed by Leon Coquard, houses the remains of Father Gabriel Richard, who pastored the church from 1802 until 1832 and brought the first printing press to Detroit in 1809. The earliest existing parish records date from 1704 with the baptism of Cadillac's daughter. This photo is from around 1887.

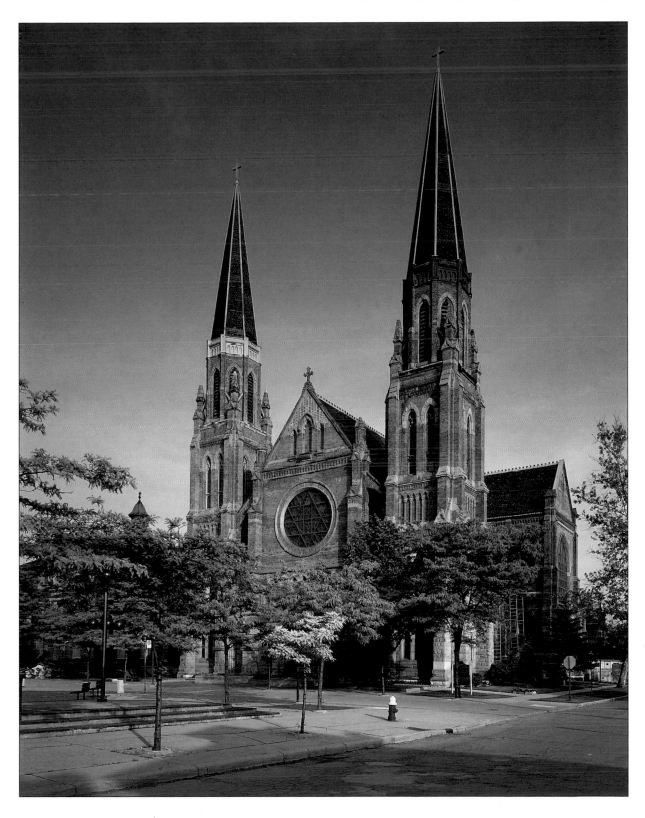

Ste. Anne's has always been associated with the French founding fathers, but today its bilingual services are in Spanish. The church is a vital part of the southwest Detroit community where many Hispanics live. Since 1987 the former convent has been rented to Freedom House, a haven for refugees seeking asylum. Another outreach program is GRACE, Gang Retirement and Education/Employment, teaching former gang members skills for jobs in the community.

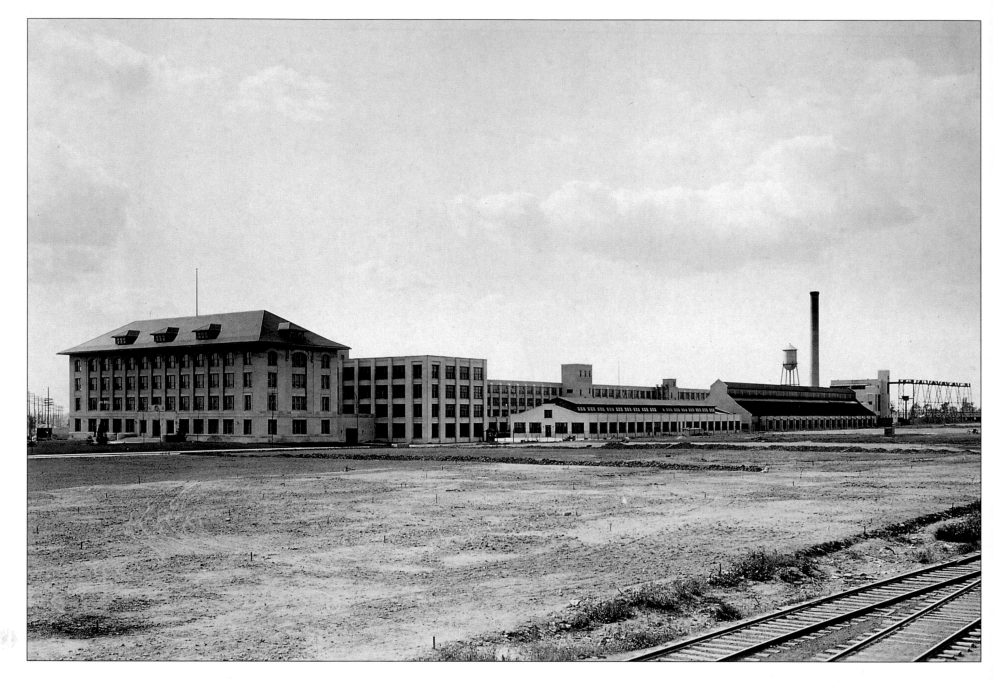

The business began as the Lincoln Motor Company in 1917, organized by Henry M. Leland and his son Wilfred to manufacture Liberty airplane engines. In 1920 the plant started manufacturing Lincoln automobiles, and in 1922 the company was sold to Henry Ford. This 1932 photo shows the entire complex of the original building designed by George D. Mason, and the additional buildings by Albert Kahn.

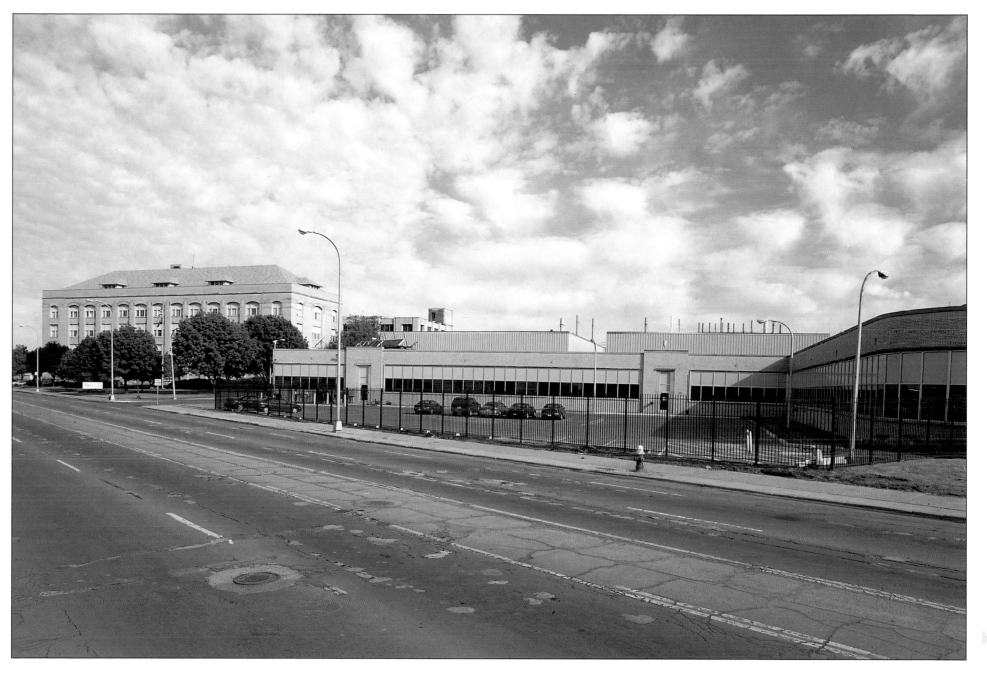

The Detroit Edison Power Company has occupied the building since 1955 when Lincoln production was moved to Wayne, Michigan. The huge facility occupies a city block on Livernois, between Warren and Tireman. It is currently used as a service center.

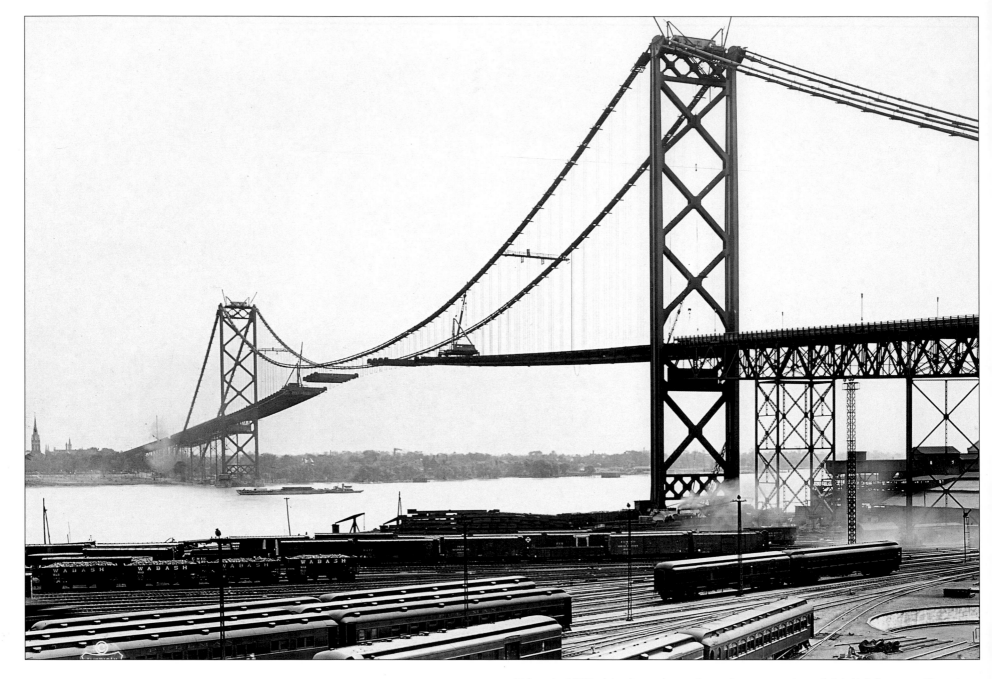

Taken in 1929, this photo shows the early construction of this link between Detroit and Canada's Windsor, Ontario. The Ambassador Bridge, at 1,850 feet, was the longest in the world for two years until surpassed by New York's George Washington Bridge. It took over two years to complete the suspension bridge which stands 152 feet above the Detroit River at its center span.

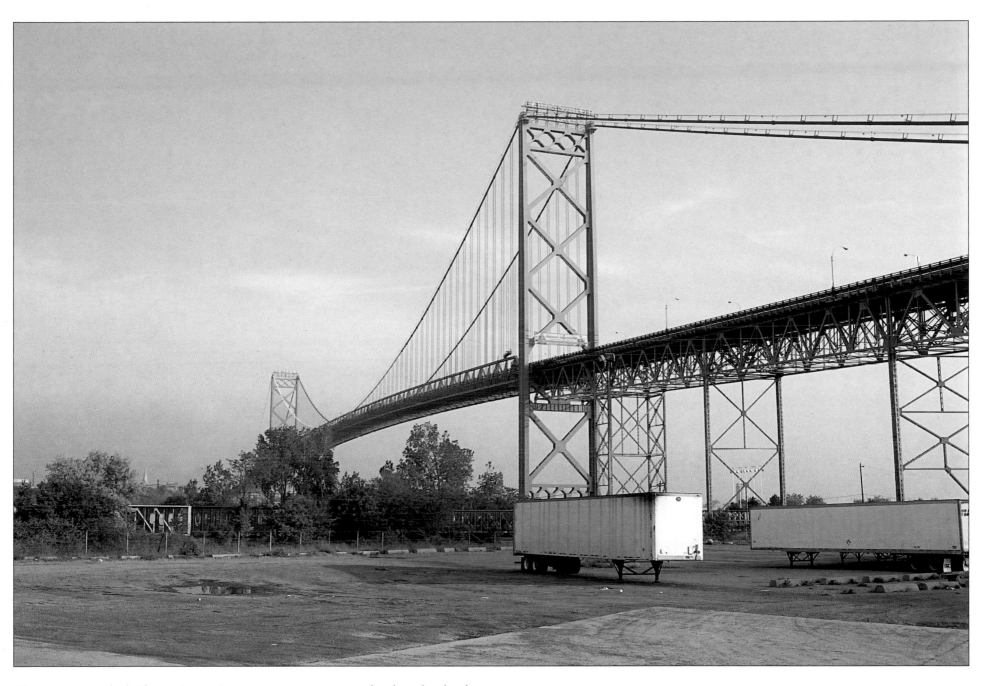

The entrance to the bridge on Porter Street is a constant, twenty-four hour bustle of tractor-trailers and cars. More than twelve million vehicles cross the bridge, in both directions, annually. Twenty-seven percent of all merchandise trade between the U.S. and Canada, two of the world's largest trading partners, crosses the Ambassador Bridge. In ten years bridge traffic has grown one hundred percent, and there are plans to increase the number of toll booths.

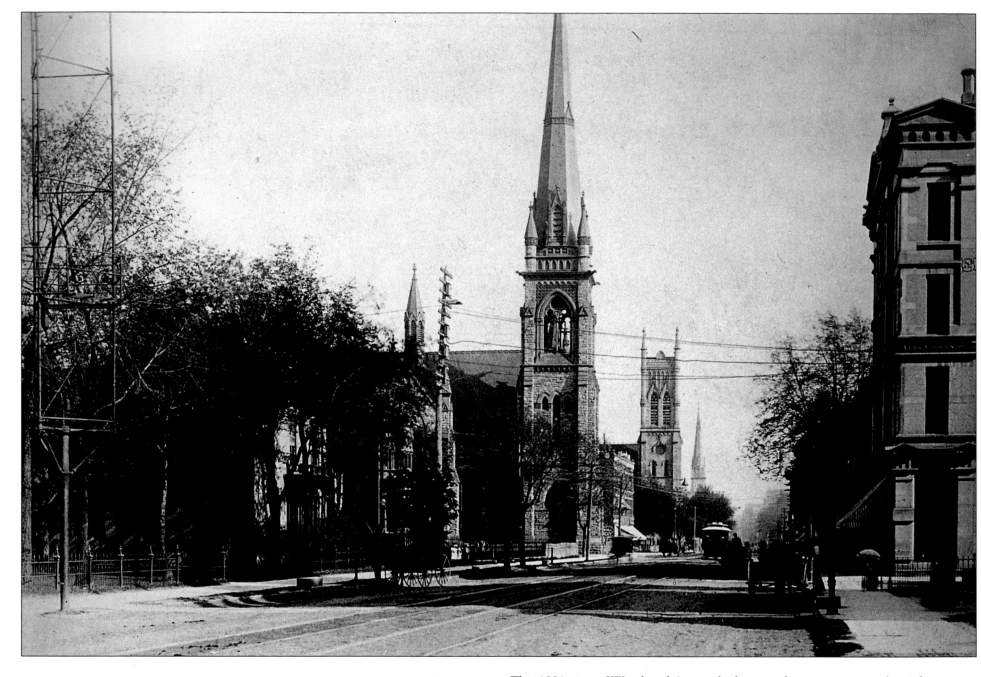

This 1891 view of Woodward Avenue looking south, gives reason to the nickname Piety Hill, actually the second of such church-dominated rises in the city. On the left are Woodward Avenue Baptist (1887), St. John's Episcopal (1861), and Central Methodist Episcopal (1866–67). One of Detroit's electric towers for lighting the streets is visible on the left.

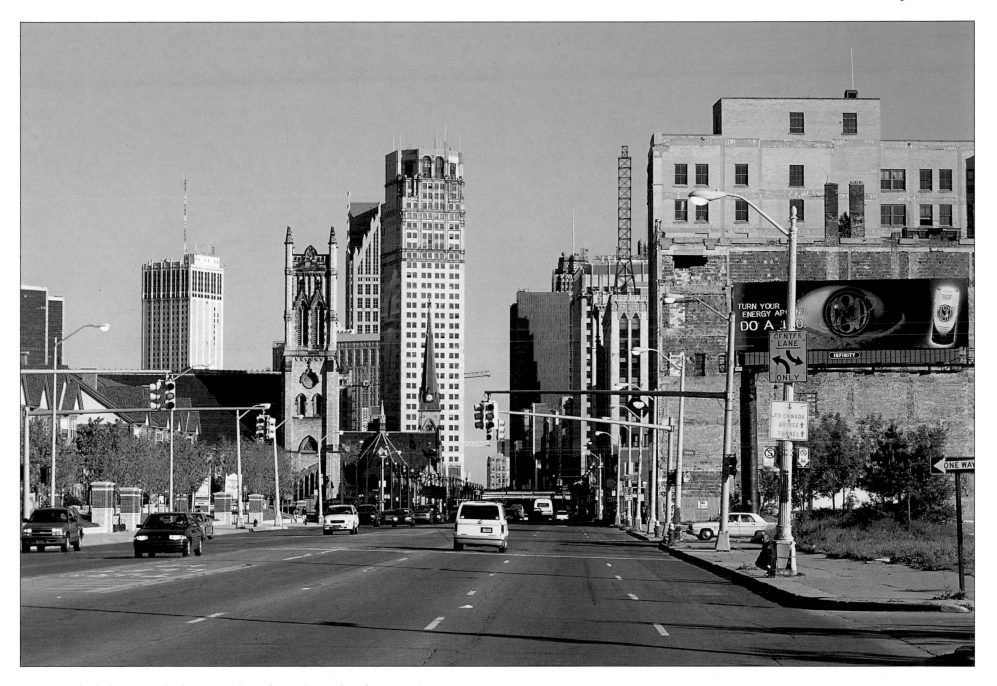

Gone are the light tower, the house on the right, and Woodward Avenue Baptist
Church, which burned in 1986. St. John's is still there, and the spire of the Central
Methodist is seen against the background of the David Broderick Tower. When
Woodward was widened, in 1935–36, each church was moved eastward. St. John's was
moved back sixty feet and its tower removed and rebuilt. Central Methodist had its
nave shortened twenty-eight feet and the steeple tower and front wall moved back.

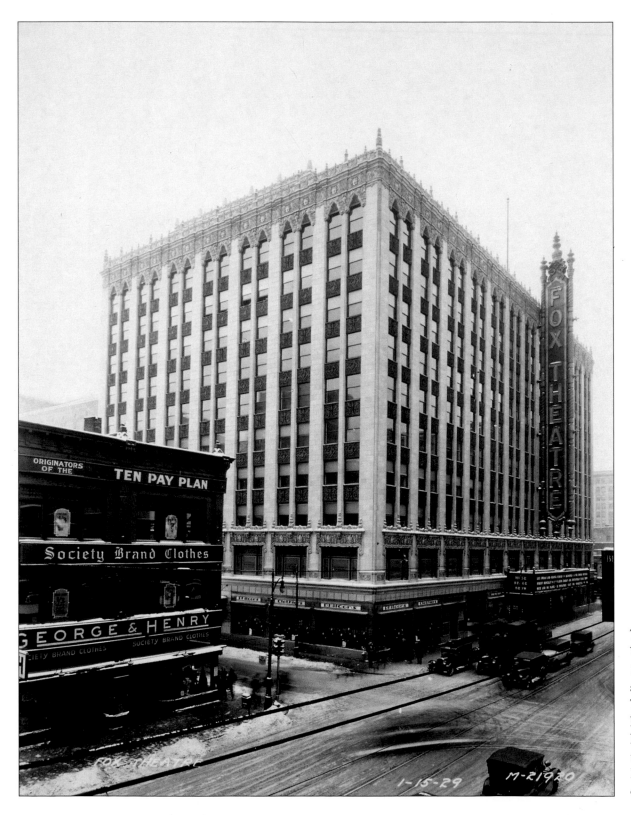

The queen of all Detroit theaters is the glorious Fox on Woodward Avenue. The C. Howard Crane creation opened in 1928 and included features of Burmese, Hindu, Persian, Indian, and Chinese architecture—in all, the work of twenty artists. The six-story lobby is adorned with red marble columns holding figures of Asiatic gods. This temple of entertainment hosted the gamut of bills from vaudeville in the 1920s and 30s, to big bands in the 1940s, to the Motown Revue in the 1960s. In 1929, as this photograph shows, Columbia Street was open on the theater's south side.

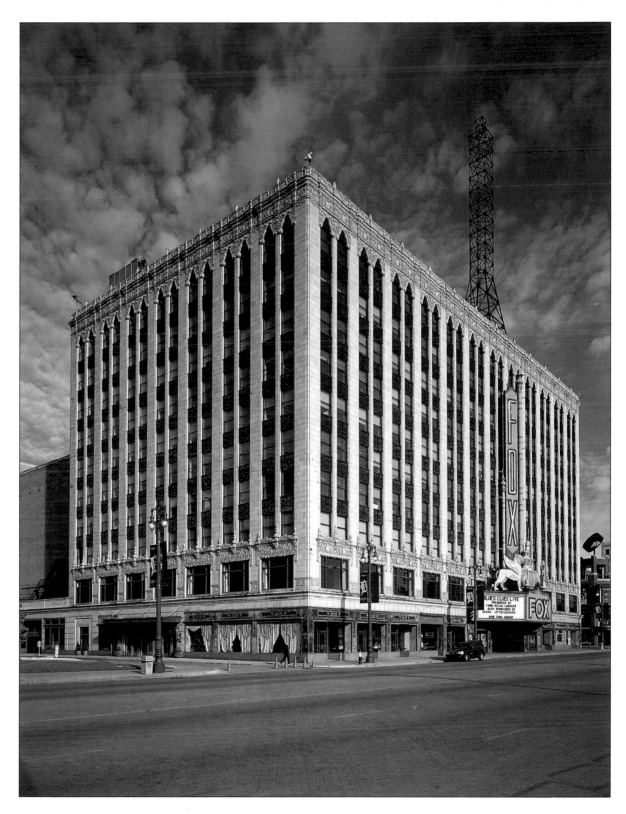

Rescued from ruin in 1987 and restored to its dazzling original condition, the Fox Theater is part of a theatre and entertainment district that includes restaurants and a comedy club. Columbia Street is now used as an entrance to a parking lot, and the Second City comedy club and Hockey Town restaurant have been built on the north side of the theater.

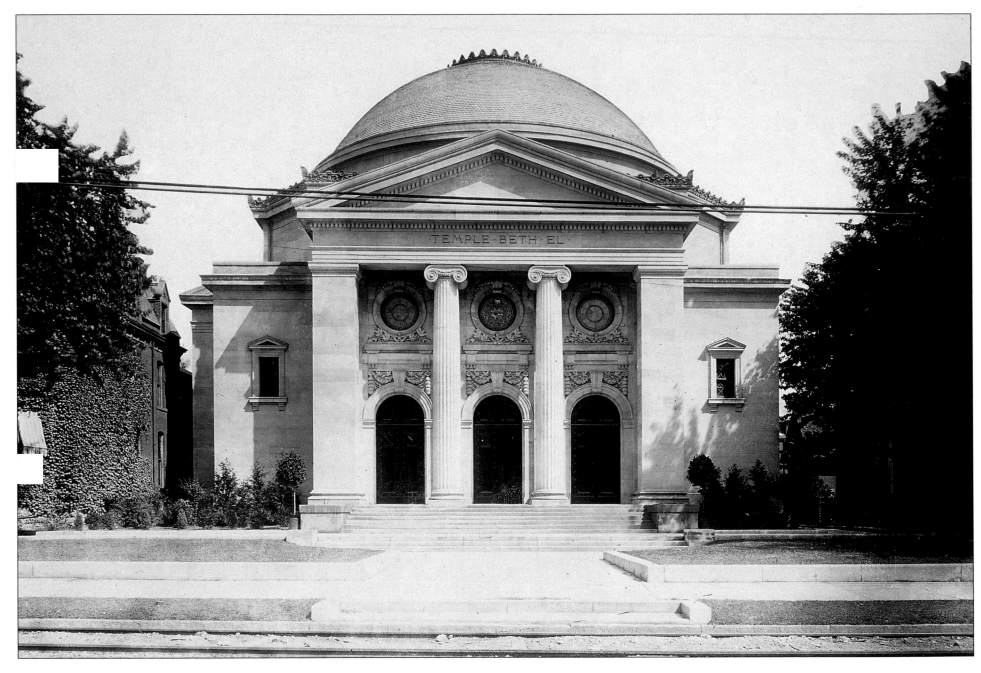

Temple Beth El, on Woodward at Eliot, not far from the old Jewish neighborhood on Hastings Street, was designed by Albert Kahn in 1903. This 1919 photo was taken three years before the congregation, founded in 1850, the first Jewish congregation in Detroit, moved to its fourth building. In 1924 play producer Jessie Bonstelle turned the synagogue into the Bonstelle Playhouse, a home for her stock theater group. The name was changed in 1928 to the Detroit Civic Theater when it became publicly owned. When Jessie Bonstelle died in 1932 over 25,000 Detroiters passed by her body, which lay in state in the theater pit. The theater closed in 1934.

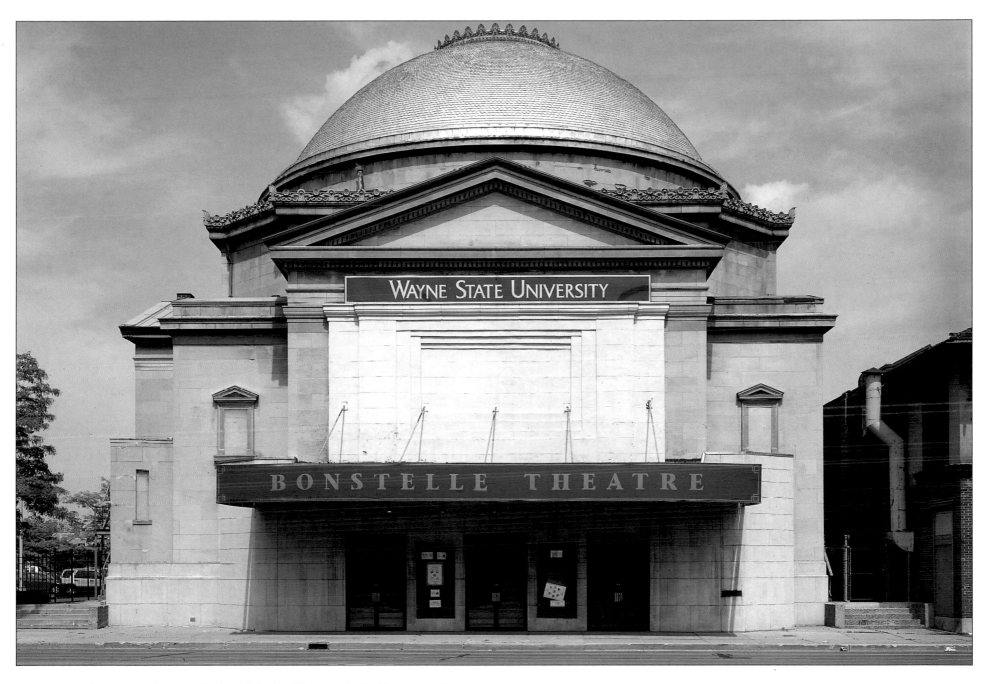

WAYNE STATE UNIVERSITY

BONSTELLE THEATRE

After a period as a movie house called the Mayfair Theater, the building was taken over by Wayne State University, which rented the facility in 1951, purchasing it in 1956. Once again it became the Bonstelle and is a showcase for five to seven productions a year by Wayne State University drama students. The front of the building was affected by the widening of Woodward in 1935–36.

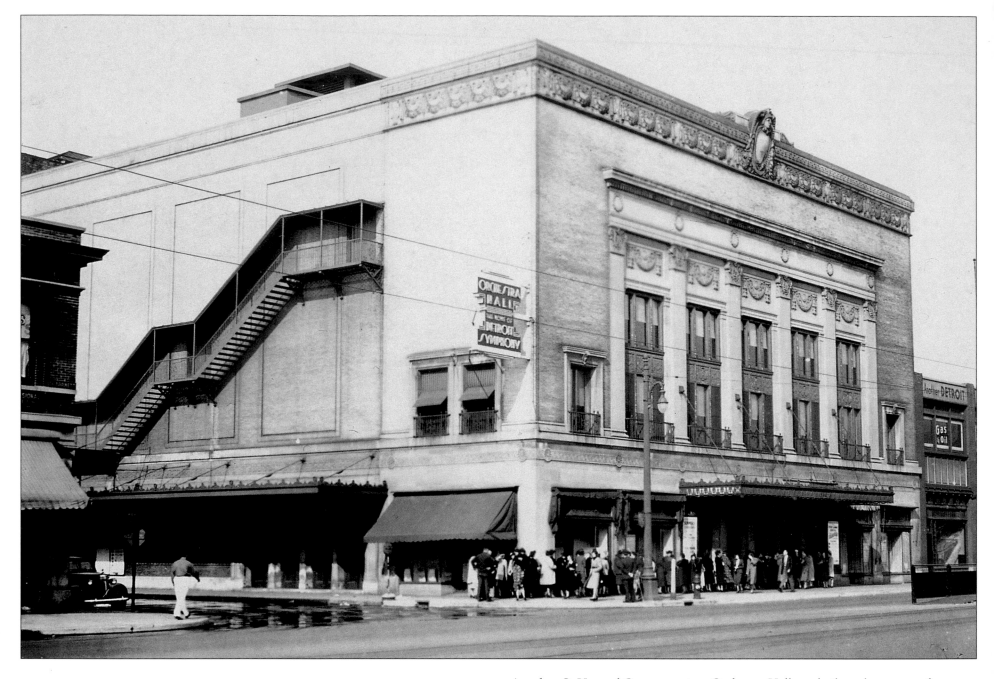

Another C. Howard Crane creation, Orchestra Hall was built at the corner of Woodward and Parsons in 1919, specifically for the Detroit Symphony Orchestra. This photo shows the hall before the symphony left for a new home in 1939. From 1941–51 the hall was known as the Paradise Theater, featuring big-name acts like Duke Ellington, Count Basie, and Earl Hines.

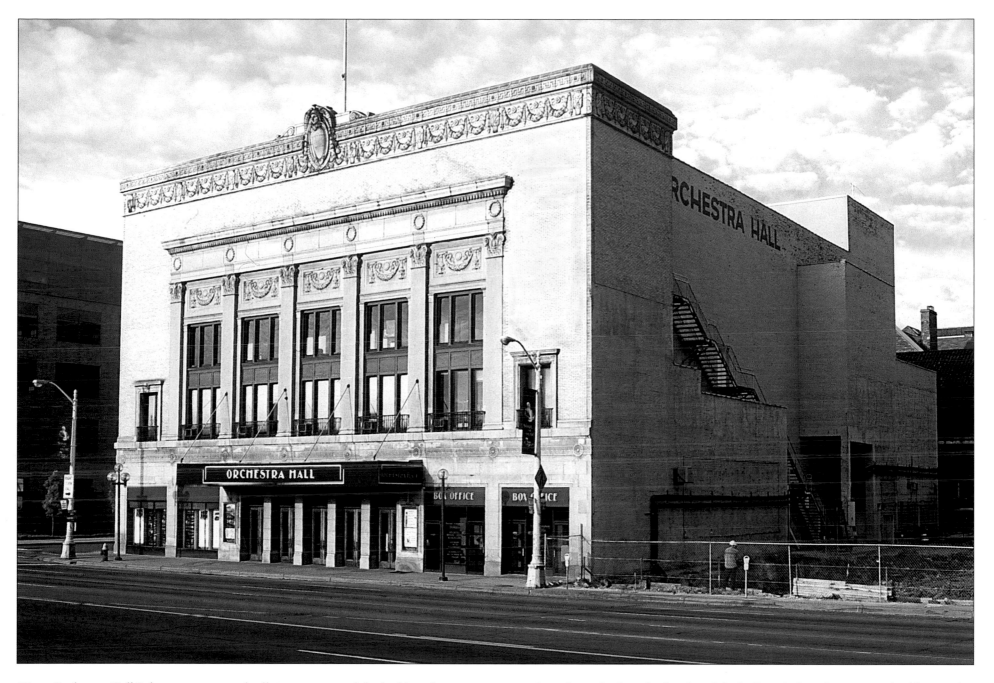

"Save Orchestra Hall," the movement and rallying cry, rescued the building from demolition in 1970 and has helped restore it to acoustical excellence. It is now home once again to the Detroit Symphony Orchestra. In what has been termed an historic alliance with the Detroit Medical Center and the Detroit Public School system, a complex is being built on both sides of the hall, including the six-story building to the left, Orchestra Place, corporate headquarters for the Detroit Medical Center. Construction to the right of the hall will encompass a 50,000 square foot expansion for a new lobby plus a new high school for the performing arts.

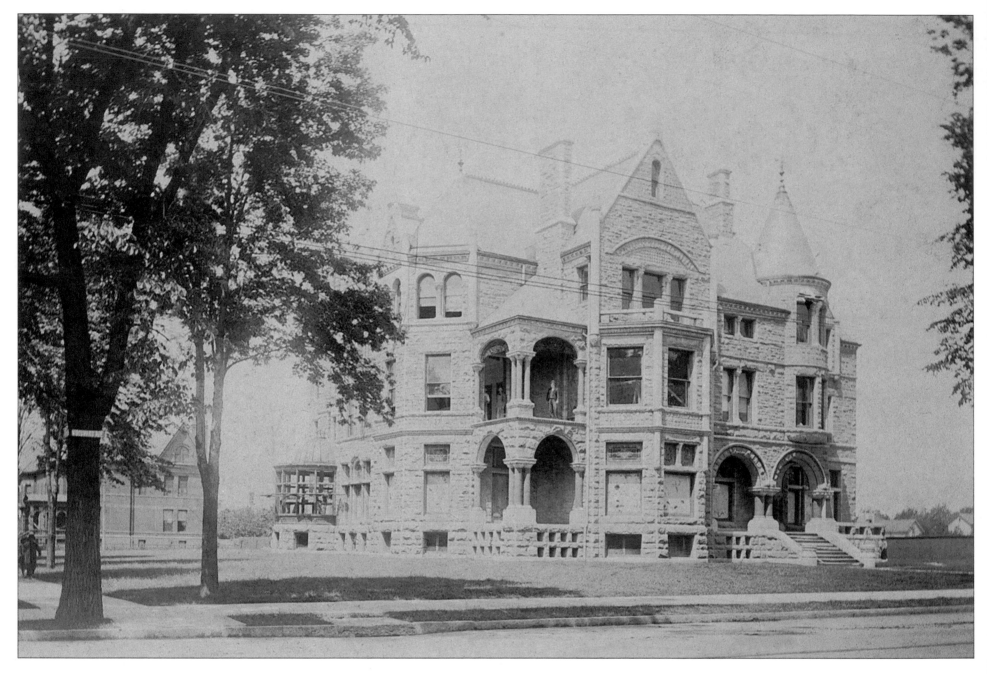

This was the second house built for David Whitney, Jr., a scion of Michigan's lumber industry. It took four years to complete the mansion at the corner of Woodward Avenue and Canfield, construction beginning in 1890. The material used on the exterior is jasper from South Dakota, a pink-hued granite. The *Detroit Free Press* described the house as enjoying "the distinction of being the most pretentious modern home in the state and one of the most elaborate houses in the West." This photograph is circa 1905.

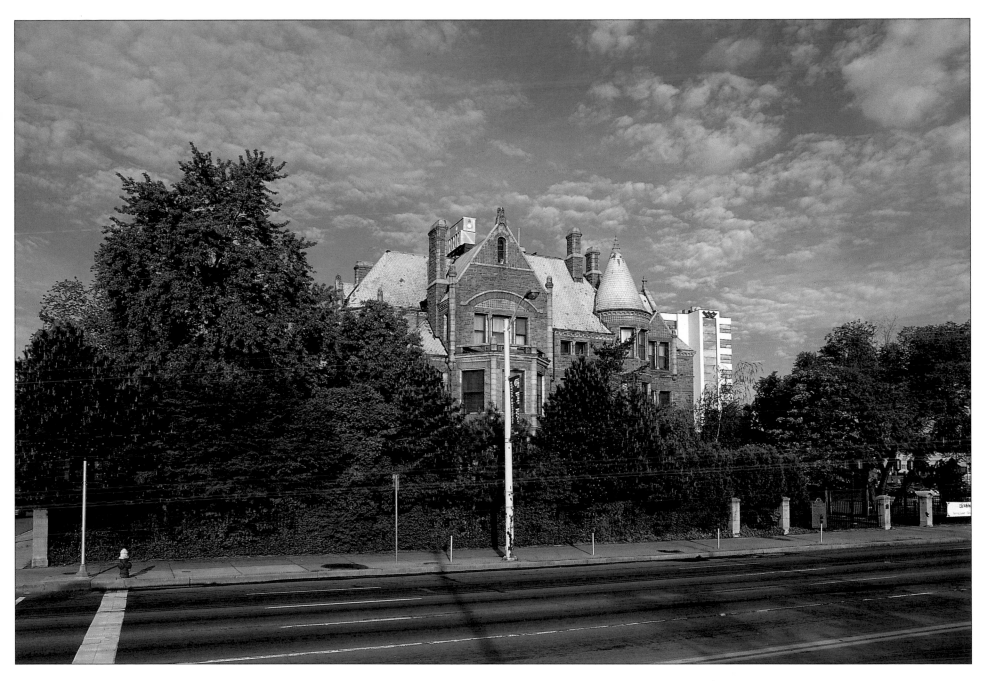

The 21,000 square foot, three-story building later became home to the Wayne County Medical Society, then the Visiting Nurses Association, before being bought by a private investor and restored. Opened in 1986 as a posh restaurant, its crystal chandeliers, Tiffany glass, mahogany woodwork, and fine dining make a visit to this American palace a special occasion for anyone. The modern building to the right is Wayne State University's Tower apartments on Cass Avenue.

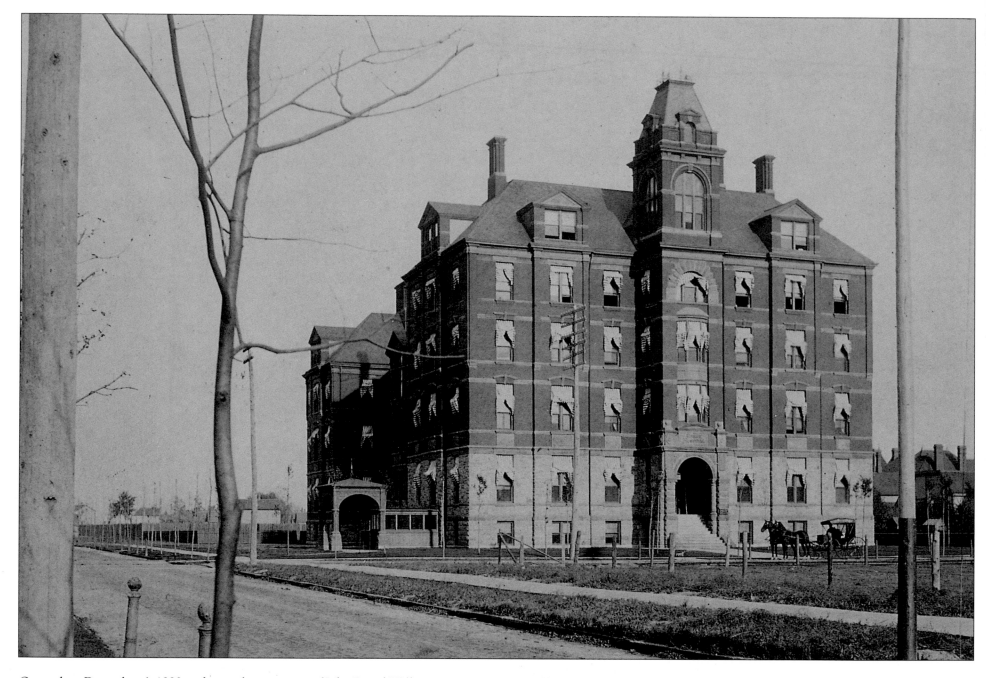

Opened on December 6, 1888 at the southeast corner of John R and Willis streets, Grace Hospital featured the latest innovations in hospital technology. The architect, Gordon W. Lloyd, also built the David Whitney house, nearby on Woodward Avenue. The five-story building had room for 122 beds that provided some relief to the overcrowding in Detroit's other four hospitals. Named for the daughter of James

McMillan, one of its benefactors, Grace Hospital was the first in Detroit to practice homeopathic medicine. The land was part of the Brush Farm, and as this 1888 photo shows, was still largely undeveloped. The hospital was also noted for its school of nursing, the longest continuing school in the state.

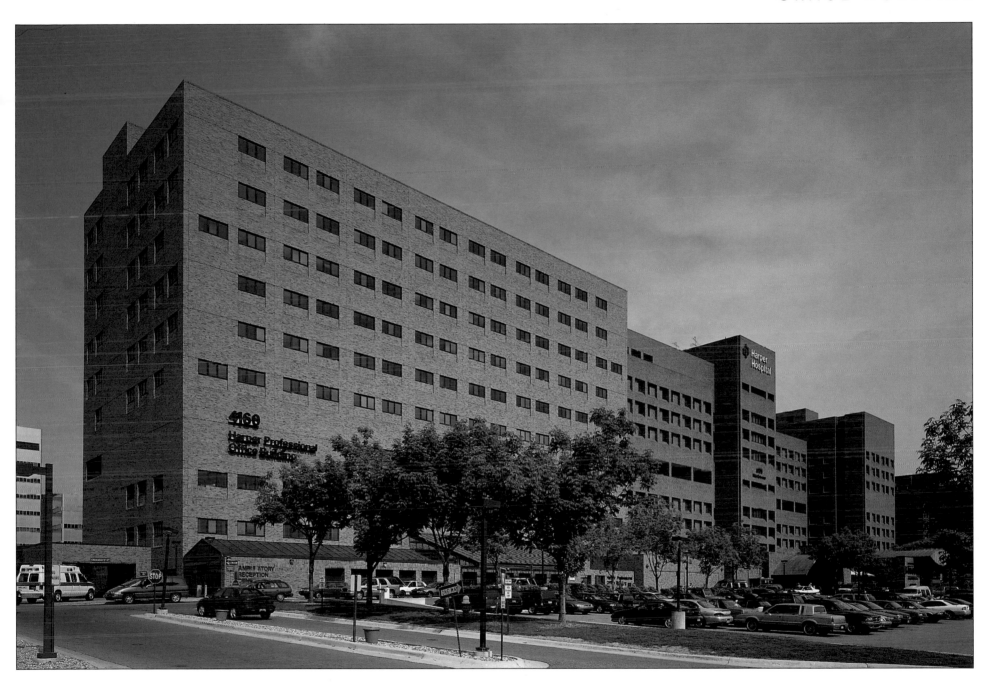

Perhaps this hospital's most famous claim to fame is that magician Harry Houdini died
here on October 31, 1926, following a ruptured spleen. After expanding into a branch
on the northwest side of the city, patient care in this building ended in 1978 when
Grace and Harper hospitals merged. The building was replaced by the Harper
Professional Office building, part of the Detroit Medical Center incorporating Harper
Hospital, Wayne State University Medical School, Children's Hospital, and the
Veteran's Administration Hospital.

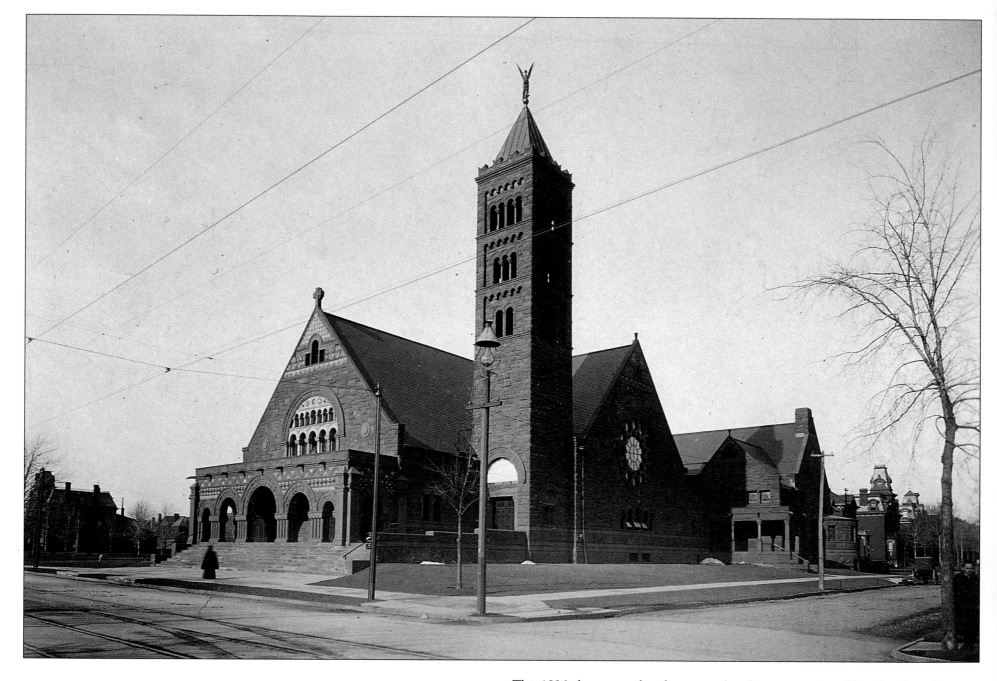

This 1896 photo was taken five years after the construction of this church at the corner of Woodward and Forest. Combining elements of the Romanesque and Byzantine, it is a striking structure on an avenue full of churches. Known as the Church of the Seven Arches, this is the third building of the Congregational Society, founded in Detroit in 1844. The angel Uriel is at the top of the campanile.

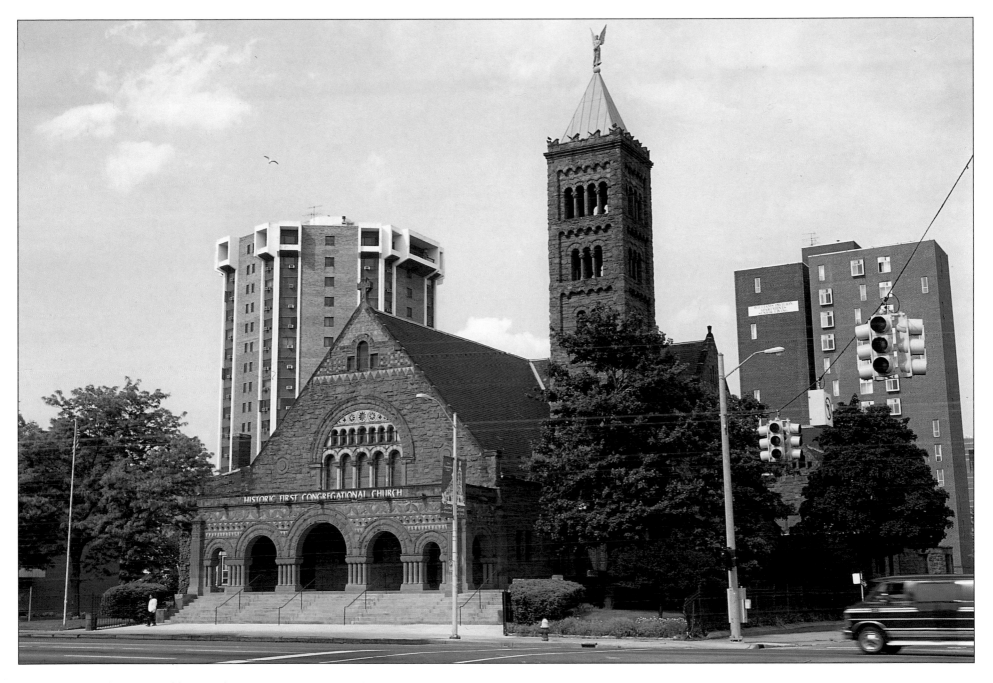

Today the church is pastored by an African-American woman, Pastor Lottie Jones-Hood, a first in the church's history. While the church is an active part of the community, it is faced with constant repairs for the 110-year-old building. However, church income is growing, helping to subsidize an outreach program to children and seniors, and increasing the restoration budget. The round building on the left is Cathedral Tower apartments.

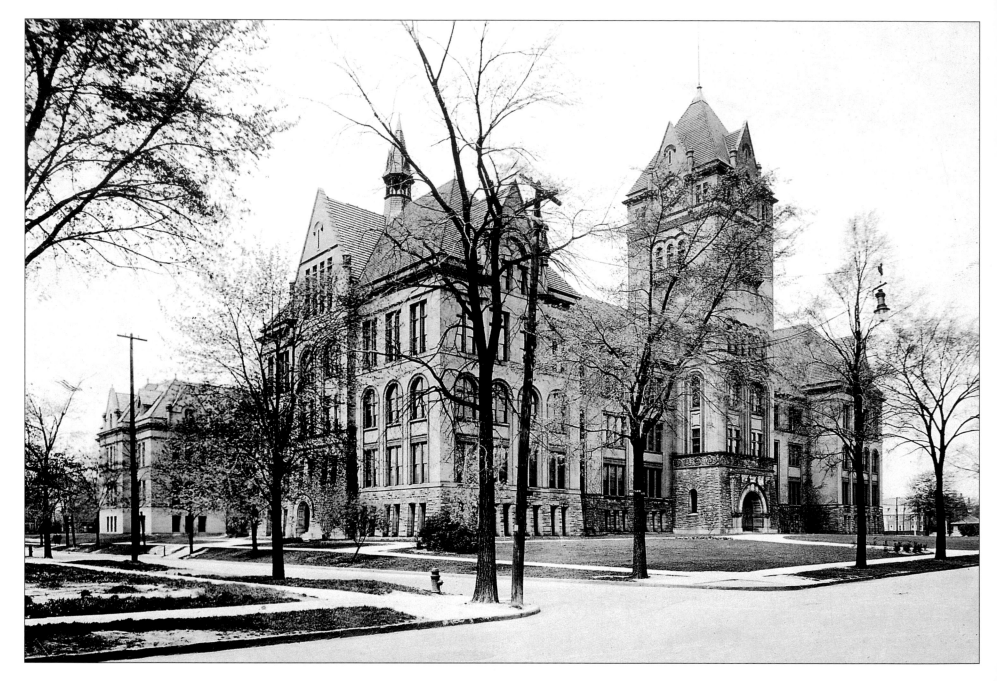

This 1919 photo is of Detroit's first high school building, built for that purpose. A Malcolmson & Higginbotham design, Central High School opened in 1896 at Cass and Hancock. The building was also used as Detroit Junior College in 1917. In 1923 it was the College of the City of Detroit, and in 1933 it became the cornerstone of the Wayne State University campus.

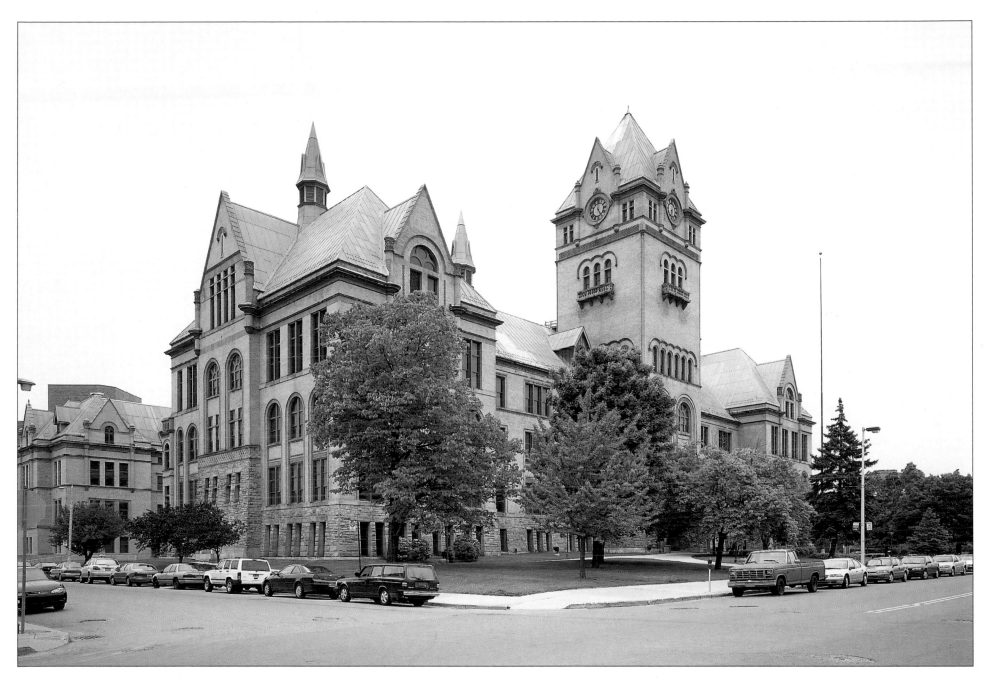

Known as Old Main, Central High was the first building on the campus of Wayne State University. Until recently, the yellow brick facade was covered with ivy and years of grime, but for its one-hundredth birthday, it underwent a forty-seven million dollar restoration that included cleaning of the exterior, plus the addition of a planetarium, an art gallery, music and theater rehearsal rooms, forty-five classrooms, and an anthropology museum.

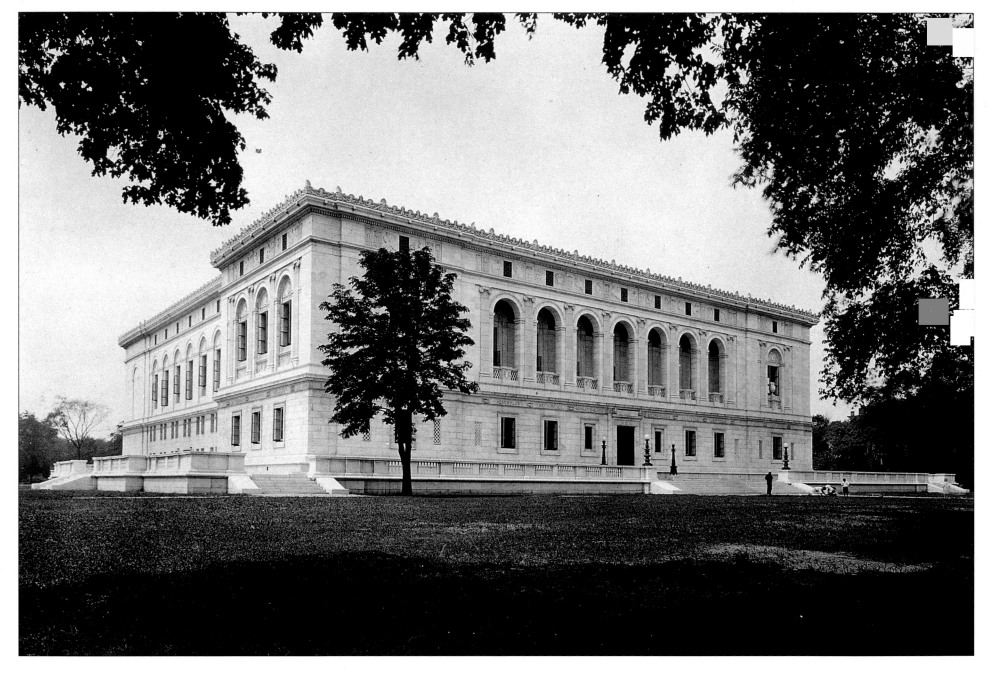

Designed by architect Cass Gilbert, this building was erected in 1921 as the beginning of Detroit's Cultural Center. Seven parcels of land bordered by Woodward, Putnam, Cass, and Kirby, were eventually purchased to create the park-like setting for the library. Built to create an environment of culture and refinement, the Italian Renaissance building features broad terraces, a second floor loggia with a mosaic-tiled ceiling by Mary Chase Stratton, and murals by Edwin H. Blashfield and Gari Melchers. Taken shortly after the building's completion, this photo shows the as-yet unlandscaped grounds.

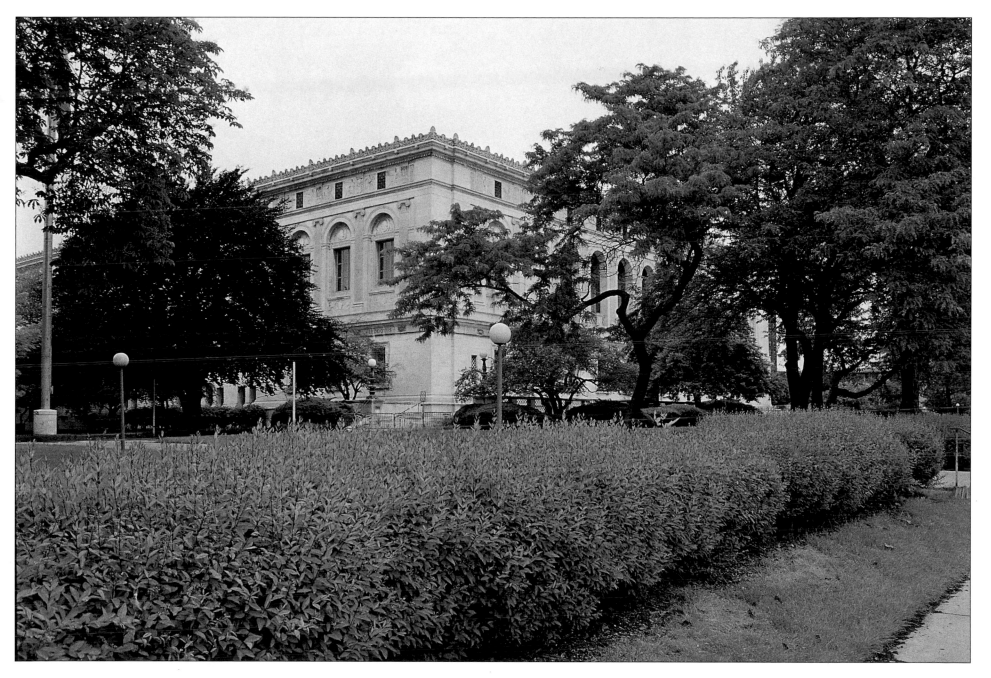

In 1963 new wings were added on the northwest and southwest sides to accommodate the library's growing collection and usage. Architects Francis J. Keally and Cass Gilbert, Jr., complemented the original design with a more modern version of the Renaissance style, though the exterior features thin marble slabs versus the large marble blocks of the original building. The addition created 240,000 square feet, doubling the original size. Today the library is the hub of a twenty-four-branch system.

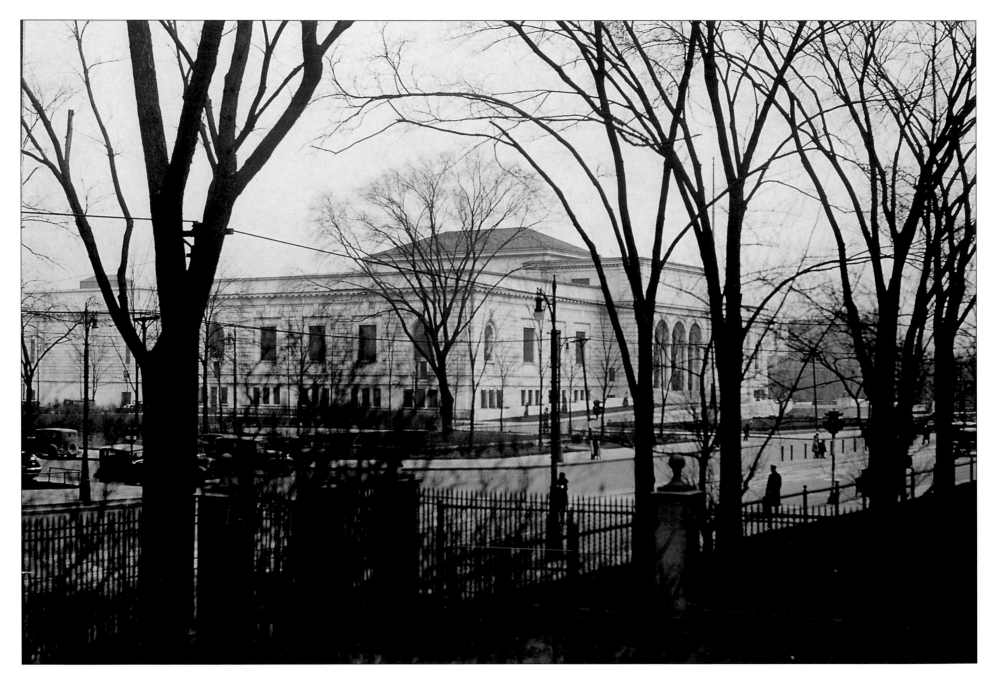

Although the land for the Art Institute was purchased before the library chose its site, the building was not completed until 1927. Occupying the block of Woodward, Kirby, John R, and Farnsworth, directly across the street from the library, the Art Institute reflected the white marble magnificence of its neighbor. The classic Italian design by Paul Philippe Cret was planned as a series of "period rooms" arranged in historical order around courtyards. The centerpiece of the museum is the great hall with walls covered by the famous Diego Rivera murals depicting Detroit's automobile history. This photograph was taken in 1933, when Rivera's murals were revealed to the public, causing an uproar and attacks on the artist's politics and work.

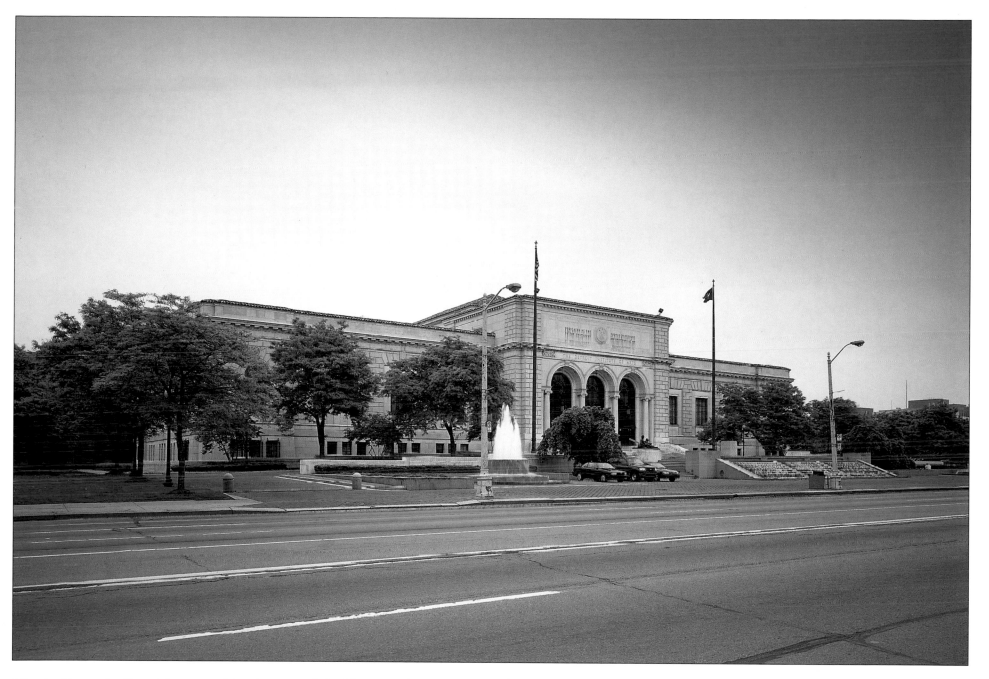

Like the library, the Detroit Institute of Arts has expanded, adding a south wing in 1966 and a north wing in 1971 for a total of eleven acres of exhibit space. The entrance to the front of the building was redesigned to accommodate a stair waterfall and two round fountains, popular spots for splashing in the summer. The northwest corner of Woodward and Kirby, where this picture was taken, is now the Detroit Historical Museum, a 1951 addition to the Cultural Center.

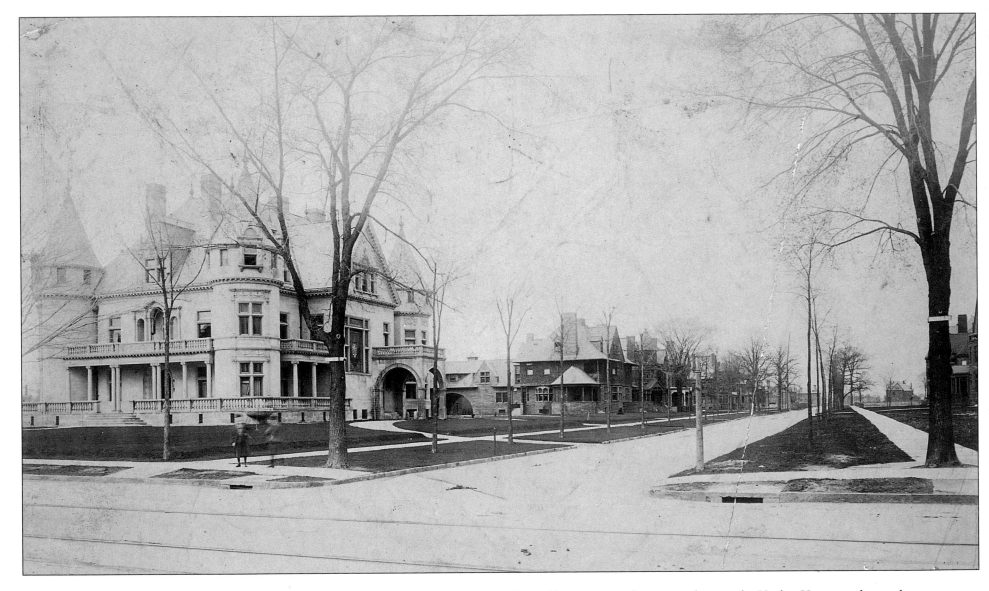

Resembling a sixteenth-century chateau, the Hecker House, at the northeast corner of Ferry Street and Woodward, was at the city outskirts when it was built in 1890. Frank Hecker was founder and president of the Peninsular Car Company, a railroad car concern. This late 1890s photo shows the magnificent limestone structure created by Louis Kamper and his firm, with its towers and carved stone details. The shingle-style home of Charles A. Freer, noted art collector and vice president of Peninsular Car, is next door.

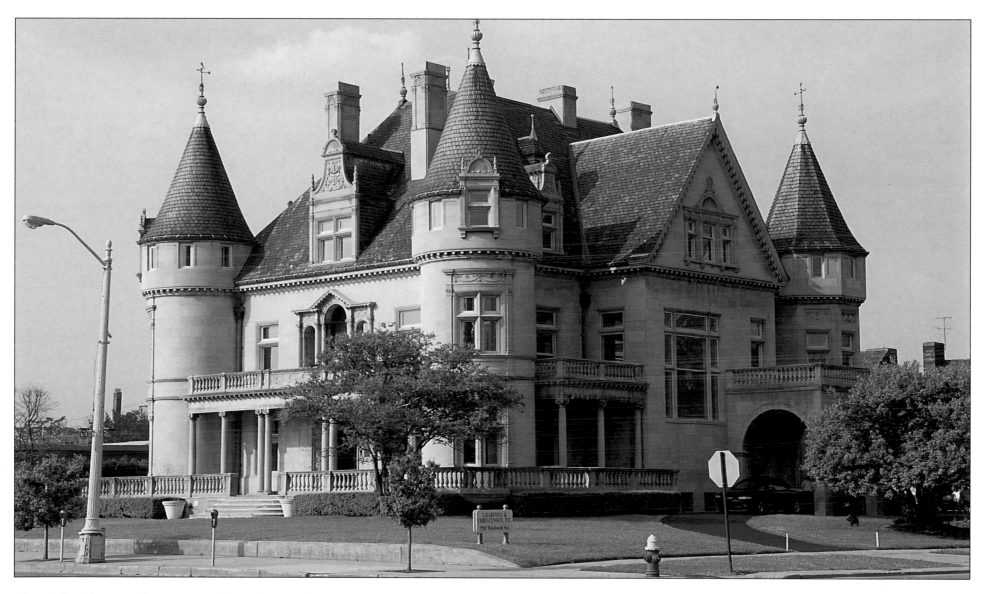

The Hecker House was later occupied by Smiley Brothers and is now home to a law firm. The Freer house is owned by the Merrill Palmer Institute. From time to time, tours are given of both houses, located in what is now called the University Cultural Center. Across Ferry street, four other mansions plus two carriage houses are being restored and renovated to open jointly as a forty-two unit bed-and-breakfast establishment.

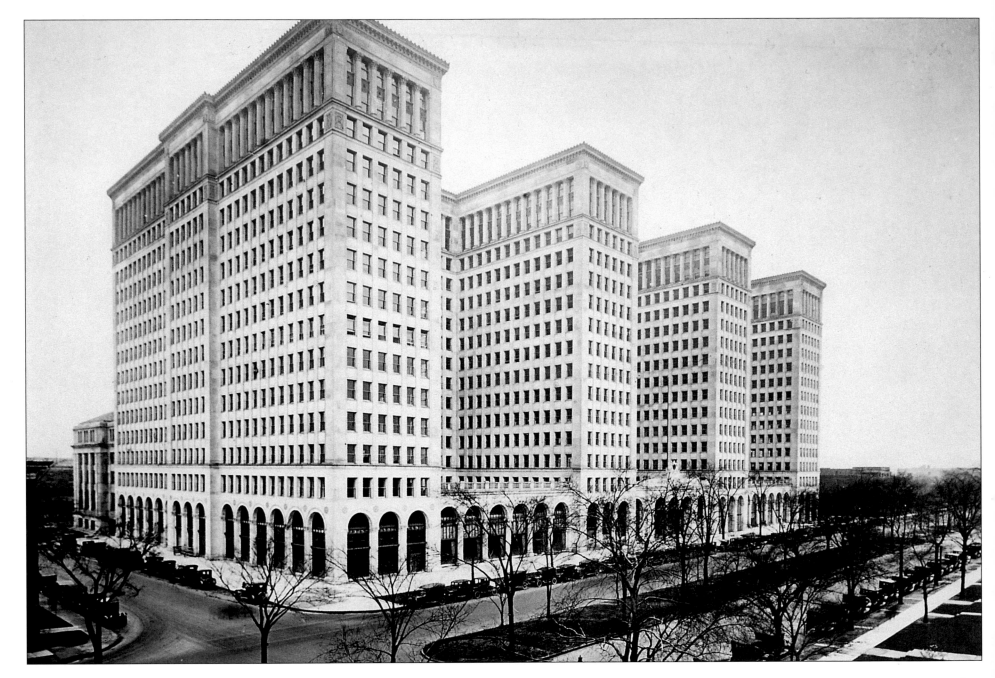

When it was constructed in 1920, the General Motors Building was in the geographic center of the city. The second largest office building in the world, it was designed by Albert Kahn. All 2,000 offices in the fifteen-story building contain windows. It is located on Grand Boulevard and occupies an entire block between Cass and Second Avenues. In this 1920s photo, the building stands as a monument to the company that spawned the saying, now misquoted as, "What's good for GM is good for the country."

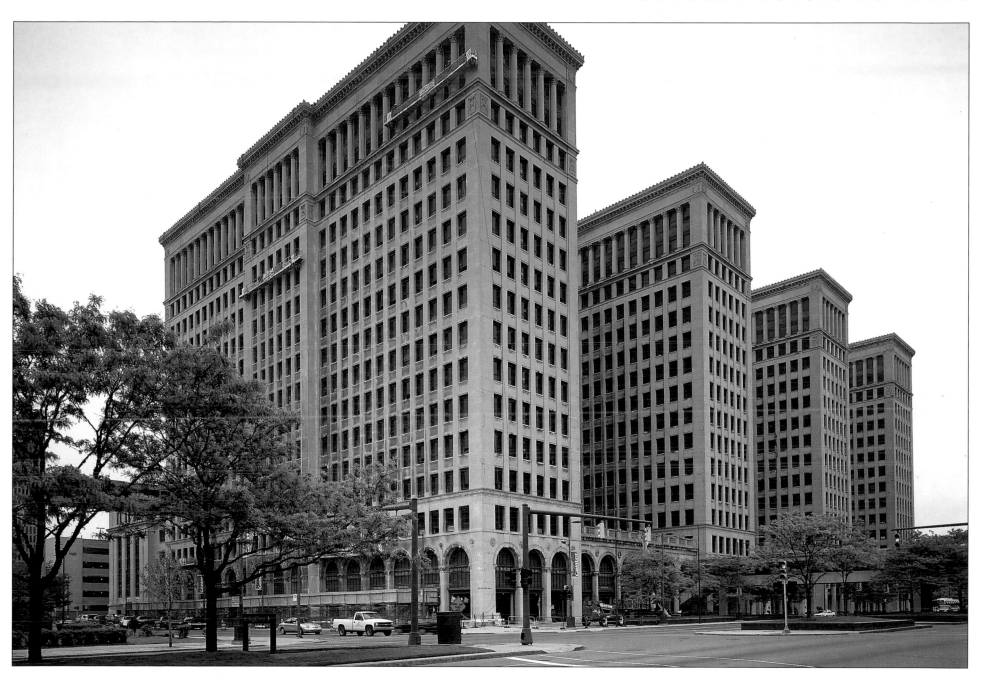

In 1996 the General Motors company started moving its offices to the glass columns
of the Renaissance Center downtown. This building is being renovated to
accommodate offices for 2,800 State of Michigan employees and will be called
Cadillac Place.

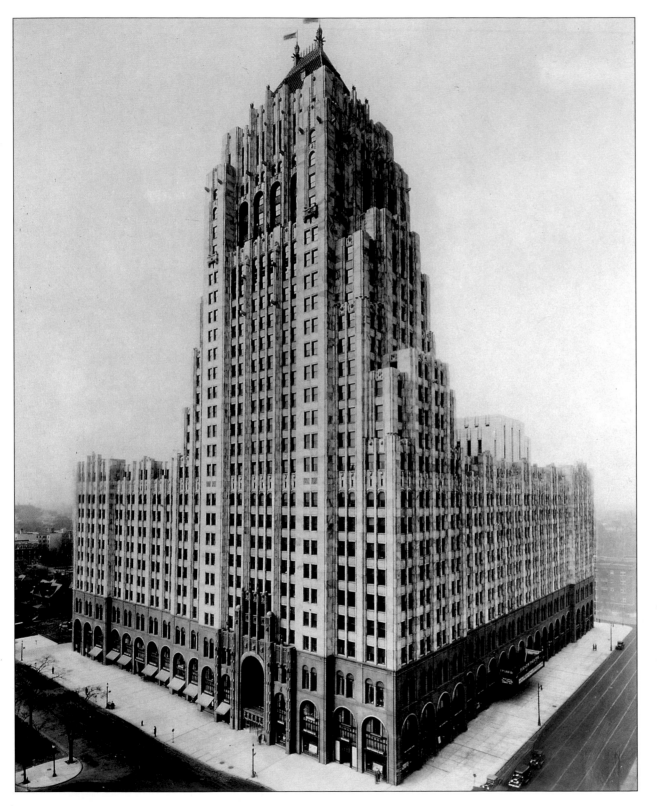

The seven Fisher brothers, made rich by their company's manufacture of enclosed automobile bodies, built the Fisher building in 1928 as their contribution to the city. This photo was taken shortly afterward. Unable to find enough land downtown, they chose this site on Grand Boulevard, across from the General Motors Building, in what is called the New Center Area. One quarter of the nine million dollar budget was spent on artwork and extravagant materials such as gold leaf and exotic marble from around the world. This Art Deco jewel is arguably Albert Kahn's greatest work in Detroit.

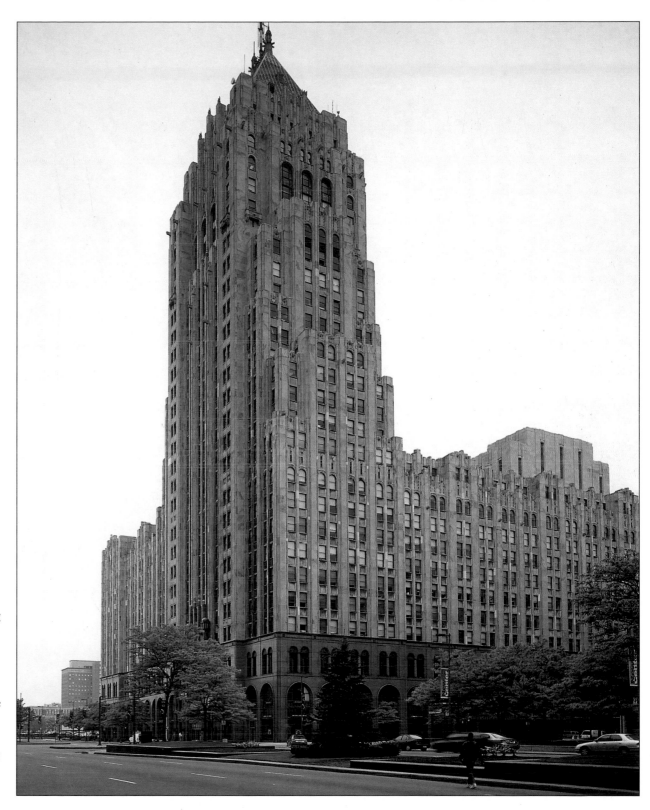

Today the building, which houses the Fisher Theater along with shops, restaurants and offices, and a parking garage, is as beautiful as ever. Continuously occupied since its opening and always well-maintained, it was designated a National Historic Landmark in 1989. Outside of normal updating and the 1961 renovation of the theater to change it from a movie to a stage show venue, the building's interior and exterior remain the same. A pedestrian walkway now connects it to New Center Place, a shopping mall across Second Avenue.

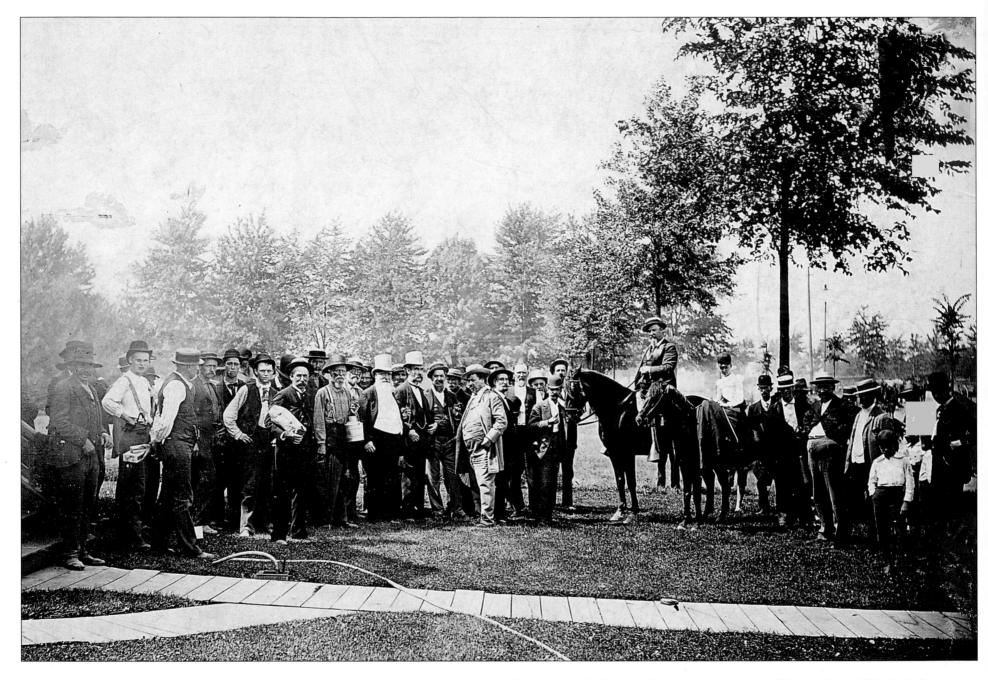

The man on the horse is Hazen Pingree, mayor of Detroit from 1890–97. Other Detroit dignitaries surround him for the dedication of the much-contested Grand Boulevard in 1891. It took six years for the plan to be approved that would create a looping boulevard beginning at the Belle Isle Bridge on the eastside, and ending near the river on the city's westside.

Today, "the Boulevard," as it is called, is still a main thoroughfare, home to the former General Motors Building, the Fisher Building, and, farther west, Henry Ford Hospital. Facing west from a probable point where the first sod was removed, we gaze into the entrance to the New Center Area, a business and neighborhood designation that was intended to be a second business district three miles from downtown Detroit.

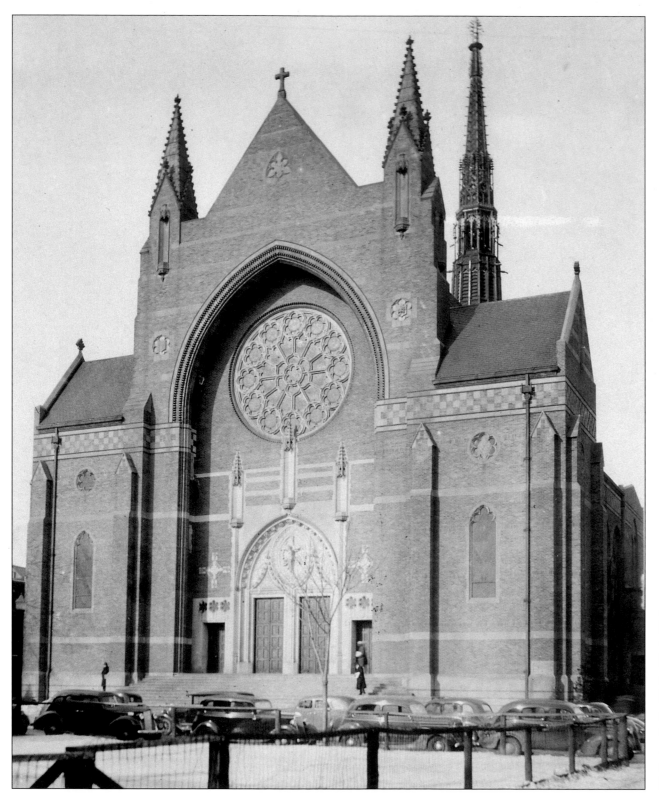

According to parish history, St. Florian was established in 1907 to serve the large number of Polish immigrants who came to the Detroit area to work in the new Dodge brothers factory. Both are located in Hamtramck, a one-and-a-half square mile city within the boundaries of Detroit. St. Florian is the oldest parish in Hamtramck and was once the second largest parish in the Detroit diocese. Ralph Adams Cram received the American Architecture Award in 1929 for his design of this church, erected in 1928 and patterned after various European cathedrals. This photo was taken in the 1940s.

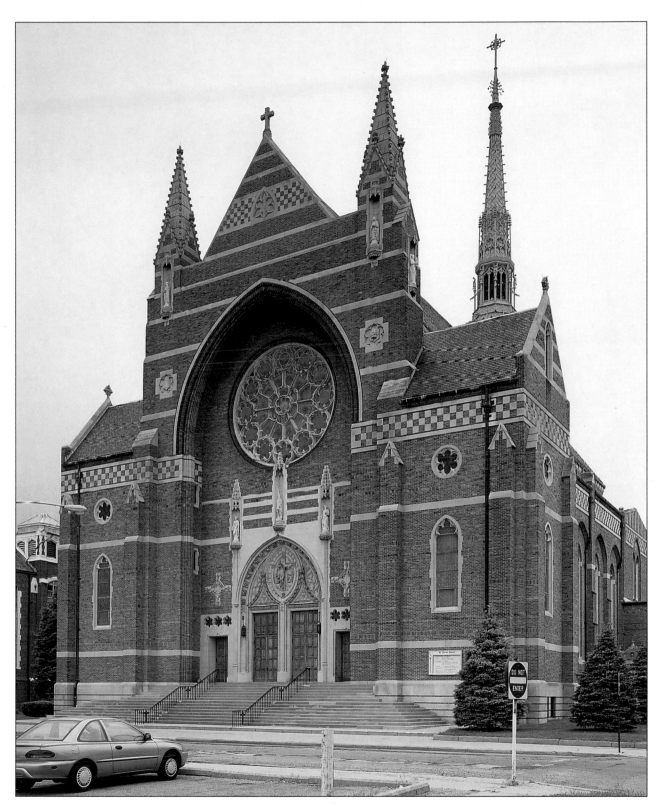

In 1984 the St. Florian neighborhood, with the church as its focal point, was designated a national, state, and local historical district. A high school and convent were added to the property in 1940 and 1959, respectively. Little else has changed in the surrounding neighborhood save for the influx of a greater number and variety of ethnic groups. A high point of the church's history was the 1987 visit of Pope John Paul II.

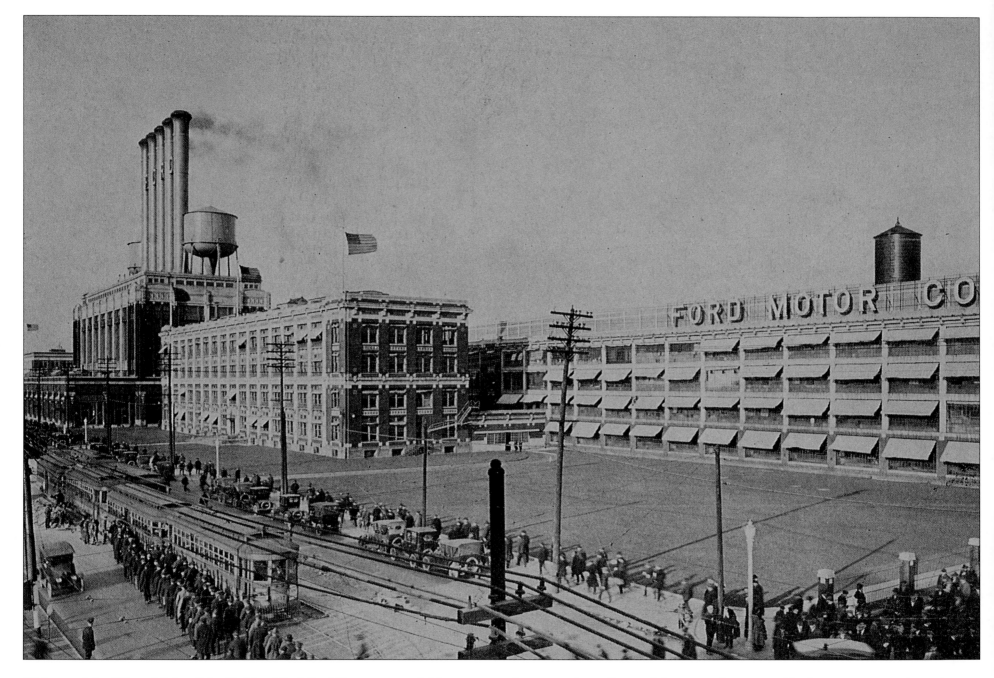

Nicknamed the "Crystal Palace," the Highland Park Ford Plant was a model for factories in the twentieth century. In this 1923 photo, the shifts are changing here where the modern assembly line was perfected and the five-dollar-a-day wage changed American labor history. Located in Highland Park, a city within the northern boundaries of Detroit, the complex consisted of a four-story, 865-foot long factory, a four-story plant office, and the power plant, topped by five enormous smokestacks. The building was begun in 1909 and, though not completed until 1914, was producing cars by 1910. This was one of over one thousand buildings industrial architectural genius Albert Kahn designed for Ford.

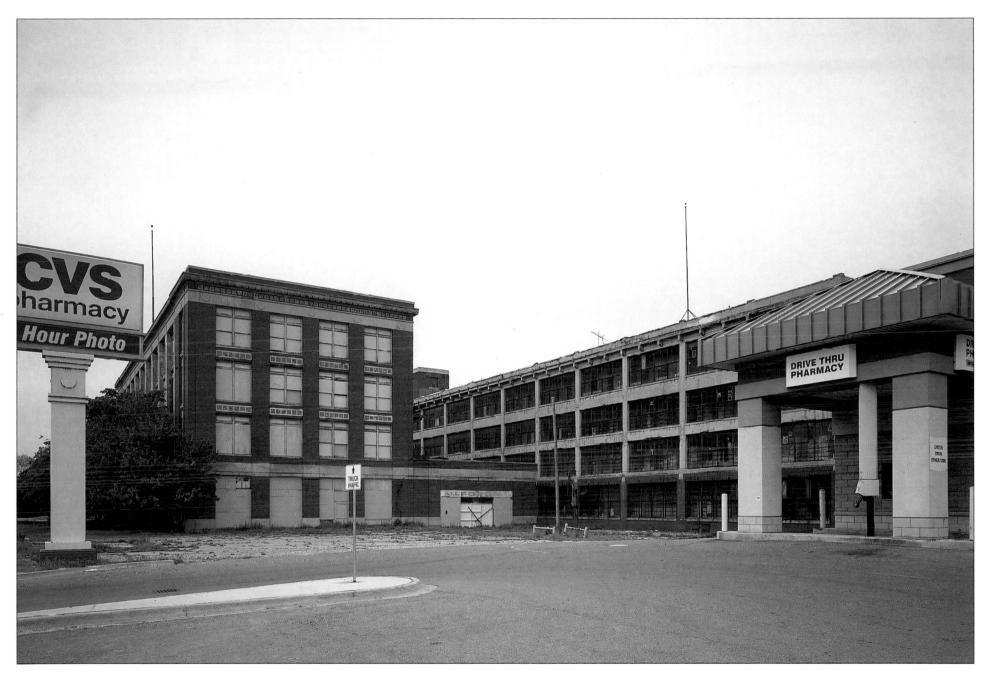

Auto production quickly outgrew this facility and was moved to the River Rouge factory in the late 1920s, although Ford tractors were produced here into the 1970s. The Ford Company sold the factory in 1981 but still leases warehouse space. The complex is owned by a development group with plans to create lofts and office space in the historic buildings. This pharmacy sits at the northern end of Model T Plaza, a shopping strip opened in 1997 anchored by a grocery store with a photographic reproduction of Diego Rivera's mural *Detroit Industry* inside.

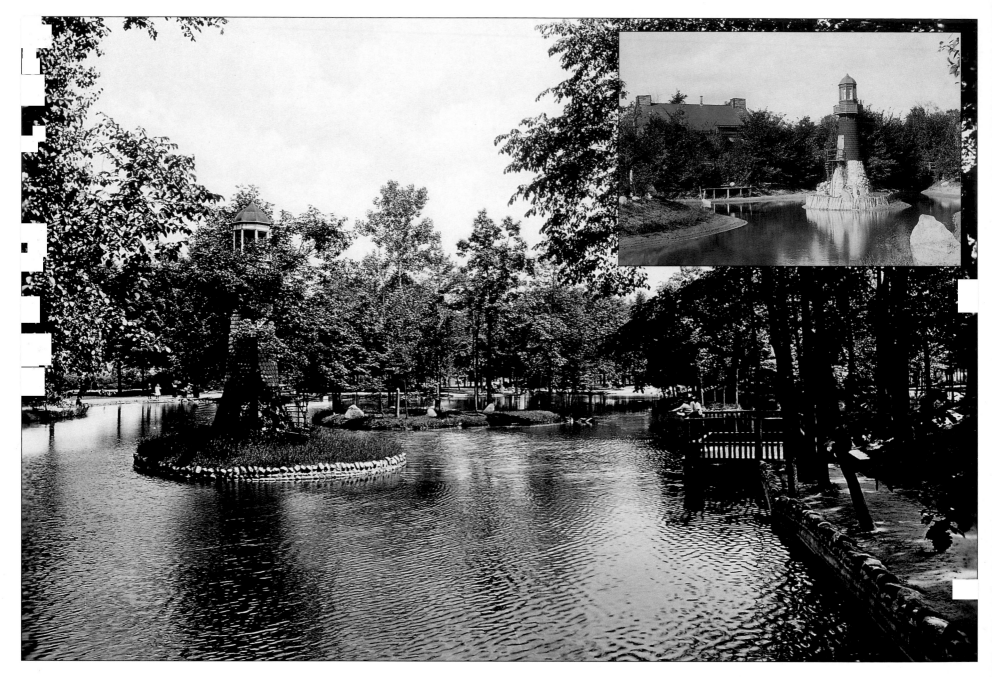

This photo of a miniature lighthouse on an island in a man-made lake was taken from the home of U.S. Senator Thomas Palmer and his wife Lizzie. The island stands in front of the 1885 two-story, 2,400-square foot log cabin that was a summer residence to the Palmers. In 1893, Senator Palmer and his wife donated 120 acres of land, including this parcel, to the city. Located at the northwest boundary of Detroit and Highland Park, Palmer Park, as it was named, became a popular place for bicycling and picnicking in the summer, and skating in the winter.

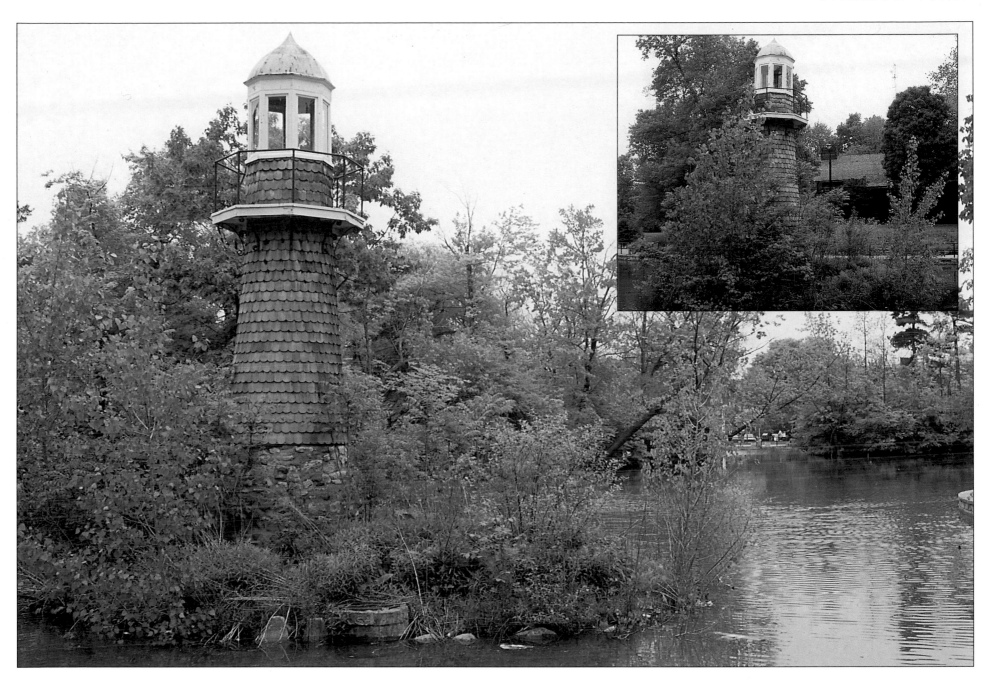

The lake, the lighthouse, and the cabin are all still here, but limited resources in the city's Parks and Recreation Department have prevented them from being fully maintained. The lighthouse seems to have lost its staircase, the stone wall at the lake shore has been replaced by a sidewalk with railing, and the small pavilion on the right is gone. Still, the park is heavily used by residents of the adjoining Palmer Park neighborhood, and much of the property remains the wooded area it was over a hundred years ago.

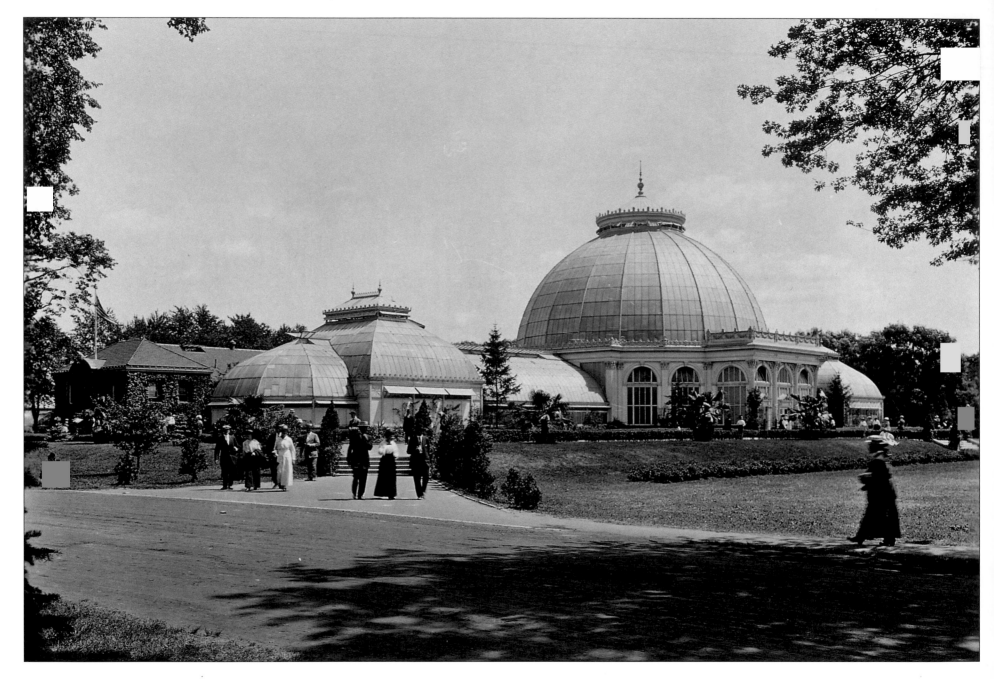

The Anna Scripps Whitcomb Conservatory, shown here in an 1890s photograph, contains more than a quarter of a million plants. Its design, by Albert Kahn, is patterned after Thomas Jefferson's Monticello. Surrounded by formal gardens, it has one of the largest municipally owned orchid displays in the country, dating back to the 1800s. The 1904 structure is located at the western end of Belle Isle, next to the aquarium.

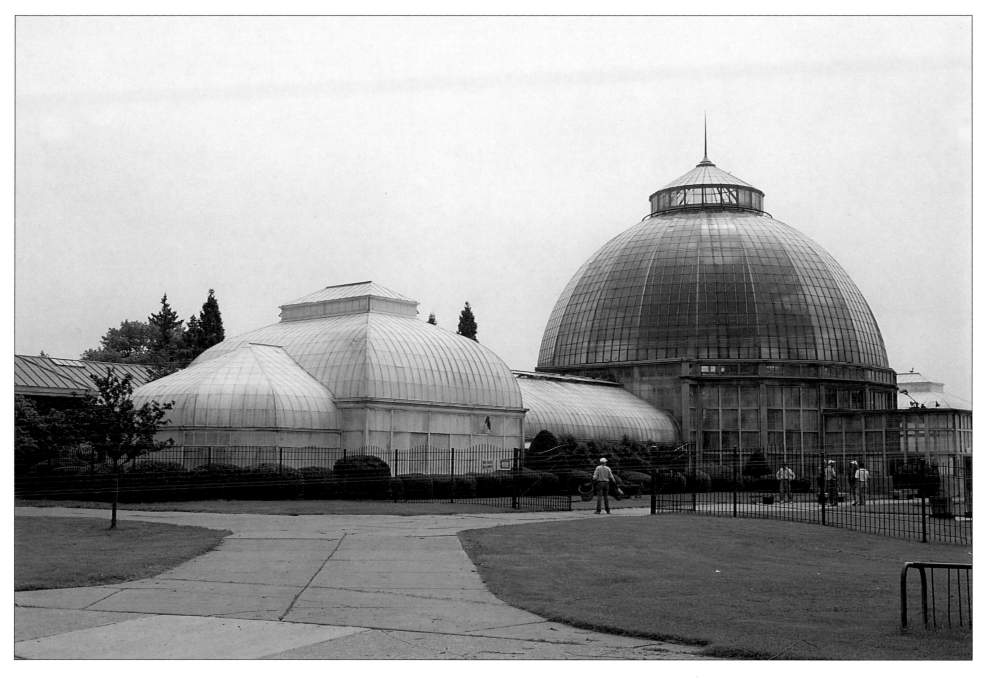

Part of the renovation plans for the island park are to create a Conservatory Promenade which will link the casino, skating pavilion, bandshell, conservatory, aquarium, and the Dossin Great Lakes Museum, all of which are clustered nearby on the southwest side of the island. The Conservatory, a popular place for weddings and receptions, is slated for a million-dollar renovation to modernize it.

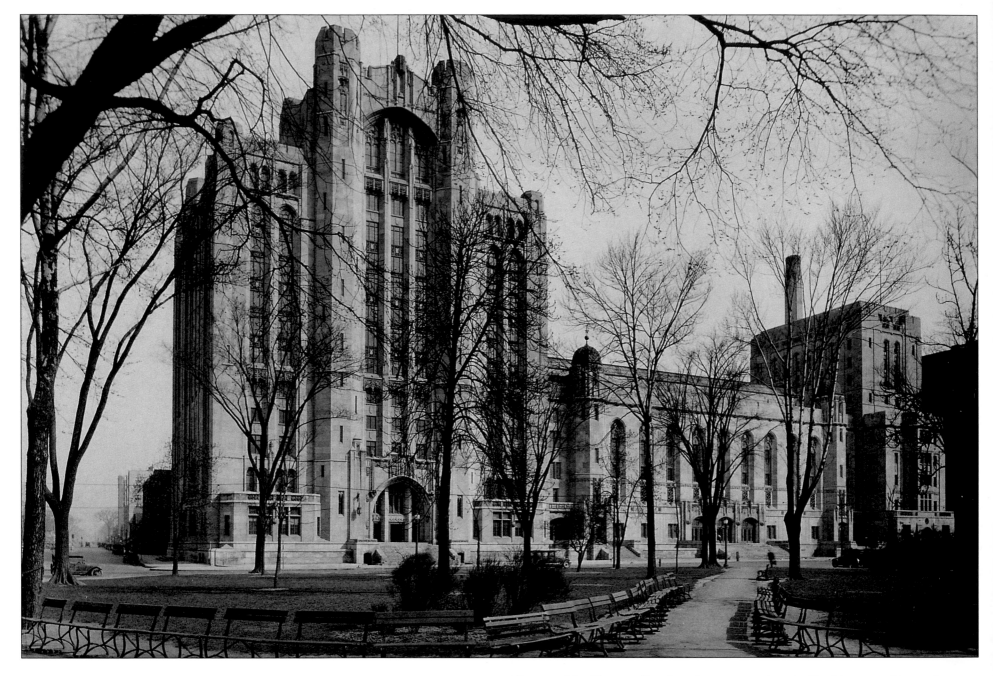

This grand building on Temple, takes up an entire city block between Cass and Second avenues. Its architect, George Mason, felt that medieval relics were the best source for present-day buildings. This is certainly evident in the Gothic temple masonry, built in the tradition of European cathedrals. The massive building was started in 1920 and opened in 1926, and contains ballrooms, banquet halls, and a 5,000 seat auditorium. Sculptor Corrado Parducci was responsible for the interior. This photo was taken by the architect not long after the building opened.

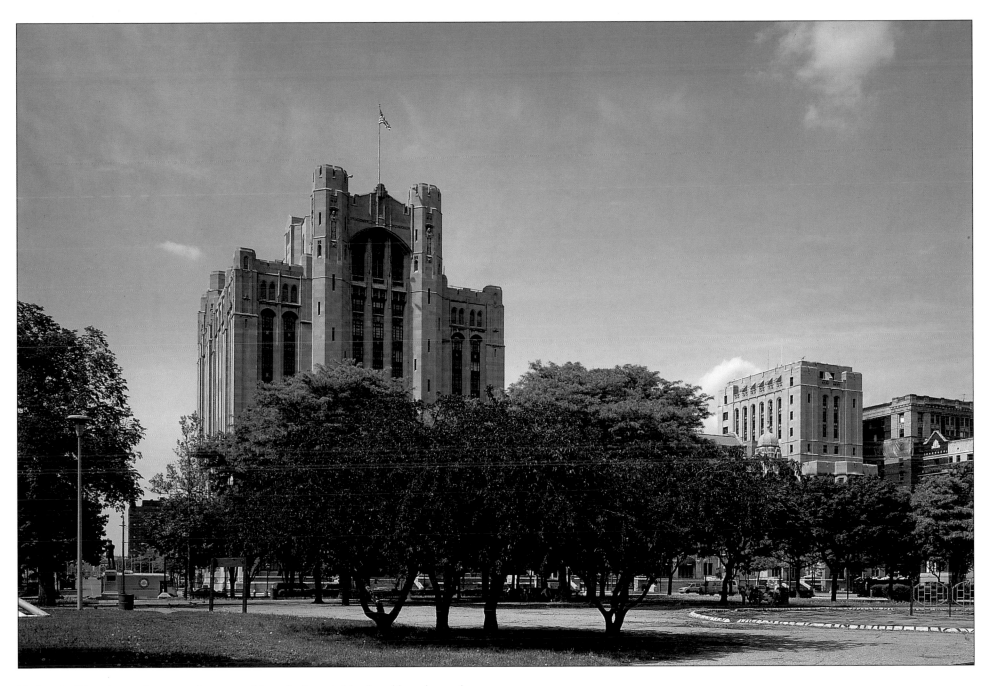

Today the Temple stands as grand as ever, although the neighborhood has changed considerably. The hotel on the right is home to an indigent population whose representatives fought and won when the Temple wished to claim the space for parking. The auditorium stage is one of the widest in the city, accommodating the Metropolitan Opera when it came to Detroit, and now used for space-demanding Broadway shows such as *Miss Saigon* or *Phantom of the Opera*.

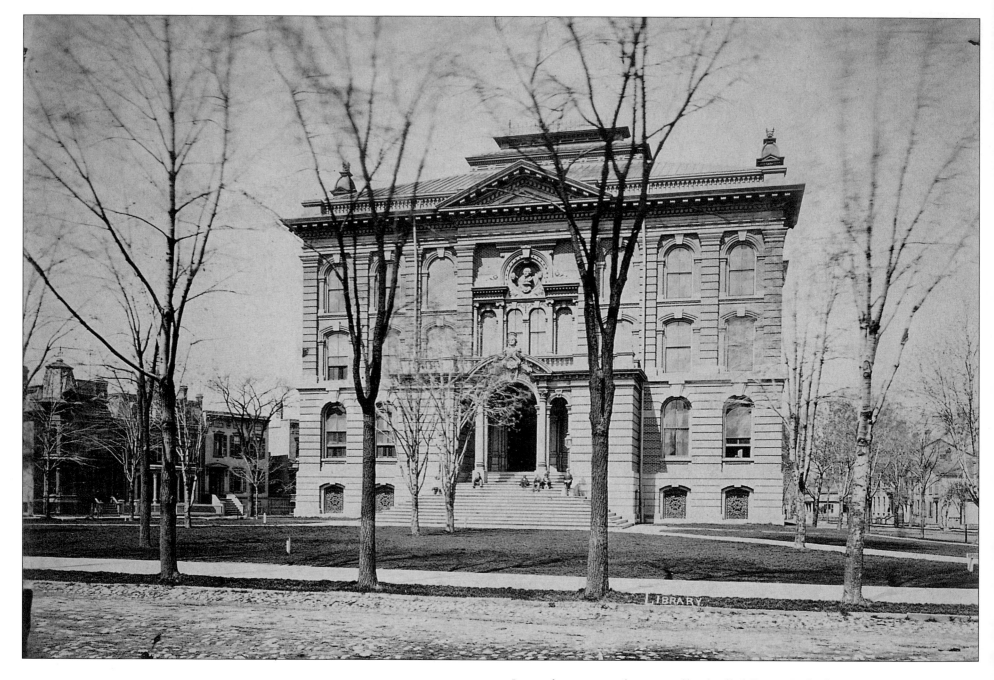

Located on a triangular piece of land called Centre Park, the Detroit Public Library's first building was completed in 1877. Founded in 1865, the library had until then used space in the old Capitol Building. Described as architecturally ugly outside, inside the four-story building was a marvel of cast-iron work. Ten columns painted lavender and light-brown rose from floor to roof with wrought iron galleries at each level. Ten years after this 1881 photo was taken, the houses to the left were replaced by the eight-story J. L. Hudson store.

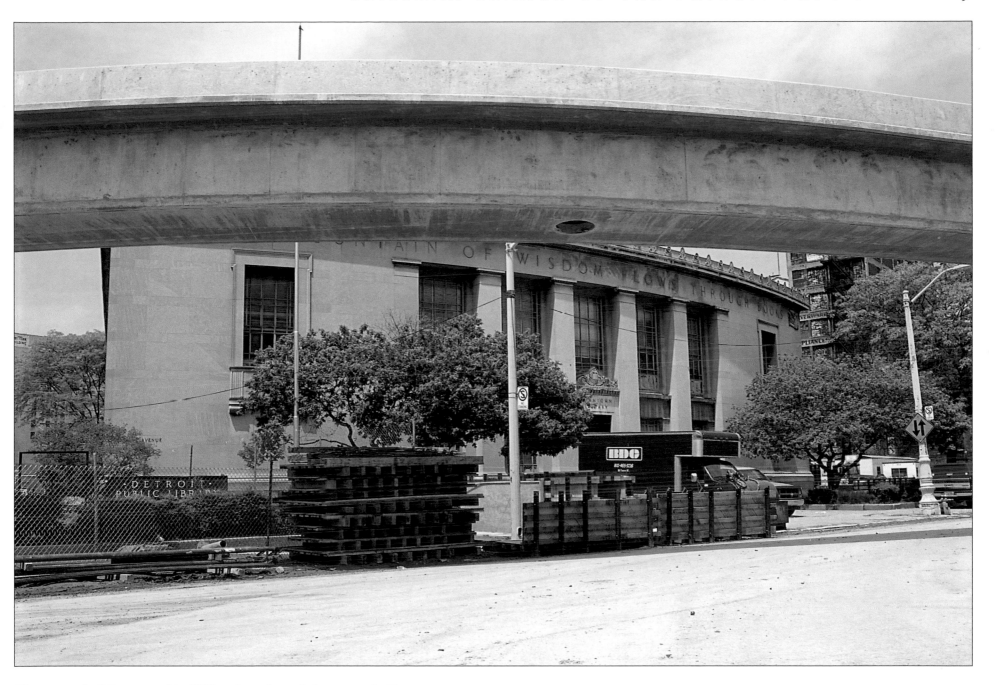

The current building opened in 1932 and was formerly known as the Downtown Library. It is now called the Rose and Robert Skillman Branch Library. Forced to close and relocate its services when the twenty-five-story Hudson's building behind it was demolished, the library is in the process of being restored and refurbished with updated facilities and services. The raised track in front is the People Mover, a transit system that makes a nearly three-mile loop of the central business district.

CICALA LOT 270

LIEBAU 46

DEANGELIS

FORTNER 156

JACOBSEN 248

BRUDER

734 427